World as Family

World as Family

A Journey of Multi-Rooted Belongings

Vishakha N. Desai

Columbia University Press
New York

Columbia University Press
Publishers Since 1893
New York Chichester, West Sussex
cup.columbia.edu
Copyright © 2021 Columbia University Press
All rights reserved

Library of Congress Cataloging-in-Publication Data
Names: Desai, Vishakha N., author.
Title: World as family : a journey of multi-rooted belongings /
Vishakha N. Desai.
Description: New York : Columbia University Press, [2021] |
Includes bibliographical references.
Identifiers: LCCN 2020050773 (print) | LCCN 2020050774 (ebook) |
ISBN 9780231195980 (hardback) | ISBN 9780231551588 (ebook)
Subjects: LCSH: Desai, Vishakha N. | East Indian American women—Biography. |
Women, East Indian—United States—Biography. | Women immigrants—
United States—Biography. | Intellectuals—United States—Biography. |
Women college teachers—United States—Biography. | Globalization—Social aspects. |
Belonging (Social psychology) | Communities.
Classification: LCC E184.E2 D383 2021 (print) | LCC E184.E2 (ebook) |
DDC 305.89/1411073—dc23
LC record available at https://lccn.loc.gov/2020050773
LC ebook record available at https://lccn.loc.gov/2020050774

Columbia University Press books are printed on permanent and
durable acid-free paper.
Printed in the United States of America

Cover design: Milenda Nan Ok Lee
Cover art: *Cell Series: 1*, Robert Oxnam, pastel on Chinese paper

उदार चरितानां तु वसुधैव कुटुम्बकम्

"For the magnanimous, the world alone is family."

—*MAHA UPANISHAD 6, 71–75,* CA. 1000 BCE

Contents

Contents

Part III: In-Between-Ness of Belonging

Part IV: Expanding the Circle/Back to the Center

Part V: At Home in the World

World as Family

Introduction

"**O**NCE YOU OPEN YOUR EYES to the world, you can never shut them again," a young Italian exchange student in Ghana told me in 2017. She was describing the effect of her transformative experience: living with a family that would magnify her idea of "family" forever. In the age of Brexit and Donald Trump, with the increasing rhetoric of nationalism around the world, the idea of an expanded belonging seemed like an idealistic pipe dream.

Nonetheless, I was deeply touched by the Italian student's observation—not only because I had been on the same exchange program (American Field Service, or AFS) more than five decades ago and could attest to similar sentiments but also because it so aptly described my life of keeping my eyes open to the larger universe that I have come to inhabit. Arguably, the young student's commitment to staying open and becoming part of the larger world has become a necessity for our very survival.

In a world of instantaneous connections and deep fissures across borders, pandemics and climate crises that know no borders, and millions on the move, one could argue that we have no choice but to expand our sense of belonging to include the whole human race. The double global phenomena of coronavirus and cries for social justice over the past year demand that we learn to navigate the interconnected complexities of the world at local,

national, and global levels. But how do we do that against the backdrop of antiglobal noise from many corners of society?

For me, it has been the journey of a lifetime. A banyan tree has been my metaphor for that journey. It all began with sitting under an old, expansive banyan tree near the ancestral home of my father when I was five years old. It was love at first sitting. I marveled at its multiple trunks that seemed to become roots, which in turn became branches. I loved the shade it provided, protecting me from the harsh heat of the Indian sun while its softer branches created gentle breezes. That infatuation matured into a deep personal attachment as I encountered centuries-old banyan trees in some of my favorite places, ranging from Gandhi Ashram in my hometown of Ahmedabad to Matrimandir at Auroville, a spiritual center in southern India.

Over time, I learned about the banyan's cultural significance in India (a resting place for the Hindu god Krishna, a Buddhist symbol of the reciprocal relationship between the desires of the senses and efforts at detachment from them). But for me, it became a personal symbol for multirooted belongings: its primary trunk and branches becoming interchangeable, the soft rustle of its leaves suggesting the presence of the windy world coming through. I thought it was an apt metaphor for the life of global belonging that I had learned to live over the years.

Then I tried it out on a number of young exchange students I met in Ghana. From Italy, Argentina, and the United States, the students had been in Ghana for three months or so and were eager to talk. An American student jumped in:

> My friends from Minneapolis keep asking me to post pictures on Instagram and write blogs about my experience here. But I'm so busy here that I really don't have time to be on social media to share it all with friends thousands of miles away. I'm not even sure if they would understand. My life is changing in front of my eyes and I know it will never be the same again.

Then the Italian student delivered her reflection about opening her eyes to the world.

I realized right there and then that my banyan-tree metaphor had little relevance for them. Their sense of time and place and their experience of the

world were fundamentally different from mine when I was their age. Like me, they were excited about becoming members of a new family thousands of miles away from their homelands. But in 2017, they were frustrated by the constant demands for instant communication from their friends back home. By contrast, in 1967 I had managed to call my parents exactly once during my entire exchange year in Santa Barbara, California. Even for that call—to report a broken ankle from a skiing accident—my American family and I had to wait for three days just to book the call, and we could talk for exactly three minutes! It was as if the young students' banyan tree had grown up overnight rather than over a lifetime.

I must confess, I was a little jealous of the young students in Ghana. As members of Generation Z, born into the globalizing world at the turn of the century, they intuitively understood their particular local experience in a broader global context. Even in our age of instant communication and split-second access to the world, the Ghana-based exchange students were appreciative of the value of a real experience as being qualitatively different from a virtual one. They understood the transformative value of the physical and cultural distances they had traveled between their home countries and their newly adopted home in Ghana.

By contrast, the larger world was not so easily available to me as a child of newly independent India in the 1950s. Growing up in the ascendant age of nation-states in a family steeped in the Gandhian ethos and nationalist spirit, I first learned to cherish the spirit of the new country. Living in a secondary city without television or ready access to plane travel, my breakout moment occurred at the age of seventeen when I went on my first plane ride to go for a year-long stay in the United States. It took me a lot longer to understand the lifelong implications of becoming a member of a new family in a faraway land. It has taken me a lifetime to learn what young students were born into and understood intuitively. In the early twenty-first century, however, we are all living with the same local/global realities in an increasingly globalizing world.

The students I meet through AFS and the graduate students I teach in the Global Thought program at Columbia University are at ease with the reality of the interconnected world. Passionate about solving global problems, they have an expansive view of the world and a more capacious sense of their local

communities. Granted, they select these programs because they are predisposed to the possibilities of working and living globally. However, their bold assertions and idealistic visions often elide their just-below-the-surface angst about questions of belonging and identity. What if in their efforts to belong everywhere, they belong nowhere? How should one reconcile the apparent dichotomy between global engagement and local action? Is it possible to be locally rooted and globally connected? These questions expose the inextricable tension between their belief in global engagement and their fear of rootlessness, resulting in what I call the "anxiety of simultaneity."

The concerns of these young netizens also reflect the current onslaught of antiglobalism everywhere. Bitterness toward the "Davos Man" as a symbol of a global cosmopolite is fierce. Economic pitfalls of globalization have resulted in resentment by those who feel their futures becoming obsolete as their jobs vanish. Political leaders in many parts of the world have seized upon the latent fears of the disaffected. Donald Trump's demonization of migrants across the southern borders of the United States and Boris Johnson's fierce defense of Brexit are integral to their efforts to pitch *global* as being antithetical to national interests. Trump has turned it into his mantra: "The future does not belong to globalists, the future belongs to patriots,"[1] making it abundantly clear that, for him, the terms *globalist* and *patriot* are mutually exclusive.

In India as well, political leaders have promoted debates about "authentic" Indian identity, attached to a narrow definition of Hinduism. The concept of *Hindutva* (essence of Hinduism), a relatively new term conflating the religious, cultural, and political identity of India popularized by the ultra-right-wing organization Rashtriya Sevak Sangh (RSS), connected to the ruling Bharatiya Janata Party (BJP), is used to sow divisions between Hindus and Muslims and other minorities. The country that was born of the values of respect for differences and protection of minorities—values that were functionally present in my childhood—is now torn apart by questions of who has the right to "belong" to the vast and varied millennial civilization that encompasses the geographic boundaries of the modern Indian nation.

Thorny issues of cultural appropriation and pervasive demonization of all things "global" create a sense of dissonance for young people who live in the multilayered reality of the globalizing world and aspire to make a difference

on a broader stage. Students I encounter are believers in "living responsibly in the global community of six billion [now approaching eight billion] strangers" as Anthony Appiah described in his seminal book, *Cosmopolitanism*.[2] These students provide a powerful antidote to the leaders and individuals shouting antiglobal slogans.

As the inaugural generation of digital natives, these members of Generation Z take it for granted that accelerated communication across the world will continue to connect people across geographies even while creating new fragmentations. Passionate about the looming climate crisis and aware of the dangers of pandemics, they understand that global problems require the coordinated efforts of countries around the world. Surveys of youth around the world tell us that they are more supportive of immigration than their elders and value travel for deep cultural encounters. They take their global condition as a reality, not a choice to be discarded or accepted at will. But they also feel anxious about connecting local issues and national priorities to larger global concerns. Contrary to popular perceptions, their problem is not apathy but a lack of structures and systems that make it possible to navigate the complexity of the world in their physical backyards and in their virtual communities beyond national borders.

Being products of multicultural experiences, many of the young people I meet have personally experienced the pain and pleasures of multiple belongings.

THE SON OF MY good friend Joey Horn beautifully described this predicament in his college application essay. Born to a self-described "originally Indian"-raised-in-the–United States mother and a Norwegian father, Nils Horn has lived in multiple locations. He wrote about his experience of being a multicultural kid in a monocultural Norway, a multicultural Singapore, and a culturally cacophonous India. He reflected on his young life after returning to Oslo from Kolkata where he "found himself" (if not his heritage) while working with disabled and mentally challenged children. Nils ended his essay with a profound reflection: "I am a citizen of the world, I concluded. I am genetically diverse and there is no one like me in Norway. I am American by birth, Asian by education, and Indian/European by heritage. I'm versatile,

I'm adaptable, and I'm a poster child for diversity. But the question still stands. Where am I from? And my answer is that I'm still searching."[3]

People like Nils recognize that for some two hundred million people who live outside their country of origin (more than two-thirds of the U.S. population), the question of "home" or "belonging" is always in a state of flux, often portable, and never singular. They intuitively accept that identity is hardly a given; it requires a conscious and constant act of negotiation and reconstruction. Many of these young people are intellectually aware that, as the critic Stuart Hall once described, identity is both a matter of "becoming" (negotiation, perhaps) as well as being (maintenance, perhaps), requiring a "double sense of identity." However, their identity predicament confirms that it's not easy to experience "global" belonging as a way of being *in* and *of* the world without losing deep local affinities. The paucity of concepts, images, and stories that define "global" as multitudes of interconnected parts—local, regional, and national—also exacerbates young people's anxieties.

Seeing me as someone who has lived through the intricacies of multilocational attachments, students often share with me their quandary of belonging: How can you *be* something or somebody if you are constantly in the process of *becoming*? These days, when I am asked about how I identify myself or where I am from, I often reply, "it depends whether you want the short answer or a long one." I feel that I traverse at least six different identities ready to spring into action when triggered in specific contexts. I am an Indian American, an Asian American, an American of Indian origin, an Indian who lives in the United States, a New Yorker, and an Amdavadi living in New York, striving to be a global citizen. I live in all of my identities, sometimes with difficulty, but often with a sense of being blessed with limitless opportunities.

World as Family is an exploration of how I came to cherish the global life of multirooted belongings. It is inspired by discussions with young people, which in turn led me to ask more probing questions of my life trajectory. These young people have become my global sherpas, encouraging me to explore peaks and valleys of my global journey. Born in Ahmedabad, home of the Indian independence but a secondary city in the newly independent India, I didn't have the multilocational, multicultural roots that young people like Nils take for granted. It was hardly a given that I would have the privilege of connecting to the world in my everyday life. What was the path that led me

to create a life of global belonging with multilocal roots? How did I become so passionate about living a life with local, national, and global dimensions? How did I learn to acquire new forms of identity and attachments, adding layers to what I was before, subtracting some parts, but never wiping the slate clean? I had the good fortune of adding layers of new belongings over a lifetime of experiences—to build my banyan tree of multiple belongings—but what about the new generation that must navigate these complex and sometimes conflicting sentiments simultaneously?

This book is less an answer to the questions "where's home?" or "who am I?" and more about "how I have become who I am." While my story can be mine alone, I am in the company of millions of others who have experienced the strain and the exhilaration of multiple belongings out of which a new sense of global belonging can emerge. By telling stories and excavating details in the process—experiences, events, locations, feelings, and reflections—I want to articulate the nitty-gritty of a liminal life lived in and among cultures leading to a life of expansive global belonging.

The Chicana scholar Gloria Anzaldua described this fluid quality of life in her book *Borderlands/La Frontera*: "Tolerance for contradictions and a tolerance for ambiguity, she learns to juggle cultures. She has a plural personality, she operates in a pluralistic mode—nothing is thrust out, the good, the bad and the ugly, nothing refuted, nothing abandoned. Not only does she sustain contradictions, she turns ambivalence into something else."[4]

I instantly related to the sentiments described by Anzaldua: "tolerance for contradictions and for ambiguity." Not only did they mirror my own experience but also, importantly, they resonated with what I have valued about Indic traditions (even as they are embattled and under threat in contemporary India). Thousands of gods and goddesses—some ancient and others quite modern—coexist comfortably in the Hindu pantheon and in family shrines. (One of my favorites was a small temple room at an aunt's house made up of calendar images of Gandhi and Christ as well as small sculptures of Durga and Krishna.) Seemingly contradictory meanings can live together comfortably within one deity: Shiva, the traditional god of destruction, could also be worshipped as a lingam (a phallic symbol) suggesting his virility and procreative powers. The same god can also become Ardhanarishvara, embodying both male and female forms and energies, a perfect example of

fluid identity long before the age of transgender identity. *Multiplicity, fluidity,* and *synchronicity* are terms that I have often used to describe the essence of Indic traditions (not just Hindu but also many other religions that have been part of the subcontinent). Notwithstanding the reality that in the current political context of India, these terms sound idealistic and even a bit naïve, they were integral to my lived experience as a child in a Gandhian household in the first decades of independent India. They are also embedded in my life of multirooted belongings, making it possible to live liminally without constant anxiety. My sense of "global" is firmly affixed to my very local upbringing.

———

I HAVE FELT PRIVILEGED to be part of two cultures that embody the possibility of being open to the world. At their best, both India and America share the ideals of openness and respect for diversity, two essential elements for building a global community. India claims the wonderful Vedic phrase "*Vasudhaiva Kutumbakam* [treat the world as family]," enshrined at the entrance of the country's parliament hall. And America has long cherished its national motto, "e pluribus unum [from many, one]." Granted, these ideals have never been fully realized in either country, but they have been at the heart of the "dream that dreamers dreamed" to quote the great African American poet Langston Hughes. As imperfectly as these values may have been actualized, both countries have at least held onto the values of diversity, equality, and tolerance as desired goals. Now, national leaders and their followers in both of "my" countries are openly attacking these values, a grim reminder that these values, to which we have aspired, are actually quite fragile. Now more than ever, there is urgency to fight harder to make these aspirational values operational, not only at home but in the world.

World as Family argues for the kind of openness that can thrive in the scruffiness of reality rather than pushing for artificial clarity. It is open to all points of compass, favoring fluidity that emerges from intertwined diversity over sharp divisions. As hard as it is to achieve one's center or balance in the midst of the unprecedented and inter-related challenges we face as a global community, it is also necessary to find personal balance while we swim in the flow of collective currents.

World as Family is written as much for the young people who are "global natives" as for people like me who have come to the idea of global belonging over a lifetime of traversing long distances in time and space, physically, conceptually, culturally, and emotionally. A personal chronicle, it's an effort to reclaim *global* as a kind of palimpsest that allows for the layers of the local, national, and transnational to coexist and comingle. As messy and mixed up as they may be sometimes, the layers are altered by being close to other layers. The proximity may blur the edges of the layers, but the uniqueness of each part can be felt palpably. This book is a chronicle of a life lived in the comingled realities of the personal and the collective, the local and the global, in the hope of creating a new sense of worldly belonging needed for the survival of our humankind.

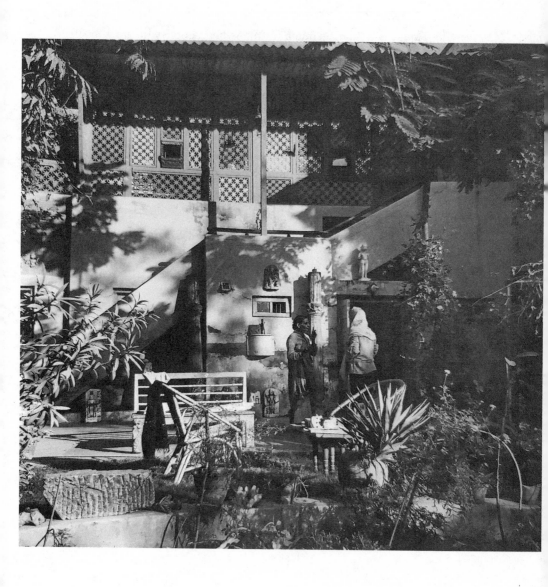

PART I

Roots

Still, your home does have a heartbeat.
But it isn't one locked in anyone else's chest.
Just look inside your own.

—NIKITA GILL, "PEOPLE AREN'T HOMES"

1

Too Bad, Another Girl!

ROWING UP IN AHMEDABAD, I loved celebrating my two birthdays, one on May 1, according to the Western calendar, and the other on Akshaya Tritiya (the third day of the fifth month) in the Indian lunar calendar. A socialist at heart, my father loved the fact that I was born on the day commemorating the "workers of the world unite." A keeper of the Indian traditions in the family, my mother was proud that I was born on one of the most auspicious days for all good beginnings in the Indian calendar. I was born in 1949 at the dawn of independent India, a young nation and an ancient civilization, caught between modern aspirations and stubborn traditions. Like the new country itself, my childhood was lived between the tenacious strands of aspiring modernity and persistent customs.

A Gandhian who was briefly a Marxist, my father Niru was well known in the western Indian state of Gujarat as an activist and writer. He was kicked out of college after the first year for his efforts to lead the resistance on campus and for hoisting the nationalist flag on the central building. Unable to attend any college thereafter (most universities were under British control), Niru dedicated his life to energizing young people to join the freedom struggle and rebel against outmoded social conventions through institutions he built and books he wrote.

Born in a highly traditional family, my mother Nirmala escaped her fate of an early arranged marriage at eighteen, attended college, and became a

committed freedom fighter with a deep attachment to Gandhian ways. In college and after graduation, Nirmala was recognized as a young leader in the women's section of the movement and was one of the earliest staff hired to lead the first institution in the region dedicated to the social and economic transformation of women.

Theirs was an unusual romance in many ways. Separated by castes, upbringing, and temperament, the only way my parents were able to come together was because of the social and political churning of the times. They had been together for seven years before their marriage, participating in the national movement, resolving personal differences, and overcoming societal constraints.

With a commitment to a strong union and a young nation, my parents had waited until 1945 to get married when the country's freedom seemed assured. By Indian standards and even by global conventions, my parents were relatively old by the time they got married; Niru was thirty-three and Nirmala, thirty-one. My oldest sister was born on Christmas day, nine months after they were married, and I was the third girl born in four years. In a span of thirteen years, they had seven children, four girls followed by three boys.

Growing up, all four of us girls felt empowered by our socially progressive parents. All around us, however, a preference for boys was amply evident. When Falgun, the oldest son in the family, was born, many family members and some friends openly rejoiced: Finally, a boy who can carry on the family name! Their whispers and outright statements made it clear that as girls, we could not "carry on the family name" as we were expected to take on our husbands' names after marriage.

As an adult, I often wondered how my parents dealt with the stigma of raising four girls. The answer came in the form of a letter, written barely two weeks after I was born. It was part of a large treasure trove of correspondence between my parents during their seven years of courtship and the first decade of their marriage, a time of frequent separation. It was due as much to Niru's frequent stays in British prisons for his political activities as to my mother's regular visits to her hometown of Surat from Ahmedabad, especially when she was pregnant with her first three children. I couldn't wait to read what my mother (Ben, or "sister" as we called her) had to say about my birth.

Following the tradition of the day, she had gone back to her parents' home in Surat for the last two months of pregnancy and delivery while Papa stayed

in Ahmedabad. He visited her every week or so and they wrote letters in between. In the first letter after Papa's brief visit at the time of my birth, Ben broached the subject of having a third girl:

> By the conventions of society, we might be seen as being in a difficult bind. Some people would even consider us unlucky. First, we began to have children very soon after marriage. Second, kids started arriving one after the other, with little distance between them. Third, as if those were not enough, we got a third daughter, not even a boy! Fourth, we don't have much money. So others felt pity for us as the baby girl arrived. I felt heaviness in my heart for a few days. Why did nature cause me to have a third girl so that others could attribute this to another stroke of bad luck? Now, once again, people will fault me and say, "Too bad! Another girl!" (May 14, 1949)

The words leapt off the fragile paper I was holding. Is that the best my mother could think of when she brought me into this world? This is hardly what I expected from my feminist mother. I know . . . she was expressing how society might perceive "another girl," but she herself clearly felt no joy at my birth. How could a woman who had fought for justice for women her entire life be so concerned about what others would think?

All the stories I had heard about the formative years of her life that led to her strong feminist beliefs kept flooding my mind. She often told us that her attraction to Gandhian values began early, when as an eight-year-old she first heard his call on a radio to forego Western textiles and wear *khadi*, handspun cotton. She continued to read about Gandhiji at her school but there was no way to put her ideas into practice in her very traditional family. Following the customs of the time, Nirmala was engaged at the age of thirteen to a young man from another prominent family in the same caste. She was expected to finish high school and get married soon after. Then, as fate would have it, her mother ("Ba" to her children and grandchildren) discovered that the boy's family had a history of mental illness. Ba insisted on calling off the engagement against the wishes of her own husband. Forbidden to enter the meeting of caste elders—all men—Ba stood by the door and pleaded her case. She was warned that such a radical move would risk her whole family being outcast and would jeopardize

the chances of marriage for all her children. Ba stood firm and luckily won the argument.

Striking while the iron was hot, Nirmala insisted that after the engagement breakup trauma, she be allowed to go to college. My grandparents acceded to her wishes, as much to keep her away from the aggrieved boy as to avoid the social gossip surrounding the occasion. The best choice under the circumstances was to send her away to a women's college in Ahmedabad. Rare even in contemporary India, Nirmala was one of the few women to go out of town for higher education and live in a hostel. Ahmedabad happened to be the epicenter of the Freedom Movement, and Nirmala was finally able to join it wholeheartedly. Like other girls in her college, she embraced Gandhian ways, wearing only *khadi* and giving up jewelry (except for a pair of ruby earrings, which her mother gave her); two symbols of simplicity that she adhered to her entire life. Right after graduating from college, she joined Jyoti Sangh, the first women's organization inspired by Gandhi, and continued to work until her children were born. She always insisted that for her as well as for all women, marriage was a choice and not a foregone conclusion.

, These were the stories I grew up on. But as I thought further about Ben's letter, I had to acknowledge my mother's past—a young girl raised in a traditional family. While Ba had taken an exceptional stand against a marriage that she thought would be to her daughter's detriment, she was also a deeply religious person. A staunch follower of Shri Nathji (a child form of Lord Krishna), Ba spent a major part of her day attending to the rituals for Shri Nathji, enshrined on the third floor of the family mansion her entire life. Nirmala grew up observing such religious customs in a joint family that included her grandparents as well as the family of her uncle. She added progressive values to her life without ever criticizing or giving up her traditional upbringing. As upset as I was while reading the words, "too bad, another girl," I could feel the personal struggles my mother and other women in the Freedom Movement must have endured in their efforts to transform deep-seated conventions.

Ben was careful to attribute the negativity surrounding my birth to others' perceptions, but she found a way to come to terms with my birth. At the end of that letter, she wrote,

I was trying to find the reason behind this [birth of another girl] and I was confused. Today, I feel that there is a hidden hand of nature behind it. If we had a baby boy, everyone would be pleased, and I would have fallen for that external satisfaction. That's why what has happened is most appropriate. Many people pity us for having three children, especially all girls, but those thoughts are like drops of water on a lotus leaf. For the sake of the three children, I hope I don't let outside noise disrupt my inner balance and peace.

The fact is that preference for boys was de rigueur in the India of my childhood and it persists to this day. In Gujarat, a daughter is often called *parku dhan* (property of the other). From the day she is born, she is supposed to prepare for marriage and become the "property" of her husband's family, bringing a large dowry as a necessary part of her marriage. At best, she is perceived as a burden.

India is not alone in this prevailing prejudice against girl children. In many parts of Asia, especially in China and Korea, similar attitudes prevail. A famous Korean proverb says: "A daughter lets you down twice. Once when she is born, and again when she marries." Now, with the help of modern ultrasound technologies, many Indian parents selectively abort female fetuses, despite a 1994 law that outlawed this practice. This has resulted in India having one of the most skewed sex ratios (the number of girls born for every 1,000 boy births) in the world. In fact, the ratio is worse today (900 girls per 1,000 boys) than it was a decade ago (940 girls per 1,000 boys).[1] Despite policies that ban selective abortions, the practice of female feticide has reached such proportions in India and China that in 2015 the United Nations declared it an emergency resembling genocide. Amartya Sen has rightly called this "the crisis of ten million missing girls."[2]

In the context of a young nation struggling to combat age-old conventions, my mother's efforts to keep her "inner balance against the outside noise" at the time of my birth seem heroic, even if with a rationalizing tone. They are also a perfect metaphor for her lifelong efforts to reconcile a traditional upbringing with reform-minded feminist values. Rather than fighting every convention, she rose above some of them, and occasionally incorporated others into her life while rationalizing her decision to do so.

If my mother was a tradition-minded reformer, my father was a communist-turned-ardent-Gandhian (in a social rather than a religious sense) who seriously questioned the role of religion and hidebound conventions. We thought of him as a firm opponent of blind adherence to religion and rituals, but never a critic of Ben's beliefs and practices. From their correspondence in the early 1940s, however, it is evident that my parents had serious discussions around the role of customs and traditions in a young and free India. Ironically, these discussions stayed at the philosophical level without any reference to how traditions would play out in their lives as a couple or in raising children.

Niru felt that "old myths cannot help new realities." Nirmala argued, "In a country steeped in ancient religious systems and beliefs, if one can infuse new spirit into age-old ideas, it will open up the hearts of people in a way that no one can silence." Niru, deeply influenced by Karl Marx, was not convinced:

> I realize that you like the idea of infusing the new with the old. But as they say, new wine does not survive in an old bottle too long. At times we actually derive a wrong message from the old. Perhaps you believe that new ideas are not possible in our religion-loving country if we don't couch them in the old systems. I don't believe that anymore. People's agonies and difficulties are so unbearable here that if they understood the situation properly and tried to do something about it, there would be a huge fiery social revolution.

He went on to say:

> Our problem is, now, without a clear understanding, our leaders have mixed up religion with politics and the results are sad. So it's crucial to leave religion aside. However, I agree with you that we have to find suitable illustrations from our own history and culture to make the arguments relevant for our situation. And for that, we do have to mine our Vedas, Puranas, and other texts carefully. But it would be a mistake to see anything new solely through the lens of the past. (March 9, 1941)

I am struck by my father's distinction between religious practices and the role of India's cultural past. He was willing to consider the value of

tradition without being enslaved by it. His acknowledgment of the importance of ancient wisdom allowed my parents to reconcile their differences. Growing up, we didn't really think much about making sense of the seemingly contradictory pattern of traditional practices and modern values represented by our parents, but this contrast was an integral part of our lives. Thus, as girls we were treated as equals or even superior to boys and encouraged to pursue diverse interests, be it dancing or mountaineering. But we were also expected to practice traditional rituals reserved strictly for young women.

———————

THIS WAS PARTICULARLY evident when it came to our menstrual cycles. Despite her progressive values in other areas, Ben perpetuated traditional practices in this matter. She insisted that we were to stay away from the kitchen and eat separately from everyone else. It was not as bad as what you would find in more traditional families in other parts of India where the menstruating woman was confined to a separate room and was not even allowed to enter the main house. The custom is based on the assumption that menstruating women are "polluted" and had to be kept away to avoid defiling food and family. For a young girl, bleeding and learning to wash soiled cottons was bad enough (we did not use sanitary pads until much later), but to announce your condition publicly was doubly embarrassing.

All major religions consider menstruation to be impure and put varying degrees of constraints on women. But the practice is perpetuated far more stubbornly in India than elsewhere. A large majority of families still keep menstruating women out of the kitchen, and many follow the superstition that menstruating women must not touch pickle jars or make yogurt so as not to soil the ingredients. As shown in a major national survey in 2015, 70 percent of Indian women use old rags instead of sanitary towels out of ignorance, shame, or poverty, increasing the risk of infection. Things are changing, even if rather slowly. The social activist Muruganantham, known as "pad man," revolutionized the concept of menstrual hygiene in rural India. Captured in award-winning films, his work has made the cause popular. Now with aggressive campaigns from organizations such as *menstrupedia.com* and with several companies producing biodegradable, affordable sanitary

napkins, there is hope for change in both attitude and practice around this primarily women's issue.

All of us Desai girls pleaded with Ben to explain why it was necessary to follow this seemingly senseless orthodox tradition in our modern household. In her characteristic rationalizing way, she explained, "Remember, in the old days, when women had to work hard in the kitchen and were responsible for all the household chores, there had to be some way for them to take a break. Also, when you are menstruating, you lose energy and your hormones get out of balance, so it is good to find some relaxing, quiet time, away from family responsibilities." As we persisted in arguing the irrelevance of the practice, it was Masi, our maternal aunt, who intervened, "You're right. This custom may not have any logic today, but this is how we grew up, and we have a hard time letting go. It's difficult not to see menstrual blood as anything but impure, capable of defiling the daily routine. Some things stay rooted deep inside you and can't be discarded easily, even if you are aware of their irrelevance today." Ben didn't refute Masi's argument and nothing more was said.

As young girls growing up in early independent India, like our mother before us, we also learned to accommodate traditions rather than discard them. We built a new life around many of my mother's traditions, without wiping the slate clean. I cannot recall my parents ever arguing about religion or even discussing whether religious training was appropriate for their children. Papa left all such discussions to Ben. My mother remained pious, while my father rarely engaged in religious rituals except when it was important to Ben.

If my parents differed on the role of religion throughout their lives, they remained united in their attachments to Gandhian beliefs and practices even as they adopted different aspects of his philosophy. Ben's desire to expand the traditions of Hinduism while selectively combating its ills was closer to the Gandhian ideas of reform rather than rejection. Papa, on the other hand, was critical of any role of religion in the public sphere. He was particularly critical of Hinduism in the way it kept the caste hierarchy alive over the millennia. In this sense, his ideas were closer to those of Dr. B. R. Ambedkar, India's first law minister and the framer of the constitution. The most prominent Dalit leader of the era, Dr. Ambedkar publicly rebelled against Gandhi's embrace of Hinduism. What connected my parents were the Gandhian values they

shared—fighting for social justice, tolerance for diversity of thought and faith, and a clear commitment to integrity of thought and behavior. And these ideas infused our lives.

The story I most remember about these values involves a nylon dress. Life-long wearers of *khadi*, advocated by Gandhi as a mark of protest against the British, my parents didn't insist that we kids do the same. But their preference was for Indian cotton produced in domestic textile mills. My mother would buy a whole bolt of printed cotton, have a tailor come to the house for several weeks, and get identical dresses and shirts made for the whole family. As a headstrong ten-year-old, I was tired of wearing the same clothes as my sisters and yearned to try out something different, more fashionable. So, inspired by magazine ads for the latest synthetic fabrics, I concocted the radical idea of getting a dress made from an entirely new fabric, nylon. Advertised as "smooth, wrinkle-free, and durable," these new materials also had colors and patterns not readily available in our local cottons. I begged my mother to buy nylon, just enough for one special dress for me.

There was just one problem. The material was quite expensive, and my mother, who had given up wearing expensive clothing or elaborate jewelry, was reluctant to indulge me. Without refusing my request outright, Ben suggested that we discuss it with Papa when he came home from work. After dinner, we had our little meeting. Papa asked why this nylon dress was so important to me. I was prepared with my answer, "I realize that you and Ben are committed to wearing *khadi*, but that was a different time. You were fighting the British and you had Gandhiji as your leader. We no longer have to make a statement against foreign powers. Why should I follow your values? Just like our new country, I want to be modern and wear modern clothes. What's wrong with that?" Papa smiled gently as he listened carefully. I became hopeful as he began his reply, "You're completely right. We have no right to impose our values on you. It's quite likely that you will develop a very different set of values when you grow up, and we will have to respect them, but until you become an adult, you are in our care, and we are trying to instill in you the values we have developed over the years. Ben and I believe that given our limited resources, it's best if we use them to give you a fine education and provide you with travel opportunities, rather than spend on such external things as clothes and jewelry."

Papa paused for a moment, then delivered the zinger, "You watch me leave the house in simple cotton clothes, and sometimes they have holes in them. You've watched many important people come home to discuss significant issues with me. Do you think they respect me because I wear nice clothes? Ultimately, people will respect you for who you are, what you think, and what you can do for others, not for what you wear."

As crestfallen as I was, I couldn't counter his logic. Besides, he had acknowledged my argument and allowed me to think for myself. Papa respected my desire and allowed me to express it without making me feel like an outcast and I felt grateful for that. I reluctantly agreed to let go of my dream dress, but requested that if nylon became inexpensive, we would reconsider the decision. Ben and Papa accepted this as a fair compromise and several years later even bought some synthetic fabrics for the whole family when prices dropped.

Ben often told the nylon dress story at family gatherings, especially to grandchildren, as a parable of ethical values over external appearance. Paradoxically, that didn't translate neatly into a consistent connection between Gandhian values and all aspects of our lifestyle, especially when it came to money. Ben took the idea of a simple Gandhian life seriously; she never bought expensive saris and had almost no jewelry to her name. Even at her marriage, she wore a simple white *khadi* sari, woven from the yarn my father had spun in his last solitary confinement in the British jail at Sabarmati in Gujarat. The only ornaments she wore were fresh flowers in her hair.

In addition to her commitment to simplicity, Ben was mindful of the family's finances. With a family of seven kids and frequent additional guests, it was her job to make sure we lived comfortably on Papa's modest salary as a journalist. Papa was far less consistent in his approach to money. He, too, wore simple *khadi* kurtas and sandals all his life, but that didn't stop him from being an inveterate shopper. His passion for collecting all kinds of art objects and books was legendary, as was his love for special fruits and vegetables, the more exotic and expensive the better. Clearly not a Gandhian trait!

The recurrent issue of money often showed up in their letters in the first decade of their marriage. Here's Papa writing in June 1954: "Returning from Surat a few days ago, I kept feeling badly about what you said. I know I am spendthrift and I spend money in the present without thinking of the future. I know it is my weakness that I don't save anything for the children."

Ben's letter did not let Papa off the hook: "You left in anger, without saying a proper goodbye, I wondered if you would write, even if I didn't . . . I know you're not happy when I ask for accounts, but please know that it's because I don't ever want us to be indebted to anyone for money. Nor do I want anyone to ever accuse you of financial impropriety" (June 14, 1954).

Ben's cautious attitude toward money never stopped her from opening our home to friends and extended family members in need. A college friend of hers, and another worker she knew from her days at Jyoti Sangh (the women's organization she helped cofound), were a regular presence at home. Widowed at a young age, both these women had been abandoned by their families. We became their family and they became part of our extended family. Another member of the enlarged family was Neela, the daughter of Ben's high school friend. Neela lost her mother to cancer when she was twelve. Her father had a government job that required living in small towns with frequent travel, making it difficult for him to take care of his young daughter. Without any hesitation, my mother, fully supported by my father, took Neela into the family. She assured the grieving father, "We already have a large family, so Neela will become part of it." It never crossed their mind that adding Neela to the family would create an additional burden on my father's modest salary.

Neela stayed with us for ten years through her high school graduation. For her, Ben was the only mother she knew. I recently asked Neela if it was hard for her to adjust to our big family, especially since she had just lost her mother and didn't know us well. She replied with tears in her eyes, "Ben gave me the permission to feel sad about losing my mother, but she never let me feel that I didn't have a mother."

Ironically, my parents had no trouble creating an extended family of friends, even though they had consciously chosen not to live with Papa's family in a large compound where they could have had their own home. They cherished their freedom from the social constraints of relatives, but made sure that their concept of family was expansive and not limited to blood relatives. In their own way, they followed the adage of the ancient phrase" *Vasudhaiva Kutumbakam* [the entire world is your family], which counters the traditional notions of family:

This one is a relative, the other a stranger,
Say the small-minded.
The entire world is a family,
Live those with an open heart.
Be detached, be magnanimous.
Lift up your mind,
Enjoy the fruit of Brahmanic Freedom.

"*Vasudhaiva Kutumbakam*"is a well-known phrase, but the full verse of which it is a part is less known. Dating from around sixth century BCE and enshrined at the entrance of the Indian parliament, the oft-quoted short iconic phrase becomes much more powerful when read in the context of the full verse. Only "small-minded people" make a distinction between those who are relatives and others who are considered strangers. The truly "magnanimous" individuals are the ones who make no such distinctions and treat the "entire world as family." Even now, most familial practices (focused on blood relatives or clans) in India remain in the purview of the "small-minded" who have not opened their hearts or lifted their minds to live "magnanimously."

It is awe-inspiring to think that some three thousand years ago, Indian philosophers articulated such a sophisticated idea, one that is so relevant for our times. However, they were not alone; almost all religions of the world embody some version of this ideal. Christianity professes, "God hath made of one blood all nations of men," and a Sioux Native American thought declares, "God is the Father, Earth the Mother. With all things and in all things, we are relatives." As Anthony Appiah points out in his seminal work, *Cosmopolitanism*, the idea of individuals belonging to the world community shows up in Greek philosophy as well. As early as the fourth century BCE, the term *cosmopolitan*, meaning "citizen of the cosmos" was formulated to reject the notion that "every civilized person belonged to a community among communities." In the Western philosophical tradition, the concept of thinking of "all peoples of the earth as many branches of a single family," has an enduring value. In India as well, the idea continues to have some resonance. Prime Minister Narendra Modi frequently recites *Vasudhaiva Kutumbakam* as the motto of his foreign policy. He argues that because of his deep respect for the concept of "the world as family," he sees no contradiction between a nation and the world.

It is easy to make such idealized declarations, but rather difficult to live by them. As proud as one can be of the ideals enshrined in India's ancient texts, one must acknowledge that these ideals are hardly visible in contemporary India. In fact, the distinctions and divisions among castes, communities, and class, often promoted insidiously by politicians, are more pronounced today than they were in my childhood.

Growing up in a Gandhian family in the formative years of independent India, "acceptance" of distinctly different viewpoints and expansive notions of community were central to our lives. I believe this was as much due to my parents' experience in the Freedom Movement as it was ingrained in Indic traditions. My father didn't see the contradictions between his simplicity in attire and his passion for art and books. Nor did he care to justify these contradictions. Similarly, my mother kept her fight for women's justice and her adherence to traditional practices in different boxes without having to make sense of them in a unitary system.

I have often wondered if my parents directly related to some of the basic tenets of Indian philosophical systems, which, rather than analyzing the dialectic conditions, allow for disjunction of distinct ideas to coexist. The great poet and scholar A. K. Ramanujan in his iconic essay, "Is there an Indian Way of Thinking?" describes in detail how Indians make context-sensitive decisions that may seem irrationally inconsistent to most other cultures. The Hindu god Shiva can be worshipped as an ultimate destroyer of evil forces and as a progenitor of new energy in the form of Lingam, a phallus symbol, depending on the specific context in which he is invoked. Such seemingly opposite elements can coexist comfortably in India. Devotees and scholars alike hold such complex contradictory affiliations without fusing them. These values—living with divergent attitudes and respecting differences—now embattled and on the verge of deliberate erasure, were part of my growing years. They laid the foundation for my future life of multiple and expansive belongings.

2

Home

Beams, Dreams, and Food

OVER THE YEARS, I have come to appreciate the value of being able to repot myself and develop a more expansive notion of home. In America, where I have lived most of my adult life, I am often asked "Where is home?" Implicit in the question is the assumption that "home" may not be where I now live. Indeed, for me now, and millions of others who embody multiple migrations and cultures, the very idea of "home" is less about a place and more about experiences and people. As writer Pico Iyer noted, home in this context is "portable and permeable, always in the process of being made, having less to do with a piece of soil than with a piece of soul."[1] For the first sixteen years of my life, however, my foundational experience was firmly rooted in 38 Jawahar Nagar, our family home for more than sixty years. It is where I developed a grounded sense of being and belonging. I consider it a privilege that I didn't have to make a choice between the physical and the psychological sense of home because they fused together at 38 Jawahar Nagar.

When we first moved there in 1957, our new home looked palatial, at least to my eyes as an eight-year-old. With ten rooms and a large backyard full of asopalav and borsali trees and rose and jasmine flowerbeds, it was indeed huge compared to our previous home, a small two-bedroom place on the first floor of the house next door. Originally built in the late 1930s for a large joint family of three brothers, our new home was in reality a mishmash of small,

ill-configured rooms to accommodate the original large joint family. The saving grace of the interior was high ceilings and green-tinted glass windows that kept the rooms cool in the harsh summer heat of Ahmedabad. Multicolored floor tiles, in keeping with the overall art deco style that was in fashion in colonial India of the 1930s, provided much-needed energy to the rooms.

The only reason my parents could afford such a big place on my father's modest salary as a journalist was its dubious reputation for being haunted. There had been an untimely death in the family of previous residents, and it was believed that the ghost of the departed wandered the corridors at night. As the house lingered on the market, the owners were only too happy to sell it to my parents at a reduced price of 28,000 rupees ($400). (Today, affluent Indians might spend as much on a single sari.) Even so, my parents had to borrow money from friends and family and take a bank loan to buy the house. We moved from our smallish rented home next door to our new home in 1957, when our family had grown to six children, four girls and two boys, with my youngest brother to come in 1958.

As soon as we moved in, the first order of business was to "cleanse" the house of whatever ghostly spirits that remained. My paternal grandfather, Bapaji, suggested that Papa consult our family "priest," Joshi Maharaj, who served as an informal adviser on all things spiritual and traditional. Ben and Papa, rebels who normally fought against superstitions, readily agreed and invited Joshi Maharaj along with Bapaji for a visit. As he walked through our new home, Joshi Maharaj declared that the house did not follow the principles of *vastu shastra*, the traditional Indian architectural rules for creating a harmonious environment: the diagonal entrance to the house was totally out of place and needed to be replaced with a new entrance on a proper north–south axis. Once the house was reconfigured with a new entrance, Joshi Maharaj promised to conduct a proper ritual to exorcise the "negative energy" of the "ghost's spirit."

Eager to make changes to the house, Papa was thrilled to hear the recommendation of Joshi Maharaj. The traditional practice of exorcism provided a good excuse to follow through on his plans. Papa took full advantage of the "necessary" architectural changes and embarked on an extensive renovation plan, adding a front porch, enlarging the living room, and closing walls to make new spaces. The ritual of doing the *vastu shilpa*

puja seemed to be successful, and no one in the Desai family ever saw a ghost at 38 Jawahar Nagar!

Integral to the renovation plan was my father's desire to add old architectural fragments that he bought at Sunday antique markets. Beautiful wooden windows with floral carvings, elegant brackets in the shapes of birds and animals, and small sculptures decorating wooden alcoves were all being torn down from old mansions and palaces in the name of modernization in the newly independent India. It was the beginning of the end of feudal aristocracy, sending once-wealthy feudal families into hard times as they attempted to move out of the rural economy and into urban life (mimicking England of the Industrial Age). Architectural fragments, decorative items, and ritual objects arrived in markets by the cartload and were sold at bargain prices. Not yet coveted by the affluent classes or accounted for by the Archaeological Survey of India, these old remnants of India's heritage were instrumental in helping my father build his dream home with a nod to the past.

Soon our house was filled with Papa's treasures: architectural pieces, stone sculptures, folk bronzes, and textiles, as well as works by contemporary artists. Two wheels of an old village cart, fitted with small cowbells, were repurposed as the house's front gate. Small marble elephants from a fifteenth-century Jain temple graced the entry pillars. The new front porch was decorated with plants and large bronze vessels originally used as dowry chests in village weddings. Two elegantly carved brackets graced the sides of the front door, and wooden sculptures of musicians with small bronze bells announced guests. Ancient stone sculptures and exuberant folk bronzes lived cheek-by-jowl in our home, inside and out, turning it into a wonderfully higgledy-piggledy museum of my father's excursions to the antique bazaars of Ahmedabad.

38 Jawahar Nagar became famous as the most unusual dwelling not just in our neighborhood, but anywhere among the middle- and upper-middle-class residential colonies that had sprung up all over "new" Ahmedabad in the first half of the twentieth century. When we were growing up, Jawahar Nagar was on the edge of the new city, not even incorporated in the municipality. Farms, villages, and a few housing societies were part of our neighborhood, and it was quite common for villagers to come by to sell fresh vegetables. One time, as we were returning from school, we found three village women inside the compound, praying to the fifteenth-century stone sculpture at the

entrance. When they saw us, they inquired about the "temple" and asked if they could come inside to make an offering to the central deity. We chuckled and explained that this was our house, not a temple, and the sculptures were only for decoration, not worship. The women were open-mouthed in disbelief. They couldn't believe that anyone would put "dead sculptures" (not in worship) on the walls of their home. Surely, this was farthest from my father's mind when he had chosen to decorate our home with them. As far as he was concerned, he was helping preserve India's past at a time when the preservation and documentation efforts of the Archaeological Survey of India were in their infancy.

Many years later, I realized that this distinction between "dead" objects or monuments and "living" ones has dual origins. The concept of *darsana* (to see and to be seen by the divine spirit embodied in the image) leads to the idea of enlivening an image by the worshipper. This traditional concept gained further currency in colonial times, allowing British officers and amateur archaeologists and philologists to collect fragments from the "ruins" and transform them into "art objects." My initial encounter with this crucial duality in Indian art—"live objects" (made live by devotees through worship) versus "dead objects" (not used in worship but appreciated for their aesthetic value)—served me well as an art historian as I developed exhibitions and installed art objects in museums.

Books were the other permanent residents of our home. My father's passion for books—developed during his frequent imprisonments during the Independence Movement—was legendary. He was often one of the first to receive a call from prominent booksellers when new titles arrived. The subjects they covered were varied, ranging from first editions of the Archaeological Survey of India volumes to English translations of Italian Marxist poetry. Older books were stored in our basement, which consisted of three large, high-ceilinged rooms chock-full of thousands of volumes. Bookcases also sprouted in the first-floor living room and second-floor bedrooms to accommodate new acquisitions. Growing up, we used to joke that our large house, full of books and objects, soon would have no room left for the family.

Ours was already a large house by Indian middle-class standards, but Papa's passion for new acquisitions and spaces couldn't be contained. A covered porch was added to the second floor to make room for the wooden *jalis*

(perforated screens) rescued from a discarded heap at the palace of Limdi, a small principality near Ahmedabad. Papa was excited about designing his new space and he worked energetically with the family carpenter to fit the *jalis* (originally used in the private quarters of women at the palace) into what he hoped would become his private reading and writing refuge. "It would be wonderful to sit on a covered porch with a nice big opening and enjoy the first drops of the monsoon season while I write," he proclaimed. In his perpetual quest for quiet spots to sit and write without being interrupted, he never designated a separate room as his study. Maybe that was because Papa embodied his own contradictions: he was a writer seeking privacy, an activist wanting to engage, and a family man, all at the same time—always ready for a meeting on important issues of the day.

The biggest structural change with the most significant implications for the entire family was the addition of a large kitchen, which faced the back garden and opened onto the back patio. Artist Carrie Mae Weems in her evocative Kitchen Table Series beautifully visualizes the kitchen as a quintessential space of domesticity, the traditional domain of women.[2] This was true for traditional Indian families but hardly the case for the Desai clan. The kitchen and the adjacent large patio served as the family's nerve center, connecting our public and domestic domains. Soon, most of the action occurred between the patio and the kitchen; kids doing their homework at the kitchen table, some doing their reading on the patio, and the older girls helping Ben with cooking, especially when we were without a cook. The back patio, where my father held court, also became the unofficial entrance to the house, with guests bypassing the main entrance and entering through the walkway on the left side of the house.

My favorite gatherings centered around food: afternoon tea gatherings for fellow workers from the Freedom Movement; large dinners for visiting dignitaries, friends, and extended family; and birthday celebrations featuring each child's favorite seasonal dishes. Because my birthday fell in May at the height of summer, mango, the king of Indian fruits, held center stage on my special day. Lunch on that day would typically include strained and cooled mango pulp with a hint of ginger powder, double-layered wheat *chapatis* as thin as fine paper laden with ghee (purified butter), *kardhi* (yogurt curry), and seasonal vegetables.

Winter was ushered in with a big dinner of *undhiyu*, a specialty from Surat—my mother's hometown. Undhiyu is made with root vegetables, banana, and eggplant, all stuffed with a delicious mixture of freshly shredded coconut, coriander leaves, green chiles, and ginger, and small *muthia* (dumplings made of whole wheat, chickpea flour, and fenugreek leaves). It takes hours to prepare and cook. *Muthia* had to be steamed and sautéed separately, and vegetables had to be added at different times to ensure that they were cooked thoroughly but without losing their color or becoming soggy. Ben insisted that all spices in this family recipe be made fresh, without getting contaminated with cumin, coriander, turmeric, or red chiles, lest they ruin the color or taste of our undhiyu!

(My oldest sister Swati has now made it a tradition to cook this special dish for the family's annual Diwali celebration in New York. Even in her warm Upper West Side apartment, these smells, tastes, and sounds of cooking and sharing the familiar meal never fail to trigger memories of being at "home." 38 Jawahar Nagar, where we enjoyed this winter delicacy in our backyard, braving the early winter evening chills wrapped in shawls, comes alive on Broadway!)

Most of our waking hours were spent downstairs, with the rooms upstairs reserved for sleep and occasionally for study. The living room was used to entertain guests in the heat of the day or on wintry nights, but most socializing occurred on the back patio. There were enough rooms in the house to ensure one room per two kids, but there was simply no concept of a private room in the culture of my childhood. Some rooms were used for specific seasonal activities. For example, during the summer months one of the first-floor rooms became a "mango room" in which we stored large crates of the delicious fruit from across India—alphonso from Pune, langado from Valsad—all at various stages of ripening, to be eaten at their peak. The same room in the winter season was given over to the family tailor, who came to sew sheets and pillows as well as clothes for the children. Except for books, art objects, and clothing cupboards, the rooms were primarily empty spaces used for multiple functions based on family needs not on individual wants. No one had a complete claim over any part of the house. Until reaching high school, we studied wherever we found a quiet place and played where we had a space large enough to congregate.

In the summer months, we took our bedding up to the roof to catch the cool breeze and to watch the stars. For us, gazing at the stars was a family affair, as all seven of us kids were given Indian names for constellations. My name—Vishakha—is the Sanskrit term for the constellation known in the West as Lyra. Lying down on our mattresses, we could hardly contain our excitement in finding our namesakes in the sky with the help of Papa, an astronomy enthusiast. Mine was not so easy to find, but we could always count on identifying Saptarshi (Seven Sages, or the Big Dipper), the name of our youngest brother. It was as if the whole sky was part of our familial universe.

If this sounds like a three-ring circus in an idyllic setting, in a way, it was just that. There was very little time in the day or space in the house for quiet time or private time. Watching Papa carve out time for reading and even writing in multiple spaces, we all learned that reading was our "time out." Sitting under a tree in the garden beyond the ever-populated patio and reading a novel that created a whole different world was one of my favorite escapes from the hustle and bustle of 38 Jawahar Nagar. It not only created a private space but also allowed for flights of fancy and reflections on the world that could be. Reading stories by Gujarati writers and meeting Bengali characters in novels translated from Bengali created my private space, a "Republic of Imagination," as aptly described by the Iranian American author Azar Nafisi.[3]

I don't quite know how my mother managed all the comings and goings, not only of her seven growing children but also the constant flow of visitors who came through our house. Ben was the family general orchestrating the daily life of the Desai children, combing the girls' hair or imploring us to help each other, keeping an eye on our homework, preparing and overseeing meals, and making sure that we were ready for school on time. Even with her general proclivity for calmness, there were times when we tested her patience. Imagine all seven of us sitting on the floor in a semicircle (before we got a large dining table), all asking for hot *chapatis* right off the gas flame and talking at the top of our lungs about nothing. If there were a moment of accidental silence, Ben would exclaim, "*avi shanti joieye* [if only we could have this kind of peace]!" Such a moment stood out precisely because it was so rare in our household. The only time she found some quiet was when we were finally off to school at around ten o'clock and my father left for the office

at eleven. I can only imagine how she must have looked forward to those few hours of peace when she could indulge in reading her favorite philosophical texts by Sri Aurobindo (a great Indian philosopher who developed the concept of integral yoga in Pondicherry in South India), meeting with women from the neighborhood who came to seek her advice, or working with the staff of Jyoti Sangh where she continued to serve on the board.

Once we returned from school and Papa came back from work, it was back to the usual bustle of 38 Jawahar Nagar: kids playing in the backyard, Papa giving instructions to the gardener about new plants, friends dropping by to discuss the politics of the day, and individuals asking for special favors. Once in a while, Ben would come out of the kitchen and sit with guests, especially if they were friends from the Freedom Movement, but by and large she stayed behind the scenes, making sure the guests were offered tea and snacks, and keeping an eye on the children. Although we had heard a lot about Ben as an activist in the Independence Movement, during our childhood she played a traditional role as a wife and as a mother while my father was the external face of the family. It is worth reflecting on the fact that Indian women like my mother were key players in the freedom struggle, fighting alongside men and even leading the movement when male leaders were imprisoned. But once India became independent, there was hardly any room for these women leaders. Their roles reverted to traditional family responsibilities, and their contributions to the making of independent India were readily obscured.

Growing up, we were very aware that our parents' marriage was between equals, and that they brought different skills to the relationship. If Papa was a romantic revolutionary, always searching and struggling to balance what he once called the prosaic of life with the desire to inject some poetry into it, Ben was a stealth warrior who had made peace with the necessity of raising a family without relinquishing her steadfast belief in social justice for women and all vulnerable populations. As children, we saw our mother as a Rock of Gibraltar to our ever-inquisitive and occasionally emotional father. But we also knew that it was not enough for our parents to get married and raise a family. To them, life had to involve larger causes and responsibilities. Ben was totally devoted to the family and may have behaved as a traditional wife, but she often reminded us, especially the girls, that for her, pursuing marriage and even having children were choices to be made, not foregone conclusions.

In a culture where a woman's value was equated with her ability to bear children, preferably boys, such an idea was radical; we certainly didn't hear that from the mothers of most of our friends.

Ben also fully supported Papa's role in newly independent India as they both felt that civic leadership earned by extensive experience also entailed public responsibilities. As a leader of the Freedom Movement and a social activist, Papa could make a difference in the lives of those who didn't have access to the emerging bureaucracy of the new country. It was expected that he would help former freedom fighters get their pensions from the government or support the housing application of a sweeper who couldn't read or write. This was one of the reasons we had a steady stream of strangers and acquaintances coming to our home asking for Papa's help with their challenges.

Papa had become smitten with the Independence Movement at the age of eight when he found himself accidentally running to Gandhiji and sitting on his lap. This happened in Bardoli, the site of one of the first Gandhian-style noncooperation protests, which also happened to be under the jurisdiction of Papa's father who served as a tax collector. When Gandhiji asked Bapaji, my grandfather, to join the protest, he demurred for financial reasons and jokingly offered my father instead. Papa often said that he was proud to have been offered as a soldier in the struggle, feeling the energy of the movement. And it became a central part of his life for more than two decades until India gained independence.

———

NIRU'S ENGAGEMENT IN THE Independence Movement took many different forms: starting an organization at the age of seventeen to inculcate the spirit of freedom among the youth, dismissal from college at age twenty-one for his "rebellious" activities, starting a journalistic career covering the famous Salt March (one of the most visible acts of civil disobedience through refusal to pay taxes on salt and instead picking it from the ocean, which served as an inspiration to civil rights struggles in the United States in the 1960s), and becoming a well-known Gujarati writer of fiction and nonfiction with a focus on social and political issues. For his leadership in the movement, Niru was frequently jailed between 1931 and 1941, including a six-month

stint in solitary confinement because of his disagreement with a British jail superintendent. (The argument began with Niru walking on the lawn of the prison courtyard and being told by the British jail superintendent, "Do you think this is your father's garden? Go back to your cell." Niru answered back, "If this is not my father's garden, it surely is not your father's garden!" This "insubordination" earned him not only solitary jail time but also rough clothing made of heavy jute used to make grain sacks to be worn in the heat of summer.)

In later interviews and writings, my father often commented that he was grateful to the British for providing the best possible education. As was the case with countless leaders of India's Freedom Movement, many of them met and became lifelong compatriots while spending time in jail. It was in the confinement of British jails that Niru met national leaders and made friends with the country's leading intellectuals, and it was there that he was able to expand his knowledge of other cultures and worldly ideas through books and discussions. In some ways, his prison cell served as a window to the world for my father as it also provided the solitude necessary for reading and writing away from his revolutionary activities. Frequent imprisonments combined with his writings and activities with young people cemented his reputation as one of the foremost regional leaders of the freedom struggle.

Soon after independence, Papa was asked by leaders of the ruling Congress Party to consider several national and international assignments ranging from running for parliament to an ambassadorial appointment to an Eastern European country. We often heard about these offers and about Papa's decision to reject them: "e used to tell uH"" '{'"I made the decision not to join the government and to remain a journalist who could provide an objective perspective on the new rulers of India. I agree with Gandhiji that Congress was meant to be a movement and not a political party. It should have been dissolved to provide new opportunities for diverse parties to function in a democratic India." But the fact that this topic was often discussed, and the fact that Papa remained very active in influencing government policies, often by badgering his Freedom Movement buddies now in senior government positions, makes me wonder about the deeper reasons for his reluctance to take on government assignments. As evident in his letters to my mother,

Papa often seemed conflicted about his capabilities, but not about his curiosities and responsibilities.

Six weeks after the birth of their fifth child, Falgun, the first boy in the family, Papa wrote to Ben, "I'm very busy and lots of thoughts race through my mind. But I don't quite see a solution. We have begun a family, so we need to raise them properly and give them a good education. At the same time, you and I didn't come together just to raise children. We have also thought about making something of our lives beyond a married life. How do we solve these riddles?" Later he elaborated, "I want to do so many things, good and bad. I get excited and go after new ideas that result in new responsibilities. I see the contradictions. I know I can stop some of these outside activities. But then what? I know that the family and the home are always there, but I sometimes feel that if it were only that, it would feel like a prison. It's quite possible that because I'm not able to focus on just one thing, I create more problems for myself and for you." (February 16, 1954)

Notwithstanding my father's personal predicament, it is fair to recognize that many leaders faced similar dilemmas. The freedom struggle had brought together people of all stripes and temperament, but not all were inclined or equipped to deal with the onerous job of governing the new country. It's difficult to overstate the challenges that confronted India and its leaders in the 1950s. Although free from British rule, India had never been a nation and was rife with ethnic and linguistic divisions following the Partition. Striking the right balance between building a new nation and responding to regional demands for new states on cultural and linguistic grounds was at the heart of the country's existence. (In fact, a World Bank report in 1954 stated that India faced an uncertain future because of its internal political instability and enormous economic challenges.) The people of Tamil and other southern linguistic regions were rioting against the establishment of Hindi as a national language, while Gujaratis were demanding their own state separated from the Marathi-speaking region of Maharashtra.

The formation of the new state became Niru's focus in the late 1950s around the time that we moved to 38 Jawahar Nagar. It allowed him to transition from being an idealist revolutionary to a builder of a new society and a new region. He was asked by the governor of Western India to be a member

of the planning committee charged with setting the borders of the new state, based on linguistic and cultural grounds. Papa was thrilled as he was now in his element: he traveled extensively looking for linguistic clues, food patterns, and cultural habits to come up with a rationale for the boundaries for the new state. It was a project that combined his passions—exploration of unfamiliar places, meeting new people, researching, and writing about key issues—all for a significant cause. Papa was skilled at mobilizing public opinion through his newspaper editorials, and he influenced public officials by offering well-conceived arguments buttressed by his on-the-ground research. During those early years, 38 Jawahar Nagar became a beehive of activity for the creation of the new state of Gujarat. Visitors included political leaders and powerful businessmen who were part of a vigorous effort to make Gujarat an economic and political success story. Finally, in 1960, Gujarat was established as a separate state.

During my formative years, 38 Jawahar Nagar was all about gatherings: groups of kids playing in the backyard, family dinners that habitually expanded to include whoever happened to be there, meetings of writers and journalists arguing about politics, afternoon teas with members of the Quit India movement reminiscing about the halcyon days of the struggle, visits from foreign dignitaries to see the art collection and to discuss issues confronting the new state, poets and painters discussing the current art environment, archaeologists hoping to get additional research funds from the government, and adventurers planning a new mountaineering institute. Papa held court and Ben participated in conversations in between overseeing appropriate refreshments.

It sounds implausible that one man could be interested in so many different ideas. But Papa was passionate about building a new India that was focused on its present challenges without losing sight of its rich past. As he said himself, his voracious curiosity sometimes got in his way, making him feel frustrated. He was aware that his varied interests were not always followed by focused discipline. When pursuing my doctoral studies in art history many decades later, I asked my father, somewhat critically, if he felt he had paid a price for being involved in many disparate things rather than pursuing a single subject in depth. His answer was illuminating: "I may

not have mastered one field, but by becoming knowledgeable about many things, I have managed to open my mind to a universe much bigger than what I found around me. I hope that I have given all of you children that sense of curiosity about and engagement with the world." I didn't realize then that his answer, and the way he lived his life, would be at the heart of my global journey.

3

Dancing with Gods

I N ADDITION TO READING under the trees, I had another special passion that was possible only in our backyard where sculptures of gods, goddesses, and their attendants peeked from the garden full of rose bushes, jasmine vines, and asopalav trees. I loved the elegant poses of the stone sculptures; they seemed to be dancing in the groves. Some were almost my height as an eight-year-old, so I thought of them as my friends: "Good morning. How are you today? Me? Well, we're studying geography in school. I like that, but I like dancing better." Then I wandered over to the female sculptures, especially the dancers. I invented little stories about each of them—speaking as if they were playmates—then attempted to imitate their graceful poses and gestures. They became part of my body, or, rather, I became part of them. Growing up, my siblings often teased me for trying to strike a pose as if I were a sculpture, my head tilted to one side and my legs arranged in some elaborate movement.

My first awareness of the joy of dancing came at age five in first grade when I was chosen as a solo dancer in the annual school program. Every day for three months, I practiced my short routine. On the big day in the assembly hall, with my whole family in attendance, my teacher sang a semiclassical Indian song as I danced to her words. I remember only fragments: "I'm a little girl"—I spun around with a coquettish smile. "It's a sunny day and I listen to the birds"—I made little gestures like a bird. "I love the big warm

39

sun"—I wrapped my arms around myself and made circles around the stage. Three minutes later, my premiere performance was over. I bowed, the teacher smiled, and everyone clapped.

I loved every minute of that little performance: I wanted to dance forever. And so I did, at least for the next thirty years. After attending my initial grade school performances and watching my garden forays to play with the sculptures, Ben and Papa suggested that I join a private dance academy that specialized in the South Indian classical dance style of Bharata Natyam.

Our classes were held in a large rented hall open to a garden on a riverbank, in the lower level of a modernist Ahmedabad building, which was also home to the first physical research lab in the state. Two hours a day, three days a week, dance became the center of my life. I was one of ten students, ranging from eight to fifteen years old. Our teacher Elakshiben was not yet a well-known dancer, but she had a great genealogy: her teacher was a great master from Tanjore (Tanjuvar), the preeminent temple town in modern-day Tamil Nadu central to the history of Bharata Natyam. In India, this mattered a great deal; the lineage was laudable as it connected me back to the very source of the temple dance tradition in southern India.

Elakshiben was a demanding instructor and she followed a well-codified regimen. For the first year, we did nothing but learn to perfect the basic body position: feet spread, knees bent and over the feet, hips centered without arching the back, arms stretched out, elbows up, and hands bent to make them look like waves. We had to hold this position while counting to one hundred, then relax for a minute or two and start over again. At first it seemed like torture, but gradually the once-strange posture became as natural as walking, an integral part of my body.

Every once in a while when we took a break, Elakshiben shared bits and pieces of Bharata Natyam lore. *Bharata* was the name of a second-century BCE sage—and the syllables neatly describe the form: "bha" stands for *bhava*, or "expression"; "ra" is from *raga*, meaning "melody"; "ta" is *talam*, or "rhythm." *Natyam* means "dance drama." We learned that Bharata Natyam as well as other classical dance forms, such as Odissi and Kuchipudi, were part of an elaborate temple system patronized by regional rulers for more than a thousand years until the late nineteenth and early twentieth centuries. In South India, temples were the permanent patrons of dancers and

musicians; in turn, dancers and musicians were supported by the rulers who saw themselves as earthly manifestations of the god Shiva, the central deity of the temples. From the sixth century onward, the close association of music and dance with religion was directly related to devotional cults (the Bhakti tradition) that spread Hinduism across the Indian subcontinent. The dancers were known as *devadasis* (maidservants of the god).

When I began my study at age eight, I didn't know that Bharata Natyam—like so much in India—had a complex history. It is both very old and relatively new. Elakshiben didn't teach us that *devadasis* were typically from lower castes than musicians, and they were not given the same kind of respect. In fact, scholars have documented the origins of Bharata Natyam (originally called Sadir Attam) to dances by *dasis*, young girls who were "dedicated" to temples by lower-caste families who considered their girl children to be family burdens. These young girls, in addition to being dancers, often became mistresses to upper-caste men who became their benefactors. By the eighteenth century, regional kings also treated the young dancers as concubines. The kings argued that their royal power was not constrained by "caste rules" when it came to their sexual appetites. Although it is impossible to know the prevalence of this practice, there is no doubt that, historically or otherwise, religious fervor, political power, and sensuous dance were a potent combination.[1] I didn't discover this hidden truth in Indian dance history until much later as an art historian.

"Taiya Tayi . . . Taiya tayi . . ." Over and over again, we heard the incessant rhythms in our second-year Bharata Natyam classes. As our teacher chanted the ancient sounds, we stomped on the hardwood floor, one foot at a time, flatly hitting the ground with a hard pop, keeping the bent plié, never lifting the body. As we advanced, ever so slowly, we learned to use the flat foot interspersed with a raised heel, bending the body to accentuate the movements of the feet. Every step was a building block, starting from the feet up. Finally, at the end of year two, when our feet kept the right rhythms and our bodies could move in synch, we began focusing on the graceful but stylized movements of the neck and the eyes. Now we were finally allowed to engage our entire body–eyes, neck, arms, legs, and feet–in dancing exercises. We had finished the first phase of the Bharata Natyam boot camp. I was happy to get this far—only four of the original ten girls were still in the class.

We survivors saw ourselves as the latest recruits in a dance tradition that had been unbroken for over a thousand years. We were the new links in India's ancient cultural chain. Never mind that the dance form that I studied was not exactly the same as its traditional roots. In the early twentieth century, the British diminished the power of temples and local rulers, promoting in its stead modernization policies that created a powerful middle and upper-middle class. Brahmins and upper-caste South Indians, in turn, sought to remove the "problematic" (meaning sensuous) elements from dance forms to "sanitize" them. The cultural renaissance of the early twentieth century, powered by upper-class elites, transformed the dance style; changing its name from the regional-sounding Sadir Attam to a more nationally relevant Bharata Natyam (associated with the ancient sage Bharata and with the Sanskrit name for the country). The rising independence movement in the 1920s fed the revivalist impulse to create a sense of pride in "authentically" Indian, non-Western art forms that were devoid of the foundations of the legendary Kalakshetra dance in 1922 by passing the "Prohibition of Trafficking in Minor Girls Act," commonly called the "*Devadasi* Abolition Act." Within months of gaining independence, the new Indian government passed that very act for the new country full of sanitized hopes. In sum, everything conspired to promote Bharata Natyam as a national form: reducing some of its sensuousness, diminishing its recent questionable *devadasi* roots, emphasizing the stage and not the temple, and making it a cultural vehicle for the middle class in the aspirational, early independent India. Now in the twenty-first century, young Indian girls by the hundreds of thousands learn the revamped Bharata Natyam dance, as do tens of thousands of overseas Indian girls living in the U.S. and the U.K., discovering and connecting to their "cultural roots."

"DHALANGU, KITATAKA KITATAKA dharitaka . . . Tat . . . Tayum tayum tat . . . Ta . . . Kitataka . . . Tat . . . Tayum tayum tat . . . Ta." Elakshiben uttered these nonsensical syllables in a sharply defined rhythm, precisely defining my very first full "dance movement" in the first traditional composition, *alarippu*. At age ten, learning a movement was a huge step, involving my whole body—raising my arms and hands, moving my head and neck in stylized gestures, and then a balanced "jump step" forward. Excited, I ran home and

offered a performance for the family, mimicking my teacher's syllables as I danced for fifteen seconds. Everybody clapped and I shyly smiled back. I wonder what my parents really thought; after all, it had taken three years to produce one of the shortest performances in dance history.

Not until I was fourteen, six years after beginning my classical dance training, did I finally begin learning *abhinaya*, the element of expression and storytelling in Bharata Natyam. We students—only three of us made it to this level—memorized the wonderful quotation from the ancient sage Bharata: "Wherever your hands go, your eyes follow; wherever your feet go, your movements follow; wherever your body goes, your mind follows; and where your mind goes, your heart will follow." I realize that using this text by an ancient sage who was active several centuries before the Christian era was yet another attempt by early twentieth-century reformists to connect the "classical" dance form to its "ancient" (and more elite) roots. Nonetheless, the verse resonated as Bharata had precisely described what musicians like Yo-Yo Ma have insisted: "musicians spend years learning the technique, but the point of art is always to transcend technique. That's when we get to meaning. We transcend technique in order to seek out truths in our world in a way that gives meaning and sustenance to individuals and communities." If Yo-Yo Ma described the intention of the training, Bharata articulated the process by which you get there.

With his remarkable phrase, old Bharata articulated the essence of dance and a curriculum for students: combining all of ourselves—physical, psychological, sensual, and spiritual—in our dancing. We realized that we had spent half of our young years learning the component parts; now the challenge was to create a seamless, flowing whole. The training was as rigorous as ever: learning by observing the teacher and other senior dancers, then repeating the movements over and over until all of it became part of your body. In all of these years of dance training, there was no room for personal interpretation or special creative flourishes. You did as you were instructed; virtuosity had to wait. Also, I was eager to please by practicing hard and doing well. The notion that I could question the method or create my own interpretation had not yet occurred to me.

While I received lots of kudos from teachers and other students, and I certainly received lots of encouragement from my parents, my after-school

dance practice meant that I was away most afternoons, causing some back-lash in the extended family.

In conversations, some family members made snide comments, often in my presence, "You can't count on Nanu (my nickname in the family) to help with family chores." "She cares more about her dancing than about helping out." "She is never at home when there's work to be done." Sometimes spo-ken in jest, such comments also reflected the prevailing values in the Indian context; collective action was always more important than individual pur-suits, the latter considered too selfish, especially for girls. I felt caught in an insoluble dilemma—the pressure to succeed at something I loved versus the pressure to be helpful at home, which made me feel guilty. I often told myself, "You're selfish! You're pursuing your passion at the cost of others. How can you be happy about dancing?"

This was my first awareness of the clash between a sense of independent self and an interdependent self. If one emphasized the need for personal pur-suits distinct from other human beings, the other defined the very notion of self as relational, to be understood only in the context of others. The very idea of pursuing a personal passion was somehow seen as being in opposi-tion to collective responsibilities. I didn't yet have the tools to manage these complex inner thoughts.

This internal tension peaked when I was immersed in rehearsing for a major school dance drama. My maternal grandfather Dadaji was visiting and was staying at my aunt's house several doors down from us. He suddenly took seriously ill. Ben suggested that I go visit him on my way to rehearsal. I told her that I had no time. Unhappy with my answer, Ben scolded me, "I don't see why you can't spare a few minutes to go see him. You are always preoccupied with your own interests. Sometimes, you need to pay attention to others." She had hit a sensitive nerve. Feeling ashamed, I quietly promised her that I would visit him on my way back from the practice.

Walking home from practice, I noticed a crowd at my aunt's home with all the lights in the house switched on. As I walked in, I was told that Dadaji had passed away. I felt as if this was a perfect symbol of my selfishness: a ghost that insisted on its presence on my psyche. None of this deterred me from pursuing dance, but it took some of the joy out of it. I often felt as though my dancing stood in direct contrast to my family responsibilities, but clearly the

Indian habit of experiencing opposite feelings without resolving them came in handy. I didn't make any attempt to address the contradiction and went on feeling occasionally guilty about pursuing my passion and feeling joyous while dancing.

My sanctuary was the dance studio, where things were going very well. Elakshiben showered compliments on my progress. She even let me develop my own narrative style about the dalliances of Krishna and his consort Radha and about the creative versus destructive tensions in Lord Shiva. One day, when I was sixteen with eight years of training behind me, my teacher said softly, "I think the time has come." "What time?" I asked, praying that she would say the word that every Indian dancer wants to hear. She smiled and said, "The time for your *arangetram*." My eyes filled with tears. That was the word—*arangetram*—literally meaning "climbing onto the stage" in Tamil: a full solo recital, a symbol of completing initial dance training, a ceremony qualifying you as a professional classical dancer. I was to be the first student from our dance school to have an *arangetram*.

The *arangetram* required a year of training after school each day, and then travelling to Baroda (Vadodara) in the summer under the tutelage of my teacher's teacher, the legendary Bharata Natyam instructor Kubernath Pillai. "Kubernath Sir," as I called him, was like a god to me, an icon of Bharata Natyam, a direct descendant of the *devadasi* tradition from Tanjore, brought to Baroda as part of the marriage alliance between the royal families of Tanjore and Baroda. Kubernath Sir was a serious man, not unkind, but stern in his teaching. He sat ramrod straight playing little cymbals for rhythm, never dancing himself. He corrected my hand gestures and foot positions by describing what was wrong rather than showing me the proper techniques. His suggestions were concrete and there was no room for discussion: raise your left eyebrow a little more, keep the rhythm when turning your neck, focus on your torso to express the power of a cosmic dancer. His teaching approach was clear-cut—if I got the physical parts right, I should be able to infuse the character with the right emotional energy. In retrospect, that summer with Kubernath Sir was not only an extraordinary advanced course in Bharata Natyam, but also a crash course in learning discipline—I practiced for five hours a day and thought about dance day and night.

My *arangetram* occurred on June 22, 1968, from 8 to 10 p.m. at Town Hall, one of the very few performing arts centers in the city at the time. Lugging a big suitcase full of four costume changes and jewelry, I walked into Town Hall at five o'clock on the biggest day of my dancing life. I was preoccupied with details—undoubtedly out of sheer nervousness—about my looming two-hour solo performance. I smiled as my suitcase jingled with each step: my beloved anklet bells, buried under my saris, were already dancing in anticipation. I opened the suitcase and took out a specially sewn costume of a beautiful olive-green sari with a strawberry-pink border and golden thread, and three other saris—silks in off-white, light purple, and yellow with gorgeous contrasting borders—from the southern and eastern parts of India. I loved the color combinations of all of these saris, my first-ever personal selections.

Soon the dressing room was filled with people. Elakshiben's professional makeup artist worked on my hair—a single long braid decorated with fresh white jasmine and orange flowers—and my elaborate makeup, adorning my eyes in dramatic fashion so the audience could read my facial expressions. One of my dance classmates helped me with jewelry—large dangling earrings, four sets of necklaces in a sequence of gold and red stones, a dozen bangles of small stones and gold around each hand, hair ornaments symbolizing the sun and the crescent moon of Shiva, and a little dangling nose ring. The last part of the preparation was to attach my heavy anklets, four lines of tiny bronze bells sewn to padded leather with long straps, to each leg of my dance costume. Central to the life of a classical Indian dancer, these leather anklets festooned with hundreds of tiny bells were crucial to keeping rhythm in synch with the teacher's cymbals.

With the costume on, hair and makeup complete, all jewelry in the right place, and finally my anklets, I was ready, at least physically, even if my stomach was a pit of anxiety. I peeked at the stage from the wings, just to calm my nerves: I could already hear Kubernath Sir's musicians on tabla, violin, and lute, tuning their instruments for the performance. Next to the musicians, on a small table was a sculpture of Shiva Nataraja, the god of all dancers, decorated with a jasmine garland and small incense burning softly with the gentle aroma of sandalwood. The stage was set. I briefly closed my eyes to calm my nerves.

As the lights dimmed in the auditorium, I took a deep breath and slowly I felt my personal anxieties evaporate and my focused energy reemerge. I took my space on the dark stage as Kubernath Sir opened the program with an invocation verse. The lights came on and I opened my arms over my head and slowly bowed to the stage. Next, I walked across the stage down to the auditorium packed with family and friends to seek blessings from my grand-parents, parents, and teachers, finishing with a bow to the small altar of Shiva Nataraja, the Lord of Dance. It was this last gesture that finally centered me. I knew it was time for me to bring the gods alive with dance.

Most of the first hour of the performance went extremely well. The first two pieces were pure dance forms, the latter two designed to display expressive skills (*abhinaya*). The third number, which allowed the dancer to express key words (*shabdam*), couldn't have gone better. I took my time interpreting the plight of the jilted heroine who tries to console herself with her pet parrot while the parrot keeps uttering the name of Krishna, her lover. Ultimately, not able to stand it anymore, she opens her beloved parrot's cage and sets him free. The magical feeling was palpable: each gesture precise, each dance step crisp, and each movement fluid. My whole body was in complete synch with the melodic voice of Kubernath Sir and the gentle but precise rhythm of his hand cymbals. I felt as if my body and spirit were the medium through which I was communicating something bigger than myself. I could sense a special synergy between what I was doing on the stage and what the audience was feeling. As I finished, the audience erupted with thunderous applause. Filled with the sensation of *rasa*, that special aesthetic experience between the dancer and the audience, I was on top of the world.

The final piece before the intermission was the most difficult—a twenty-minute composition called *varnam*—a test of interpretative ability, technical skills, and raw endurance. It began so well—the rhythm was spot on, the ever-increasing pace of the dance did not faze me, and I could just taste the expressive part of the last five minutes. And then, just at the end of the last rapid dance section, disaster struck. One of the anklets fell off my leg—throwing me off rhythm and leaving the audience staring at the fallen anklet. Clearly during my hurried costume change between dances, I had not buckled the strap properly. Not once in a thousand practice sessions had this happened. I felt like a runner who suddenly loses a shoe in the hundred-meter

Olympic final. I managed to complete the piece to polite sympathetic applause, but I was crestfallen.

At the intermission, I listened to kind speeches from several people, and I even managed to give my memorized little talk expressing appreciation to folks and sounding like a robot when I kept saying, "I can't thank you enough." I struggled to keep my emotions in check as I received my certificate from the governor of Gujarat, the chief guest at the function. I proceeded to complete the recital. The rest of the numbers were fine, but I don't remember much about them.

As I finished the recital after more than two hours of dancing, family and friends came rushing into the green room. The principal of my college came and hugged me to say how composed I was even when the bells fell off. Another family friend, a fine connoisseur of dance and music, complimented me on my *abhinaya*, not the flashy pure-dance parts but the more subtle interpretive elements that he called the "true soul" of Bharata Natyam. None of these compliments mattered. It all felt as though people were just being nice and offering token praise for what I viewed as a screw-up of major proportions. By this time, I had been dancing for a long time in school dance dramas, in folk dance competitions, and elsewhere. Nothing like this had happened before. I was not yet old enough to see it as a mistake from which you learn. Utterly devastated and incapable of holding on to any sense of pride, I needed someone to share my "ouch."

Papa came backstage and gave me a warm hug. Ben, on the other hand, remained a bit distant. Then she quietly said, "How could it happen that your anklet fell off?" And before I could respond she continued, "My goodness, you sure sweated a lot!" Her words pierced my entire being. I was crestfallen, without an ounce of self-defense. As I cried out loud, she finally took me in her arms.

It took me a long while to get over the trauma of both the anklet coming undone and my mother's reaction to it. For years to come, I often woke up with a bad dream on the night before a major performance, frightened that my long braid or a piece of jewelry had fallen off, requiring a hasty retreat from the stage. My worst nightmare involved walking onto the stage without a blouse—the ultimate shame of baring my body in public.

It took me even longer to acknowledge that Ben's reaction was as hurtful as the shame I felt from the fallen anklet. In many ways it was typical of my

mother: keenly observant but unable to be empathic. It was as if she could sense my pain and yet could not comfort me. She internalized my embarrassment but not my agony. For her whole life, my mother had always been more comfortable avoiding the world of emotions, providing solutions to problems rather than dealing with feelings themselves.

My mother often seemed overly rational and unintentionally judgmental, and those "ouch" moments got etched in my young mind. But as life went on, I found myself understanding the pain that she must have felt from her own challenging childhood, which was much more traumatic than my own. It must have been painful for her as a young girl when her father lost his business and had to come back to the family as a pauper. And I can't even imagine how she dealt with the trauma of her engagement breakup that seemed so radical for the time.

When Ben was in her eighties and I had gone through some therapy to recognize my own tendency to rationalize hurt feelings, I talked with her about her unwillingness—or her inability—to express emotions. I asked, "Ben, whenever we fell down or were hurt physically, you first asked how we fell down and then reminded us that it wasn't so bad and it would get better. What we needed was just a simple hug to make us feel better. Why?" Her answer was a true surprise: "When you were all young, I felt that it was important that you learn to deal with difficulties rationally rather than wallow in emotions. Now, I see it with our grandchildren that more than anything else they need a hug when they are hurt, not a lecture or a question." I couldn't help but cry and hug her as she smiled and held my hand. My loving respect for her stoic side became ever stronger, especially as I better understood her pivotal roles in our family and in the women's movement. The letters between Ben and Papa reveal not only Ben's tough veneer but also a heart of gold. If Papa has given me a sense of imagination and empathy, it is Ben who has bestowed a sense of resilience that has seen me through inevitable rough patches.

———

I LOVED DANCING because it grounded me in my body while opening my mind's eye to the world beyond everyday reality. I feel blessed that for the first thirty years of my life, dance remained a key part of my identity. Long

after I stopped dancing, I thought of my work in dance metaphors. Once asked about my leadership style, I responded, "I aspire to jump like a bird in flight, but land like a solid rock, all in a split second, just like the fabulous dancer Baryshnikov." As Ed Henry, the president of the Doris Duke Charitable Foundation and a fellow former dancer, once told me, training in dance is perfect training for life. First, it teaches you discipline and focus. Second, it reminds you again and again that you will make mistakes. You will fall, but you must get up. Resilience is not a luxury but a necessity. Third, it teaches you to transcend the training to create sublime experiences, at least some of the times. Fourth, dance reminds you that it is never just about you. The sixth-century Indian philosopher Abhinava Gupta described the responsibility of a dancer to create *rasa*, the aesthetic experience that happens when the audience is actively engaged with the performance. It is not just what an artist does on the stage or on the temple floor, but how she engenders the interaction with the audience that matters most. Fifth, a dancer learns to combine precision with passion to create a purpose. Above all, dance and all other art forms open the mind to the world of imagination. Precisely for these reasons, I am grateful to have been trained as a dancer.

4

Who Is Kwame Nkrumah?

EVEN THOUGH THE British are long gone from India, the language they left behind continues to elicit an air of superiority among Indian elites, and this was even more so in the early decades of independent India. In Bombay (Mumbai), Madras (Chennai), and New Delhi, upper-class families sent their children to English-language schools (English as a medium of instruction) with British curricula, generally run by Christian missionaries. If such a choice conveyed a sense of sophistication and cosmopolitanism, at some level it also reflected a colonial mentality. Those who attended St. Xavier's, Mount Carmel, Loyola, or Cathedral considered themselves superior to those attending "vernacular" schools where pedagogy was in Hindi, Gujarati, Marathi, Tamil, or any one of India's many regional languages. It was assumed that such "provincial" schools would produce parochially minded students incapable of becoming the intellectual or political elites of the new nation.

In contrast to the big cities that were at the heart of the British project, an alternative opinion flourished in select smaller cities such as Ahmedabad. Steeped in the Gandhian spirit and devoted to a fervent nationalist ethos, Ahmedabad elites—the well-to-do and the progressives alike—preferred Gujarati-medium schools during my formative years. For many of them, including my parents, such an education was as much a matter of principle as of pride. In a society that often equated quality education exclusively with

knowledge of English, attending a Gujarati-medium school was a conscious form of resistance. Thus, multiple generations of the Desai family attended a well-known Gandhian school called Sharda Mandir (temple of the goddess of education). Many such "nationalist" schools emerged throughout the country in the early twentieth century to counter British colonial education and to heed the call given by nationalists, especially Gandhi, for children to attend such schools to engender a nationalist spirit among the young. As students during the first two decades of independent India, we were proud to attend a school that was imbued with the spirit of the Independence Movement in direct contrast to the English-medium schools created under the British Raj.

Sharda Mandir was inspired by three powerful forces: the Gandhian philosophy of self-reliance and conscious nationalism, the teachings of philosopher-poet Rabindranath Tagore who had created an Indian alternative to British education at Shanti Niketan (near Kolkata), and the child-centric approach developed by the Italian educator Maria Montessori. Madame Montessori actually spent the war years in India as a guest of the Theosophical Society in Chennai and spread the Montessori system of education throughout the country. She visited the kindergarten at Sharda Mandir and taught some classes, complimented the founders on their implementation of the Montessori technique, and declared that Sharda Mandir was "an exemplar temple of life."

In keeping with the Gandhian philosophy that education should be about drawing out the best in a person's body, mind, and spirit, our school principal Vajubhai established a curriculum that focused equally on intellectual rigor, experiential learning, artistic expression, and athletic exercise. The campus buildings were constructed in two phases on thirty-acre plots: Old Sharda Mandir (founded in 1924) served kindergarten through fourth grade, and New Sharda Mandir (built in 1949) housed fifth grade through high school. Both campuses consisted of whitewashed stucco classrooms nestled among thick mango and asopalav groves with open-air assembly halls in the center. Large playgrounds behind the school buildings fulfilled the needs for all manner of athletic exercise—slides and swings for younger kids and large fields for the Indian games of *kabbaddi* and *kho kho*, as well as cricket and volleyball for the older students.

Despite its sprawling campus, Sharda Mandir's enrollment was quite small: each grade had two classes and each class had only twenty-two students. Typically, students stayed in the same school all the way from kindergarten through high school, resulting in strong familial bonds among multiple siblings in different age groups. At one time, all seven Desai siblings were in different grades at the school. Teachers could identify family traits through generations. When my brother's daughter Antara attended Sharda Mandir, she was often identified as the niece of her aunts even though all of us, her aunts, had graduated almost twenty years earlier.

In keeping with the egalitarian practices of Gandhi Ashrams, in the earlier years the students helped clean floors, serve food, and tidy up the classrooms. We learned to spin cotton and wore *khadi* uniforms (white blouse and blue skirt for girls, and short-sleeve shirts and shorts in the same colors for boys) until I was in sixth grade. Our daily student assembly began with a recitation of the *shloka* (a Sanskrit verse) dedicated to Sharda, the goddess of learning and the namesake of the school, followed by a few songs and a group discussion about current events. Public performances, speaking assignments, and democratic student elections were designed to nurture leadership skills. Principal Vajubhai, a staunch believer in experiential learning, followed the spirit of the famous Chinese proverb: "Tell me and I'll forget, show me and I may remember, involve me and I'll understand."

Vajubhai's other big passion was travel. He considered it an indispensable form of education and included school trips at all levels. In first grade, we learned about the history of Ahmedabad by visiting monuments: climbing up a fourteenth-century mosque minaret, walking down a fifteenth-century step-well, traipsing through a nineteenth-century Jain temple—all in a day. Instinctively, we embraced the Hindu, Muslim, and Jain heritage of our city. We were as fond of the beautifully carved windows of the fifteenth-century Sidi Saiyyed Mosque in the heart of the old city as we were of the Gandhi Ashram at the edge of the city.

Despite our pride in the multireligious, multicultural heritage of the city, this historical reality was not fully evident in the school. One could safely say that most of the students came from upper-middle to elite classes of Hindus and Jains: there were no Muslims in our school nor any Dalits or members of other lower castes. Neither unique nor deliberate, these acts of omission

were invariably aided by exigencies of history and unconscious biases. After the Partition of the subcontinent, many well-off and educated Muslims left Ahmedabad to settle in Pakistan, and the few who stayed usually selected English-medium schools. Providing little opportunity for Hindus and Muslims from the same economic class to socialize, these self-segregated schools ultimately created a more divided city with dangerous future implications.

The location of Sharda Mandir in the new urban area of Ahmedabad on the other side of the Sabarmati river also exacerbated the class discrepancy. While the aspiring middle-class and affluent families moved to new areas, the working class and the poor remained in the old city. The fees for the school, rather miniscule by the standards of American private schools, were nonetheless unaffordable to these poorer sections of society. And there was really no effort to provide more opportunities for those without access to resources. We did visit nearby slums on special occasions and even developed some projects for study, but that's as far as it went. The values preached and practiced in our school were laudable even if they were not always followed at all levels of its administration or pedagogy.

By fifth grade, we embarked on weeklong trips to neighboring states, which later turned into three-week trips to other parts of India. Because trips were voluntary, parents were expected to pay these costs above and beyond the annual tuition. Even though this was not so easy for our large family, it was one area in which my parents didn't skimp. My first three-week trip was to South India when I was in the seventh grade. Giddy with excitement, we prepared for days in advance. The instructions were clear-cut—each student must have a single suitcase and a bedroll (a small mattress, pillow, blanket, and pair of sheets). Snacks were permitted as long as we brought enough to share with others and were willing to keep them in the common pool. A full railway car was rented from the government to accommodate about twenty-five students, two teachers, the principal, a cook, and a cleaner.

The Railway Ministry had to approve the detailed itinerary in order to grant permission to connect our *bogie*—as the train car is referred to colloquially in India—to relevant trains on the trip route. This meant that our *bogie* had to be hinged and unhinged to different trains at different times of day and night. I loved spending the night in the railway yard of a train station when we had to wait for the next connecting train to show up. We would

simply take over parts of the station platform and turn it into our kitchen and dining room. Lovely cotton *dhurries* (carpets) were laid out and small *thalis* (metal plates) and bowls were placed in two rows, one for boys and one for girls. The cook prepared the food in the train car and we took turns serving the simple but delicious dinners that included *poori* (puffed fried bread) or *thepla* (spinach bread); vegetable curries made of potatoes, onions, or green beans; rice; and seasonal fruits.

Today, given the twenty-four-hour train traffic with millions of people running into and out of stations, a quiet evening on the platform is unthinkable, but back then it was pure bliss. Nights spent at the railway yards were always full of surprises, sometimes involving slightly flirtatious encounters with boys on the trip. Generally assigned to separate compartments, the boys tried to escape the teachers' watchful eyes during those nights, tossing little stones or making soft birdcalls to encourage girls to come out and play on the tracks. Because interaction between boys and girls was frowned upon back at school, such encounters seemed quite clandestine. Of course, we were too young, and our culture too prudish, to think of anything beyond simple pranks. Boys notwithstanding, I loved to sneak out in the early mornings and walk the tracks, my feet tingling from the vibrations of the trains that had just passed. It was an apt metaphor for our feelings of excitement as we encountered new experiences on our travels and discovered new parts of ourselves. As travel writer Pico Iyer has said, "We travel literally to lose ourselves, and we travel next to find ourselves."[1]

Our trips were well orchestrated, combining cultural heritage sites, natural wonders, modern buildings, and meetings with political and cultural leaders. For example, on our South India trip we visited the magnificent eleventh-century Chola temple in Tanjore (Tanjuvar), an important seat of the Bharata Natyam dance tradition, as well as the first aeronautical plant in Bangalore. I remember being surprised at the request to take off our sandals and put on white socks at the modern plant in Bangalore. One usually did that at temples as a symbol of respect for sacred sites but certainly not at an ultra-modern facility. "Is this also meant to suggest that we are entering a sacred space?" I asked one of the teachers. She smiled and said that it was really to avoid bringing dirt into this spotless space, but you could think of it as another kind of sacred space for our new country. In characteristically

Indian ways of thinking, she had no trouble conflating the sacred and the scientific into a complementary relationship.

These trips expanded our view of ourselves and of India. We learned to think of ourselves as Indians, not just as Gujaratis or Hindus. At the southern tip of India, to see the three oceans (Bay of Bengal, Indian Ocean, and the Arabian Sea) come together, with their distinct colors and various patterns of waves lapping at the shore, was to feel viscerally the very idea of the new country. It was "our" country even if we did not share the language, food habits, or styles of dressing we encountered among people we met on the shore. Our minds were stretched by new vistas and new experiences, expanding the more provincial dimensions of our lives back in Ahmedabad.

Vajubhai used to say that a capable teacher finds teachable moments in any situation and manages to apply them in other relevant contexts. He would turn such moments into catchy slogans that we could remember long after the event had passed. I remember well one such example. When I was in tenth grade, we went to Kashmir (this was easily done in the early 1960s) and planned to visit one of the oldest mosques in Srinagar. Our visit happened to coincide with Eid al-Fitr, an important religious holiday for Muslims. Vajubhai proudly proclaimed, "*Potano dharma sahuno, sahuno te potano* [your religion belongs to all and others' religion is yours]," and urged all the boys to don caps and the girls to wear headscarves before entering the mosque and paying respect to the religion that had been part of India for more than a millennium. The phrase has stuck with me over the years; through it I can still take myself back to that moment of recognition that I was no stranger to Islam, it was part of my identity.

For me, these travels instilled not only a passion for India's glorious past but also an optimistic excitement about its future. We went to the Taj Mahal and were entranced by its beauty, and we also visited the Bhakra Nangal Dam in Punjab, stunned by its size and power. We now know that the Nehruvian model of development conflated successful modernization with large-scale industrialization, yielding modest levels of economic growth fraught with enormous environmental damage. As young high school students in independent India, however, we were impressed by the successes of "our" new country. Focused on the achievements of hard-fought independence, we the children of independent India had not yet learned to be self-critical.

Notwithstanding serious challenges, India had become a nation and there was much to be proud of. The potent glue of nascent Indian nationalism had endured in the first few decades, and we kids, along with our parents, remained attached to the idealism of the young independent country. In the early 1960s, the dangers of rapid modernization and the slow erosion of the moralist ethos of the Independence Movement were barely noticed.

In addition to exposing us to the diversity of India, Sharda Mandir also opened our eyes to a rich world of traditional art, music, and dance. Every year, the school put on an extravagant dance drama, and these performances were serious business. Professional choreographers and musicians worked with us after school hours for minimal pay. They composed new songs, wrote brand new librettos, and developed original choreography. From the first grade on, I was hooked on these performances. By the time I reached fifth grade, I was often given a featured role. The cast practiced late into the evening, then rode home on the school bus hoping to be dropped off last so we would not miss out on any fun. Often our performances were held not in the school auditorium but at a major performance hall in the city, Town Hall, with professional lighting, set design, and a full orchestra with accomplished singers.

In the context of our dance dramas, I must reveal one not-very-Gandhian trait of Sharda Mandir. Even in our supposedly "egalitarian" school, preferential treatment was often given to children of the wealthy and those with fair complexions. It was an established fact that the lead roles in the annual dance dramas went to rich kids. So it came as a big shock when in sixth grade I was offered one of the two lead roles in the first bird-dance drama, "Doves Nest." Several students whispered about the anomaly, and even my own family members were surprised. But I did have some advantages: First, I had already started private training in classical dance. Second, I was fair-skinned, hence considered attractive by Indian standards (a preference that continues to this day, despite nascent efforts against the preference for "whiteness").[2] So, I guess for once, appearance and training, combined with social capital, trumped affluence and I got to play one of the lead dancers.

I was selected to play the lead villain, a bossy crow trying to break up a peaceful community of doves. The whole story was supposed to be a parable of the current Indian political situation, rife with tensions between holding

together the nascent union of the country and regional units asserting their individual powers against New Delhi's central authority. Clad in a wonderful crow costume—all in black with a headdress with a hooked beak, long feathery wings, and black pants—I really got into character. I danced a slow weaving pattern with furtive head moves and shifty eyes; the audience went silent watching evil incarnate. In the finale, I chased a group of white doves, pecking at them until they discovered there was strength in numbers and I was pestered off the stage. After that first lead, I ended up playing major roles in most annual dance dramas until graduation.

In addition to dance, my other favorite activity was a class on general knowledge. Unusual in Indian schools, the class was based on Vajubhai's firm belief that the best way to teach a student to learn was by creating curiosity, not just about her immediate surroundings but also about the world beyond. Vajubhai was not alone. Many education leaders, who were passionate about formulating a new pedagogy embracing the ideals of secularism, plurality, globalism, and the Indian Freedom Movement, attempted such experiments across the country. I loved learning about current world events, sharing insights in class, and sometimes presenting at the school assembly.

As a sixth grader, I was tasked with learning about the Non-Aligned Movement (NAM). It coincided with the NAM Heads of State 1961 meeting in Belgrade. I gave an assembly presentation on NAM based on newspaper clippings and excursions through the atlas with copious help from Papa. Proudly smiling, I pronounced the names of world leaders without a hitch: Nkrumah of Ghana, Sukarno of Indonesia, Nasser of Egypt, Tito of Yugoslavia, and our own Prime Minister Jawaharlal Nehru who cofounded the NAM and chaired its first meeting in Bandung, Indonesia. It felt wonderful to be able to pronounce these names and learn about far-away places. When I visited Ghana and Indonesia many years later, it was a pleasure to tell my hosts that my first awareness of their countries had come from learning about their leaders in the NAM.

We were encouraged to open our minds to the currents of the world but not at the expense of studying the richness of India's ancient past or understanding the Gandhian traditions of the more recent past. Thus, we learned Sanskrit from sixth grade on and were encouraged to take external national exams to enhance our language skills.

Another special activity came out of the Gandhian tradition of starting the day with early morning prayers and meditation. Concerned about the focus on scientific learning in early independent India, Vajubhai decided that children of new India should also have some training in self-reflection and contemplative traditions. This turned into a special initiative called *Pratah Prarthana* (morning prayers). Totally voluntary, this program was extremely popular with students even though it required getting up at 5 a.m. every day during the three coldest winter months. As crazy as it may sound, we couldn't wait to get to Assembly Hall by 5:45 a.m. for morning prayers. Patiently sitting on cotton *dhurries,* we tried to quiet our breathing and calm our beating hearts to the soft sound of a meditative phrase repeatedly played by our music teacher on the *dilruba* (a small bowed string instrument). It lasted about fifteen minutes, but sometimes felt like an eternity. It was my first experience with the practice of meditation, but there was nothing precious about it. It felt natural, simply a way to observe one's breath and find a quiet space within even when surrounded by other students. At the end of the meditative session, we were awakened physically and mentally by the sounds of bells and conch shells, to participate in more physical activities.

Yoga class was first, with a teacher gently guiding us through a progression of *asanas* (postures and exercises) and ending with *pranayama* (breathing meditation) to complement our mental focus and strengthen our bodies. The final half hour was devoted to team sports, which were not overly competitive but full of vigor. By seven in the morning, *Pratah Prarthana* was over and we headed home with fruit or nuts, courtesy of different parents each day. At home we had time to clean up, finish homework, have an early lunch, and get ready to return to school by eleven where we stayed until five.

Even now, when I meet my former schoolmates, we invariably identify *Pratah Prarthana* as a unique and cherished part of our education. It touched something very special in Indian tradition, the core of which has been called the cultivation of "mind, body, and spirit." This fundamental way of nourishing the whole self has deep roots across time and throughout the geography of the subcontinent. The great Indian thinker and philosopher Sri Aurobindo considered this integrative thinking a unique gift of Indian civilization to the world. And yet, ironically, Sharda Mandir was the only school in the city that practiced *Pratah Prarthana* in the 1950s and 1960s. The practice of meditation

and yoga, now a twenty-seven-billion-dollar industry in the United States alone, was not yet a central part of newly independent India. By the 1970s, our wonderful principal Vajubhai was gone, and *Pratah Prarthana*, along with other special elements of the school including the general knowledge session and the trips, disappeared with him.

Sharda Mandir is still in operation, as a Gujarati-medium school now augmented by English medium to compete with the plethora of English-medium schools that have sprouted up across the city. (No longer associated with the former colonial masters, English is now seen as a necessary tool for success in the globalizing country and beyond.) None of the young children in my own family—sons and daughters of my nephews and younger cousins—attends Sharda Mandir. All traces of the Gandhian tradition are long gone, as is the study of the Independence Movement beyond a few pages in history books. The preference for simplicity in clothing and appearance is no longer desired. A maniacal focus on exams has crowded out all experiential initiatives including school trips. It's as though the idealistic and imaginative experiences in education that were central to aspirational India during the first decades of independence were the exceptions, and the country comfortably pivoted to rote exams and a transactional education system.

Some of these changes were already becoming evident in my last years of high school. By the time I was a senior—eleventh grade—the only thing that counted was the final statewide exam, with top rankings published in the newspapers. The outcome of these exams determined which college you could attend and what fields you could choose. If you were smart, regardless of gender, you were encouraged to take more math and science classes and prepare to be a doctor, scientist, or an engineer. In Nehruvian India, these were the privileged fields necessary for the modernization of the new country. Only the less talented would consider the arts, humanities, social sciences, or education—a prejudice that persists to this day. At the recommendation of my teachers, I had taken math and science for the statewide high school qualifying exams, partly because I was good at them and partly because it would guarantee high marks on the state board exams. Indeed, I did very well in the finals, earning the highest marks in general science and the second highest in arithmetic out of more than one-hundred-thousand kids in the whole state. But I had no interest in pursuing math or science in

college. My heart was in languages, history, and other humanistic subjects, and I had made up my mind that I would attend a liberal arts college with a focus on philosophy and psychology.

When some of my teachers heard about my decision, they were so distressed that they came to see Ben and Papa. It was an ironic conversation: three teachers from a Gandhi-inspired school making non-Gandhian arguments to two Freedom Movement leaders who still believed in Gandhian values. Vajubhai had retired as the principal by this time, and his educational spirit was fast waning. My physics teacher was adamant, "You must encourage Vishakha to go into the sciences. She is so talented, and you will let all that intelligence go to waste." The math teacher made his pitch, "Her grades are so good in sciences that she will be able to do whatever she wants." And the assistant principal delivered what he thought was a slam-dunk comment, "It's okay to be interested in subjects like philosophy or Sanskrit, but it won't help her in developing a career." Ben and Papa had just the right reply, "We know you came with Vishakha's interests at heart. But we firmly believe what Gandhiji said, 'the purpose of learning is to open the mind, not to close it.' And the purpose of an open mind is to open one's heart and follow wherever it takes you." And that was that. The three teachers left a bit crestfallen. I smiled at my parents; they were on my side when I needed them.

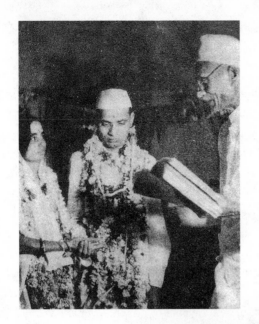

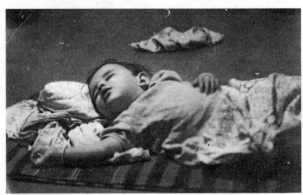

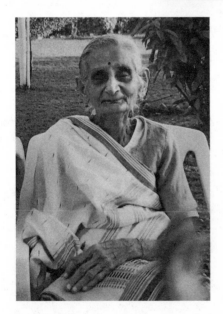

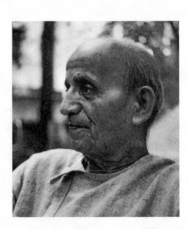

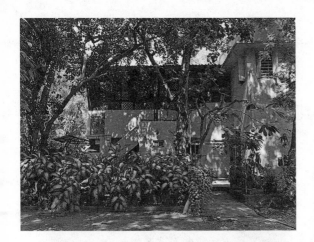

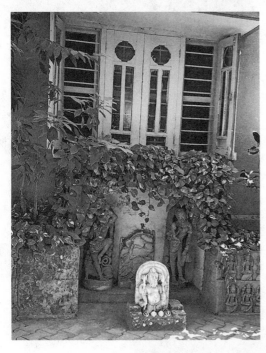

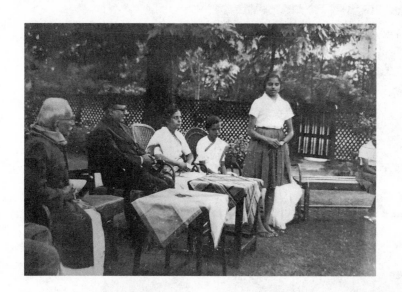

PART II

Crossing

When transplanting plants, you may notice a gently ripping sound as the roots are torn away from the soil. This is to be expected: for the plant, transplanting is always a painful process.

—THE PRACTICAL GUIDE TO GARDENING

5

Strangers Become "Family"

B Y EARLY 1966, I had graduated from high school, started St. Xavier's, an elite college in Ahmedabad, and was busy with preparations for my first solo classical dance recital. I loved my classes in brand new subjects ranging from world religions and logic to psychology and sociology. Even though it was initially difficult to get used to taking all of my classes in English taught by a group of learned Spanish and Indian Jesuit priests, it was exhilarating to course through unchartered intellectual journeys. There were other pleasant distractions too, including my first-ever boyfriend and his shiny imported Studebaker with impressive wings.

On one spring day in 1966, Papa came home excitedly holding a newspaper announcing a special scholarship competition for students between sixteen and eighteen years old: an all-expenses paid, year-long exchange program in the United States facilitated by an organization called the American Field Service (AFS). He beamed like a prospector who had just struck gold: "It's perfect for you, Nanu. You're a terrific student, but imagine how much you could learn from living abroad and meeting so many different people. I wish I had a chance like this when I was young."

I stared at Papa dumbfounded. I dared not say what went through my mind. "What??? I'm getting ready to have the dance performance in three months and I'm just getting to know Naresh, my new boyfriend. Why would I go back to high school when I'm looking forward to majoring in psychology

in college? I surely have no desire to go to a faraway place like America where I don't know a soul. I've never been on a plane and I can't imagine speaking English all the time, let alone understanding the strange American dialect. The whole idea is absolutely crazy."

Papa watched me carefully as I said nothing for several minutes. He just looked at me gently and knowingly, his smile urging me to think more deeply. Well, I thought, as crazy as it seems, the AFS program could be an interesting opportunity. Besides, I have heard that some college students are beginning to think about the United States for graduate studies; it might give me a leg up if I wanted to pursue a higher degree abroad. And I've got to admit that it could be fun to be the first person in my family to go abroad.

"Okay," I said with a little sigh and a hint of a smile about our unspoken conversation, "you're right, I'll think about it."

"Good for you. Never turn down something without exploring it," Papa replied, handing me the newspaper clipping, "now look at the details." I gulped when I read the fine print: the AFS conducted a nationwide selection process so highly competitive and selective that fewer than 1 percent of applicants were accepted.

Confused and a little intimidated, I biked over to the house of my best friend Manisha to talk this over. We had been together from kindergarten through high school, often competing for the top spots in exams. Her eyes opened wide; she already knew about AFS from her father and was seriously considering it. "Wouldn't it be fun to apply together," she smiled, as I said, "If we both get it, each of us would know at least one person in the United States."

It's hard to imagine now that until the immigration reforms of 1965 when the anti-Asian "exclusionary laws" were finally repealed, it was difficult for Indians to go to the United States. The enormous surge in the Indian population in the United States, now close to three million strong, was not even a trickle yet. From a regional city like Ahmedabad, going to the United States was rather rare in the mid-1960s. The few who went were graduate students in engineering and science. It was practically unheard of for a seventeen-year-old girl to go to the United States alone, not just to attend an American high school but also to stay with a family who were perfect strangers.

I came back from my chat with Manisha intrigued and even excited about the adventure, now actually hoping that I could win a slot in the AFS program.

Both my parents reinforced my newfound enthusiasm, but for different reasons. Explorer and inquirer by nature, Papa was genuinely excited about any opportunity for his kids to learn new things or visit unfamiliar places. Ben agreed with Papa's assessment of the benefits of travel and new educational possibilities. But the program would also create some needed distance from my adolescent love affair with Naresh. Ben was worried that I was too young to foresee the potential conflicts in the relationship because of our different upbringings. He came from a much more tradition-bound family than ours, with more conventional expectations of women in the household. Even though hers had been a "love marriage," my mother still believed that marriages were as much between individuals as among families.

Many years later, Naresh long gone from my life, I asked Ben if a desired distance from Naresh had been one of the motivations behind her enthusiasm for my going abroad. She gave me an enigmatic confirmation: "Yes," she said with a sly smile, "that was *a* reason, but not the *only* reason." To be honest, I was so busy with the AFS application process that I had little time to spend with Naresh or think about what it meant to leave the place I had called home all my life.

I was less concerned about the lengthy written submissions for the application and more about the final interview, to be conducted in English if I made it that far. After all, I was competing with students from all over the country, many of whom had gone to English-medium schools and were fluent in the language. Much to our mutual surprise, both Manisha and I made it to the final hurdle: an interview with a panel of five judges including a retired barrister, a school principal, and a social worker, in an intimidating setting in a quintessentially colonial building in Mumbai. I was relieved when they asked about what I had learned outside the classroom. My answer relied heavily on contributions from my parents, especially in my understanding of national politics, art, and culture.

Within a few days, Manisha and I were thrilled to hear that we had made it! Among a select group of forty-eight students out of more than three thousand applicants across India, we were the only two from Gujarat and among the very few who came from Indian-language schools.

The AFS Indian committee reminded us that we were to be "cultural ambassadors of India" and "should be prepared to answer any and all

questions about India" when we got to America. Papa made sure that I was ready for this important encounter. His recommendations included Indian census reports to understand the country's diversity and planning commission summaries to get up to speed on the economy, nothing I had read about or even laid eyes on before. For ancient wisdom, I got books like A. L. Basham's *The Wonder That Was India* and summaries of the Upanishads. From the AFS committee, we received an extensive bibliography that included biographies of our national heroes as well as collections of songs including Christian hymns and Tagore poems sung at Gandhi's Ashrams. The idea was to project a positive, dynamic, and tolerant image of a young, independent nation. No one asked us to focus on India's enormous economic and political challenges, and we were certainly unprepared to counter American popular stereotypes about India—poor and backward with beggars, elephants, and snake charmers at every corner.

As I was the first person in my immediate family to go abroad, the family came out in full force at the Mumbai airport to wish me well, not just my parents and all my siblings but also Mumbai-based uncles, aunts, and cousins, some forty strong. I started crying even before we left for the airport. With tears in his eyes, Papa tried to console me by reminding me that he would soon visit me in America. (He had been invited by the U.S. State Department as part of the Distinguished Visitors program.) Ben remained predictably stoic; no tears at all, reminding me that one year would pass in the blink of an eye. Papa offered some final advice, "You have a rare opportunity, make the most of it."

In all their professed enthusiasm and expressions of support, my parents didn't say much about what it would feel like for me, a seventeen-year-old, to go away for a whole year to a completely strange environment with no family support. No one ever warned me about culture shock nor prepared me for the emotional impact of leaving the comforts of the home and family I had known all my life.

I also had no idea how my parents really felt about sending their young daughter away to a strange land for a whole year. Two decades later, I finally asked Ben how they really felt when I left. Ben was quiet for a moment before speaking, "Your father and I closed our door after returning from the airport and stayed inside the room for the whole day, mainly crying and worrying.

We wondered whether we did the right thing to send you away at such a young age. We didn't know where you were going or what your host family was going to be like. We hadn't even thought about what would happen if you got into some kind of trouble and needed to reach out to someone in the United States. But had we even hinted at our deep fears, it would have made you more anxious. We had to be strong to give you the strength to flourish in your new life."

These days, in the age of constant connections and complete familiarity with countries like the United States, it never ceases to surprise me to see Indian parents who accompany their kids to settle them at a new university and to minimize the inevitable shock of separation. When they hear my story, they are amazed to learn that my parents sent me so far away at such a young age so long ago. I have talked to friends and students who first left their family to go to college in another country. While the large majority of them talk about the initial sense of dislocation and a desperate desire to find familiar tastes and faces, the Dutch Moroccan writer Abdelkader Benali had an unusual response: "I was happy to go. It felt like going for freedom. Which it was, for someone like me who came from a family-oriented environment. I loved the sense of dislocation; I loved the idea of being out of place, being the outsider. I loved the dizziness that came with it, something I would read later in the literature of Baudelaire or Rimbaud."

That was certainly not true for me. Having never traveled outside of India, I literally didn't know enough to have any expectations. But I also didn't really have a fear of the unknown. I have to admit that my parents may not have provided emotional comfort by sharing their genuine feelings, but they did engender a sense of resilience that comes from the assurance of rooted-ness, a confidence to survive and flourish anywhere.

Of course, when the plane took off from India, I was so excited and bewildered that none of this crossed my mind. All forty-eight of us Indian AFS students flew together on Pan Am 001 from Mumbai via Beirut to New York. Many of us had never traveled by air before and we were all pretty befuddled by the whole experience of leaving, saying goodbye to our families, and heading out into the big unknown. Chattering constantly, as much out of nervousness as excitement, we hardly slept on the long journey. Two days later as we approached JFK Airport on a crystal clear summer morning, we were glued

to the windows, two or three to a window, stunned by the immensity of New York City. It was an awesome site—big bridges gracefully reaching across rivers, huge highways leading out in all directions, buildings three times taller than we had ever seen. The captain announced on the public address, "Now look down, there's the Statue of Liberty just below Manhattan Island, welcoming you kids from India."

A few hours later, our bleary-eyed contingent arrived at the Tudor Hotel in mid-Manhattan. Although AFS representatives offered helpful briefings on what lay ahead, the whole experience was peppered with many little surprises. I found out that my host family (parents with two teenage daughters) lived in Santa Barbara, California, but we would spend the first two months at their summer home in Sagaponack on New York's Long Island. An AFS chaperone stage-whispered, "Santa Barbara and Sagaponack—*very* upscale." I felt some jealous glances from others in the group and was delighted that I would have two girls my age as companions.

The next morning, accompanied by an AFS staffer, I walked anxiously to the United Nations Plaza apartment building to meet my "American parents." I was at my Indian best; waist-length hair in a single braid, a dot on my forehead, a pink *kameez* tunic over white *churidar* (tight pants) with a blue chiffon scarf. Edward and Mary Reed came down to the lobby to greet me. Edward, "Poppy" as I learned to call him, was a tall, thin, almost bald, bespectacled man with a slightly shy but pleasant demeanor. He instantly reminded me of my father with his easy smile. Mary "Mummy" Reed was more garrulous. Her greyish hair was cut short with soft bangs and her bright red lipstick contrasted starkly with her sharp blue eyes. She didn't look or feel remotely like Ben.

I prepared to bow to her with hands together in the customary Indian gesture of *namaste* as Mummy Reed came forward to hug me; we ended up somewhere in the middle, laughing at our awkwardness. Then Poppy asked me if I had a shorter first name since "*Visheekha* is a bit long and difficult." I was taken aback; no one had ever had trouble pronouncing my name back in India. Over the years, I have learned to accept a wide range of short names and mispronunciations—*Vish, Vishy, Vicky, Vishikaki, Veroushkha*, and so on. But at that moment I was not yet ready to have them call me Nanu, my nickname reserved strictly for the family back home. I told them that I would

give "careful thought to their kind request." As they stared back quizzically, I was embarrassed to realize that they didn't really understand my Indian-accented, slightly British-inflected English.

After going up the elevator, we looked around their friends' spacious corner apartment with a view of the United Nations and the East River. I said, "Oh, it's so beautiful. But where are your daughters?" "Didn't you know?" replied Mummy Reed, "They're both on overseas travel programs, Noni in England and Julia on a short AFS program in Laos. They won't be back until the end of the summer." Oh my God, I thought to myself, a whole summer alone with no kids but just two old folks who can't understand me and can't even pronounce my name right. I had my first sharp pang of homesickness.

I gradually felt better as they told me about their active and engaged lives, somewhat akin to those of Ben and Papa. Quintessential New Yorkers, the Reeds had moved to Santa Barbara five years earlier but had kept their Sagaponack home. Poppy Reed, a journalist like my father, had formerly been editor of *Theater Arts Magazine* and had edited major conference publications for the United Nations. Then he was invited to go to California to serve as the editor of the monthly publication of the Center for the Study of Democratic Institutions, founded by the legendary educator and former president of the University of Chicago, Robert Hutchins. Mummy Reed was active in the Democratic Party politics of New York and California and had even run for Congress in the heavily Republican district in New York's Upper East Side. She explained, "I put up a good fight but lost."

I didn't know it at the time, but I had just experienced the psychological whiplash effect of living in the space between two cultures with sharp ups and downs in moods and experiences. Unlike my friend Abdelkader, I didn't particularly cherish the "dizziness" that accompanied the visceral feeling of dislocation in a brand new place that was to become my "home" for a whole year. My next downer, quite literally, occurred as we drove through the Midtown Tunnel on our way to Long Island. Mummy Reed casually asked, "Have you ever been in a tunnel like this before?" "No," I shook my head. "Just think," she said brightly, "you're way under a large river, millions of gallons of water right above your head." Thank goodness I was in the back seat so she couldn't see my panicked reaction. What if there was a leak? I'd be crushed by the water, I'd never see my family again, and they would never

know what happened to me. I felt dark inside, almost suffocating as if the whole car ride were in some forbidding tunnel resembling a death trap. I'm not a pessimistic person and had never before contemplated such doomsday scenarios. Even after we had safely exited the tunnel, as Mummy Reed persisted with her enthusiastic commentary about New York and Long Island, I fought back tears.

In retrospect, my experience in the Midtown Tunnel was a perfect metaphor for what Salman Rushdie called a "leap in the dark,"[1] precisely because it was a step into the unknown. My entry into my new American life had been far more traumatic than I had acknowledged at the time. The strong pressure to be a good representative of my country generally overshadowed my ability to handle my mixed emotions of separation, diminished confidence, and loneliness.

By the time we reached the Hamptons, where Sagaponack is located, the cool breeze of the ocean and the gentle greens of the cornfields lifted my spirits considerably. "It's almost dinnertime," Mummy noted brightly, "so let's stop at a fish store." I wasn't sure how fish and dinner might be related, but already confused and disoriented, I'd given up trying to make sense of things. At the fish store, the Reeds picked out some weird-looking green live creatures with long antennae. Coming from a strictly vegetarian family where we didn't even eat eggs, I had never been to a fish store nor had I seen any live fish except in a fish tank at a relative's home. I just assumed that these crawly creatures were for a decorative fish tank, so I was surprised that Mummy Reed deposited them in the refrigerator.

No sooner was I settled in my room on the second floor of the Reeds' historic "salt-box" home, my very own room for the first time in my life, when Mummy Reed called me to come down and help her with dinner. As I entered the kitchen I saw on the stove a large pot filled with boiling water, and when I got closer I heard scratching sounds and little cries. As if in an Alfred Hitchcock film, I stood ramrod still with my eyes opened wide, shocked by the obvious conclusion even before Mummy confirmed it. "It's the lobsters. I really hate this part. They always squirm and cry when they're boiled. But they're a true delicacy. And it's the perfect season."

Oh my God, this whole thing was going from bad to worse. What could I possibly do? Thinking quickly, I said I was going for a bike ride to get some

fresh air. I promised Mummy I'd be careful and would return soon. I grabbed one of the beat-up bikes belonging to the Reed girls and took off on the main road. Riding into the wind with my long braid bobbing around, I couldn't stop sobbing. HONK! HONK! A car swerved, just missing me, and the driver screamed, "You idiot! Get on the right side of the road!" I had forgotten the AFS briefing: "Americans drive on the right side of the road. Same for bicycles." Quickly darting to the other side, my bike wobbled along as I screamed out loud. "Nothing's going right. I almost got killed. There's no one my age. I can barely understand what the Reeds are saying. Now they are giving me sea monsters for dinner. I want to go home. I'm going to write Ben and Papa and ask them to get me out of here. This is the stupidest thing I've ever done."

As I calmed down a bit, I turned the bike back toward the Reeds' home. My parents—I thought of them again—what would they do? Another thought crossed my mind. Our Gujarati food would be just as strange to the Reeds as their food was to me. How would my family feel if the Reeds came to our house and didn't eat anything we had prepared? I remembered that Western visitors who came to our home for meals often tasted all the dishes offered, at least a little bit; being perfect guests and making us feel like proud hosts. Besides, in my family the idea of being vegetarian was not argued along religious lines but more in accordance with the Gandhian tradition of nonviolence. So, half an hour later I returned, having resolved that I would try everything my new family had prepared, no matter how strange it looked or tasted.

Poor Mummy Reed was terribly worried, not knowing where I had gone in the dark of the night or if I had gotten lost. Seeing my reddened face, she took me in her arms and asked if I had been crying. No, I lied; it was just a windy night for bike riding. Finally, as we sat down to dinner, I confessed my dilemma: I had never heard of nor seen these creatures called lobsters. In fact, I had never eaten meat of any kind—fish, bird, or animal. But I vowed to eat at least a bite or two of whatever they offered me, just as we would expect them to do if they came to our home in Ahmedabad.

Mummy was so chagrined, "Oh, I'm so very sorry. We had no idea. We knew you were vegetarian, but in the States that means you can eat chicken and seafood, but not red meat. You don't have to taste the lobster."

I responded emphatically, "Oh yes, I do." Using the tiny fork, I picked a small piece of white meat from the big red claw, dipped it in butter, and gulped it down. "It's really not bad," I said, surprised, and tried a couple of other little bites. "Oh, you're so brave," Mummy said. "You're like a brave little bird. How do you say 'little bird' in Gujarati?" I smiled. In fact, "little" was my own pet name—*Nanu*. And "bird" was *pakshi*. Mummy was delighted, "That's it! You are our "Nanu Pakshi." Poppy also beamed, "So you do have a nickname after all. From now on, I'll call you Nanu, a lot easier than Vishakha!"

Something significant happened in that moment. When Poppy first asked me about my nickname, I had resisted. It was as if he didn't yet have the right to use the name that was reserved strictly for "my family." Now, with our bonding experience of the lobster meal, we had become "family." It felt right that he should call me by my family name.

The next morning Mummy had an idea, "Nanu Pakshi, now that you will eat whatever we eat, let's reverse it all tonight. Why don't you cook some Indian food for us?" I was truly touched by this suggestion. The only problem was that I had never learned to cook; my mother always oversaw food preparation and, like most upper-middle-class Indian families, we usually had a full-time cook. Luckily, Ben had given me a few simple recipes just for such occasions. I selected the simplest sort of Gujarati meal—rice, a yogurt curry, and a vegetable dish of potatoes and onions.

For much of the day, Mummy and I drove around the Hamptons trying to find the ingredients. Vegetables were easy and so was rice; unfortunately no Basmati then, so Uncle Ben's had to suffice. The hunt for yogurt was more difficult; the 1960s were pre-Danon yogurt days. Finally, we found our yogurt at an exorbitant price in a Southampton specialty shop. All that remained was *besan*—"chickpea flour" or "gram flour"—a Gujarati staple found in every corner shop in Ahmedabad, but nowhere to be seen in the Hamptons. We even went to a pet store, thinking "chickpea flour" might be sold in the same place where they sell "chicks." Finally, at yet another specialty shop, the proprietor said, "Lady, I've never heard of chickpea flour, but we do sell graham flour." "That's it!" I said excitedly, misunderstanding his pronunciation and thinking he had said "gram flour," as chickpea flour is more commonly referred to. To make a long story short, the curry was a total disaster. Made from wheat rather than chickpeas, the graham flour produced a sticky lumpy

brown mess with globs of white yogurt on top, resembling a melting ski slope in mud season. The Reeds did eat my rice and vegetables, but we all agreed that we would pass on my "yogurt curry." This was not my finest hour as a cook, but it did cement my relationship with my new American parents.

Our days in Sagaponack were wonderfully lazy. We got up at eight, drove to town to get the *New York Times* and freshly made Crutchley doughnut holes, and enjoyed a leisurely breakfast of fruit, doughnut holes, and coffee while perusing the newspaper. Later in the morning, our ritual included making peanut butter and blueberry jam sandwiches with Pepperidge Farm whole-wheat bread (Mummy Reed scoffed at Wonder bread and canned, processed food), filling a thermos with iced tea, packing the car with books, and driving to Sagaponack Town Beach where we stayed until late afternoon.

At the beach, our main activities consisted of going into the ocean (pretty cold by my standards), reading, and leisurely beach walking. I didn't know how to swim, but splashing in the ocean and learning from Poppy to ride the waves was a lot of fun. Mummy Reed was determined to introduce me to some classic beach reading material—crime thrillers and light fiction—in addition to more serious authors. A passionate reader since my childhood days, I had spent hours reading Gujarati novels and major Bengali writers in translation but not much English literature. I loved the idea of exploring a whole new world of literature in a completely new language under the guidance of Mummy Reed.

One of the books I read was *Rebecca* by the British writer Daphne Du Maurier, which was familiar to me because of the Hitchcock movie of the same name, but was not always easy to comprehend. Mummy and Poppy encouraged me to ask them about words I did not understand. They also made sure I learned to pronounce words the "correct" way, making distinctions between "v" and "w" and between different forms of "th" as in "thinking" versus "Thailand." Mummy Reed sometimes joked that I was Eliza Doolittle to her Henry Higgins, referring to the famous 1964 film musical *My Fair Lady*. I didn't really know the story at the time, but it didn't feel good to hear that it was about a poor unsophisticated girl being taught to speak "proper" English by a famous professor. A star student back in India, I was used to speaking in public with perfect Gujarati diction, and I was certainly not used to being corrected all the time. As much as I appreciated their efforts, I have to admit

these sessions also made me feel diminished and even humiliated. It took me a long time to acknowledge that those lessons served me well in my adult life of frequent public speaking in English.

After reading for a few hours, I usually took a nice long beach walk. There were plenty of young people my age all around, frolicking in the sand and water. Deprived of the company of siblings and friends, I was desperate to talk with them, but they were preoccupied with their own friends, oblivious to a strange-looking foreigner. The biggest shock to me was the very public displays of affection between teenagers. My diary from this period is filled with surprised comments: "I can't believe that these two people have covered themselves with a towel and are actually rolling around, going on top of each other! I am desperately trying not to look, but I can't take my eyes off the young couple in passionate kiss and embrace! Are they really doing what I think they are doing?" I had not seen anything quite like this in my entire young life. Even holding hands with Naresh was done furtively, mainly in darkened restaurants and movie theaters. I tried to make some sense of this and concluded that it was not fair to make value judgments about such behavior as it seemed like an accepted behavior in the United States. If anything, I learned to go about my business without staring. Withholding judgment while encountering unfamiliar behavior, central to any life of global belonging, was a crucial aspect of my AFS experience.

Finally, toward the end of the summer the two Reed daughters returned from abroad. By now, I had developed a close familial relationship with Poppy and Mummy. As much as I had looked forward to having the company of girls my own age, it took a while to create a bond with Noni and Julia. They must have felt that I had intruded in their tight-knit family. Thankfully, by the time we were ready to leave Sagaponack for Santa Barbara, we had begun to connect. At summer's end, Noni, the older daughter, went back to Franconia College in New Hampshire while Poppy, Mummy, Julia, and I flew to Los Angeles on a daytime flight. Mummy sat next to me, providing history lessons as we flew over the flat cornfields of Iowa and the majestic mountain ranges of Idaho. I couldn't believe the huge expanses of land completely devoid of human settlement. I hadn't flown over the Indian landscape, but having traveled all over the country on our school trips, I was aware that there was hardly a piece of earth in my country that had not been occupied

by masses of people over millennia. Only later did I learn the startling fact: India has three times the population of the United States, living on one-third the land. No wonder there were huge empty spaces in the United States!

As we drove on coastal highway 101 from Los Angeles to Santa Barbara, I was stunned by the beautiful landscape: ocean on one side, mountains on the other, and the city of Santa Barbara nestled in the foothills between the two. I had been to the Himalayas, and I had seen the oceans coming together at the southern tip of India, but never had I seen tall mountains and a wide ocean come together. The sheer majesty of the landscape complemented by the intermittent rays of sun brightening the foam of the Pacific Ocean waves, was a heavenly sight I never got tired of throughout my year in Santa Barbara.

When we arrived in the village of Montecito, an exclusive part of Santa Barbara where the Reeds lived, I kept thinking that it all looked very empty; large houses nestled in the woods barely visible from the street, and no one on the road except cars and a few horseback riders. The Reed house was unlike any I had ever seen—separate units for the garage, bedrooms, guest room, and living quarters, all linked by covered walkways—family members separated from each other but surrounded by nature, practically living like hermits. What a contrast from our home at 38 Jawahar Nagar, a beehive of activity with a gaggle of kids and uninterrupted flow of visitors at all times! I was grateful to have had two leisurely months in Sagaponack to bond with the Reed family, but I was not prepared for what hit me when we came to California.

For several weeks, I felt desperately lonely, especially with Poppy back at work, Mummy back to her political activities, and Julia back to her friends, occasionally but not always including me in her social activities. Being left on my own was an unsettling experience. At home in Ahmedabad, I had to sneak out to our backyard to find time to read or commune with the sculptures. In Montecito, I had all the time in the world to read or to pursue new hobbies. But it felt as if I had been robbed of an essential part of myself, the part that defined itself only in relation to attachment with others. The values of personal independence and privacy, hallmarks of the American way of life, seemed similar to those of *sadhus* and *sanyasis* who renounce the social life and obligations that come with it. As a seventeen-year-old, I didn't know that I had encountered the twin concepts of independence and interdependence, ones that would become important elements in navigating my life going forward.

I couldn't wait to get to my new school, Santa Barbara High School, one of the two public high schools in the city. I looked forward to making new friends and learning new subjects. But I was utterly unprepared for the sheer scale of the school: four thousand students in three grades, over a sprawling campus of giant buildings and never-ending playgrounds that made my little private school with less than six hundred students from kindergarten through high school look diminutive. The sheer variety of classes, the extracurricular activities available to all students, and the constant shuffle of students from class to class punctuated by locker visits boggled the mind. In normal circumstances, all exchange students would be baffled by such changes and then get used to the atmosphere. But the 1960s were not normal circumstances.

The social upheaval of the late 1960s came as a much bigger shock to me: kids arguing with their parents and fighting against all existing social norms. No one had prepared me for the frequent use of drugs, especially marijuana and even LSD at parties, along with alcohol. On the first day of classes in my study hall (a concept alien to me), I was introduced as the new exchange student from India. No sooner had I sat down after saying a few words, a student sitting behind me passed a note: "Is it true that *ganja* is legal in your country? Can you get it anywhere?" It took me a while to figure out what he was asking. I tentatively wrote back: "I think only villagers use *ganja*. It is frowned upon by city folks." I could tell he was quite disappointed. Enamored with the emergent hippie culture in California, my fellow student was excited to meet his first "genuine" Indian girl, and I had let him down! Over time, I had to reconcile my two contradictory impulses: a desire to belong and experiment like all teenagers, and a fear of breaking the law and disappointing my country. Ultimately, the latter won out that year, but the tension between desire and responsibility continued to be part of my life during the AFS year and beyond.

While I had an ambivalent relationship to drugs, I loved rock and roll music, especially the Beatles, the Rolling Stones, and the Monkees. My absolute favorite gift for my surprise eighteenth birthday party in 1967 was the early-release album of the Beatles, *Sgt. Pepper's Lonely Heart Club Band*. It soon became an iconic album of the era, combining drug culture with flower power and occasional forays into Indian spirituality. I loved it for its diverse musical styles, especially for the way George Harrison used North

Indian classical musical style and Indian instruments on the song "Within You Without You." The song, with words based on Vedic texts and melody inspired by the Indian raga Khamaj, performed by the most popular band of the time, became a perfect symbol of my desire to connect the best of India with my new world in America. I loved the Beatles because they loved India and respected Ravi Shankar. I cherished the album for decades, taking it with me every time I moved, from the United States to India, and back again to the United States. Even now, when I hear "Lucy in the Sky with Diamonds" or other songs from the album, it never fails to evoke memories of the "summer of love" in 1967 that marked my experience in Santa Barbara.

My love for the new popular music also bonded me with Julia who was in a constant state of conflict with her parents. Mummy Reed would yell at Julia, "I don't know how you can listen to that junk! Why do you have to wear such short dresses? And that hair of yours! It's constantly in your eyes and I can't see your face!" Julia would shout back or walk out of the room, depending on her mood.

I was such an integral part of the Reed family by now that nothing was held back, neither shouting arguments nor slamming of doors. These kinds of emotional outbursts were completely absent in the Desai family, so I had no emotional mechanism to cope with them. Shocked and a little scared, I generally would say nothing and retreat to my room. To my surprise, after the emotional storm subsided, the familial love and serious intellectual conversations generally returned. I recognize now that much of the tension in the Reed family was part and parcel of the rebellious spirit of the times. Many of my American friends constantly talked about how they "hated" their parents and couldn't wait to get out of the house after graduation. The concept of teenage rebellion was completely alien to me. I loved my parents and missed them terribly, but there was no way to share such "old-fashioned" sentiments with my new friends.

I wanted to blend into an American setting, embracing it as much as I could, but I also wanted to hold on to my Indian self. This was not an easy task in 1966. I learned that there were just two Indian families in town and very few Indian graduate students at the University of California, Santa Barbara. (I met one of them and promptly disliked him as he pushed himself on me, causing me to reflect on the fact that I didn't have to like all Indians

just because they were in short supply.) There was no way to find the flavors, sounds, and smells one would find back home, things all new immigrants long for. And there was no way to call home as it was very expensive, took a few days to schedule, and was actively discouraged by the AFS organization.

I wrote long letters to my family, generally describing new things I was learning and lectures I was giving about India. Of course, this reinforced my Indian-ness, but I never really shared my anxieties or an occasional sense of isolation; I actually didn't know at the time how to process such feelings. To quote writer Gloria Anzaldua again, it was the beginning of "kicking a hole out of the old boundaries of self and slipping under or over, dragging the old skin along, stumbling over it."[2] This was my entry into a new world with parts of my old world constantly inserting themselves into that new territory. Or rather, I was desperate to hold on to the parts of my old life that seemed to recede faster than I could handle.

Occasionally my efforts to stay rooted while reaching out to a new life got entangled in unexpected ways. It showed up in spades when Papa came for his planned visit as a special guest of the U.S. State Department. For very good reasons, AFS had rules prohibiting family members from visiting their children during their exchange year abroad. Such visits can cause confusion for the student and concerns for both sets of parents, sometimes resulting in a complicated emotional situation. As it turned out, Mummy Reed was the official hostess of the State Department program in Santa Barbara, so in spite of some quibbling from the AFS head office, "Mrs. Mary Reed" declared that she was "obligated" to have Nirubhai Desai as her "houseguest" during his stay in her city.

I awaited my father's arrival with excitement and anticipation. But when I first saw Papa in Santa Barbara, he looked haggard from jetlag. His rumpled *khadi* clothes and open-toe sandals from the Ahmedabad Gandhi Ashram seemed totally out of place in California. He spoke with a heavy Indian accent and people had a hard time understanding what he was saying. To my rapidly Americanizing mind, Papa looked small, provincial, and quaint. And he saw me differently as well: when I first began talking to him, he pointed out that even my Gujarati accent was Americanized (after all, I had not spoken a word of Gujarati for almost five months). If I thought he looked too Indian, he let me know that he thought I sounded too American. Once a giant of a man in

my imagination, now he looked fragile and diminutive, reminding me of how small I felt when I first landed in the country months earlier.

The State Department had arranged several meetings for Papa, and Mummy Reed had organized a big dinner for him to meet some of the liberal intellectuals from Poppy's think tank. I accompanied my father to his meeting with the editor of the *Santa Barbara News-Press*. When asked about the Cold War and the U.S. role in Vietnam, Papa advocated differentiated understanding of Communism in China, the Soviet Union, and Vietnam. This was in stark contrast with the prevalent American view of a homogenized Communist bloc sweeping Asia. Long before the Nixon–Kissinger overtures to China, Papa suggested that the United States needed to take advantage of the rift between China and Russia to create stronger ties with China. He was featured on the front page of the paper the next day, complete with a photograph. I couldn't believe that he was totally on top of the biggest issues of the day and had a lot to say about them.

By the time he left Santa Barbara, my father had managed to win over all the intellectual heavyweights he met. The public recognition of his intellectual insights wiped out all my reservations about his provincial demeanor. Papa once again showed by example that intellectual curiosity and engagement knew no bounds or cultural barriers. When he departed, we both cried and gave each other a hug. As he walked off in his *khadi* clothes and handmade sandals, I fondly remembered the nylon dress story and his statement about privileging values over appearance, something he had taught me long ago. An additional bonus of my father's visit was the close friendship he forged with Mummy and Poppy. My two families came together in a way that gave me comfort in belonging to both without having to choose.

Now fifty years later, as the chair of the board of AFS International, I have the privilege of seeing the lasting impact of AFS experience on thousands of people, not just the students who went on the exchange program but also on the families who hosted them. Today, the organization is no longer just about exchanges between America and the world; it encompasses exchanges of young people among ninety countries. United by our shared experience of making families across borders and maintaining them over the years, we bond instantly through the stories we tell regardless of the year we went on the program or the country we come from. Vincenzo Morlini, a former

president of AFS International and a fellow returnee, talks fondly about how his American parents, now in their nineties, stay in touch with him and welcome their "Italian son" with big hugs on his visits, more than fifty years after he first joined the family. My fellow trustee Amalie Ferdinand from Denmark is much younger, but she speaks with the same passion about her "family" in Peru where she first discovered her passion for Latin dancing.

More than once, I have met an AFSer by accident or at one of our international gatherings and felt the cultural differences and geographic distances melt away in moments. Whether it is a globally recognized person such as Christine Lagarde of the European Central Bank or a twenty-year-old recent returnee, all it takes is a story of how we became members of a family who were once strangers. Often the first line is, "AFS changed my life!" And then we go on to talk about how we became who we are because of that experience.

I wish the founders of AFS could hear these stories of changed lives and expanded families. As young ambulance drivers during the World Wars who picked up the wounded from both sides, they had witnessed the tragedy of wars firsthand. The drivers first used the name American Field Service during World War I. After these young American men returned from the Second World War they asked themselves, What can we do to stop such carnage from happening again? Idealistically, the ambulance drivers decided that the best thing was to have young people go and live with families in countries that had been previously enemies. The very first AFS programs involved Germany, Japan, and Italy. The simple idea was that once they experienced the love of strangers who then become family, they would never want to fight them. It is debatable whether the AFS exchange program has prevented wars, but the original ambulance drivers would be proud that the program has created a huge cadre of internationally minded adults, myself included, who continue to engage with the world.

6

Vietnam

War or Country?

"SCHOOL HAS ALWAYS been my second family, in India as well as here. But I was truly lost on my first day at Santa Barbara High School. I was astonished to see such a big high school, everyone going from one class to another while the teachers remained in their classrooms." I wrote these words for the school newspaper in Santa Barbara as I was getting ready to leave the school that had truly become my second home for ten months.

In addition to its size, there were many things about Santa Barbara High School (SBHS) that required huge adjustments of me academically, socially, and politically. Academically, I learned to explore subjects with which I had little familiarity, such as American literature, American government, anthropology, and etymology. I didn't even know what the word *etymology* meant, at least initially. But once we started exploring the origins of words and their meanings through time, etymology reminded me of my study of Sanskrit: I was thoroughly hooked. The other big surprise included the practice of writing term papers and book reports on subjects that I chose, a brand new experience for me. I loved learning about America through its literature and history, requiring analyses of iconic plays such as *Our Town* by Thornton Wilder and writing book reports such as the one on *Ishi*, the story of the last survivor of the Native American Yahi tribe in California. Equally important,

I relished the process of learning to synthesize what I had read and constructing my own observations about the text.

In addition to the typical academic subjects, my other classes included a public speaking class, fine arts studio, and dance classes with a student of Martha Graham (Graham was a graduate of SBHS, and I had the honor of greeting her when she came back to the school to receive an award). I became good friends with some of the dancers who were also cheerleaders for the school's football team.

Much to my surprise and chagrin, this complicated my social life. At Sharda Mandir I was used to doing well academically while also playing major roles in dance dramas and leading various team sports, but this was neither accepted nor expected of young women at one of the most highly ranked public schools in America of the late 1960s. There were clear demarcations between female students who did well academically versus those who were good at sports or dance and music: You were either an intellectual and a nerd, or physically active and "popular." One had to choose a side; there was no way to be part of both. The situation was particularly exacerbated by the fact that my American sister Julia was part of the intellectual crowd that was smart, socially progressive, and politically engaged. Tall and physically somewhat awkward, Julia looked down on the "popular" crowd and was not particularly fond of my dancer friends.

It was as if physical agility and an intellectual mindset couldn't go together for women in 1960s America. I was reminded of Jackie Bouvier's (future Mrs. Kennedy) well-known statement about her year in Paris in 1951: "I learned not to be ashamed of a real hunger for knowledge, something I had always tried to hide."[1] By the late 1960s, young American women could be hungry for knowledge, but there was no way to combine the intellectual quest with athleticism and artistic achievements. The perception of such exclusivity persists to this day. For instance, when describing Alexis Sablone, a competitive skateboarder with a master's degree from MIT, most writers begin with how Sablone defies the popular perception that scholastics and skateboarding can't coexist, especially for young women. At SBHS, the lines clearly drawn between "us" versus "them" crowds often made me feel like an interloper, especially to the intellectual clique. Ironically, it was less my real outsider status as an exchange student and more my desire to be part of the two mutually

exclusive social groups that created a sense of confused belonging within me and for those around me.

One place where these divisions seemed to soften was the studio of Jack Baker, our art teacher. Mr. Baker was an unusual teacher for several reasons: he had traveled the world, had been to India twice, and had even named his daughter India. Well known as a painter and represented by an established gallery in New York, Mr. Baker was also politically active. In addition to attending our regular classes, many of us hung out in Mr. Baker's studio during our lunch breaks to discuss the latest political news, especially the raging war in Vietnam. After hearing my father's observations about the futility of the war during his stay in Santa Barbara, I had become much more acutely aware of the intense divisions it sowed in American society. The Vietnam War was one topic where students from different social backgrounds and academic persuasion could come together, especially in Mr. Baker's studio.

By the spring of 1967, American involvement in Vietnam had deepened considerably and the draft was causing many young people to question the very efficacy of war in a distant land. Hundreds of thousands of students were organizing protests in New York, Washington, DC, and many other major cities around the country. Julia and I joined with a large group of Santa Barbara antiwar students, part of the crowd at Mr. Baker's studio, to organize a major demonstration coinciding with nationwide protests. Now Julia, inspired by her parents' Quaker background, and I, motivated by my parents' participation in India's Freedom Movement, were working hand in hand.

As the only Asian on the organizing committee, I was given a prominent speaking role. I offered an argument slightly different from that of most other speakers, "Of course, we are all joined together in opposition to the Vietnam War. It makes no sense on political, military, economic, or moral grounds." But I added another dimension. "It also makes no sense in human and cultural terms. We speak of Vietnam as a war, not as a country that has existed for thousands of years. We use the names Da Nang, Hue, and Halong Bay, but we take no time to learn about these places. It's easy to obliterate a country when you just see it as a name, but it's only when you realize that you are crushing innocent people and precious sites that it becomes harder to drop a bomb. See the face of Vietnam—mothers, fathers, children, priests, shopkeepers, craftsmen, doctors, and teachers—can you possibly want to

burn them all with napalm? What do we know about the country that we seek to destroy? Almost nothing. The latest polls show that most Americans can't even find Vietnam on a map. Can you believe that? I'm from India, a country with a five-thousand-year-old civilization, but Americans know next to nothing about us. Wouldn't it be just as easy, should war somehow break out between India and the United States, to drop bombs on my family? We would refer to it as the 'India War,' not a place with a rich cultural past and a promising future." I barely heard the resounding applause as I tried to stop tearing up. The war was no longer an abstraction for me. By comparing Vietnam with India, I had created a personal emotional attachment with the plight of the Vietnamese people. It was the beginning of my lifelong quest to connect cultural values with political realities.

We didn't know at the time that ours was the first peace vigil to be held by high school students on the school premises. It created a big stir in the press. I proudly clipped out the photo of me at the protest rally in the next day's paper—the perfect memento of my greatest day as an exchange student. I felt as if I were channeling my parents in the heyday of the freedom struggle. But "one of my greatest days" was not viewed in the same way by the AFS authorities. Soon I received a call from the AFS New York office. Sensing it was a reprimand, Mummy Reed picked up the phone in her bedroom as I spoke from the breakfast room. "Vishakha, we understand you have been active in the antiwar movement in Santa Barbara. This is a highly charged political issue, and we try to have AFS students not get involved in domestic political controversies. AFS is a nonpartisan organization. We have heard from some supporters of AFS in the Santa Barbara area and they are concerned that your public participation in the protests will threaten the support for future AFS exchange students in the area."

Frightened and speechless for a moment, I took a deep breath before speaking, "I hear your concerns, but I thought America was a democratic country committed to freedom of speech. I come from a family of Gandhian freedom fighters and I strongly believe in the cause of ending the war. Are you suggesting that you will forbid me to express my opinion?" Mummy Reed immediately chimed in, "I realize that Santa Barbara is a very Republican community and our family, with its liberal democratic values, is in the minority. We will take Vishakha out of the program and are prepared to

support her on our own as a member of the family. So, you need not worry about finding community support for her. And by taking her out of the program, there will be no threat to its future."

Oh my God, I thought, Mummy has become unhinged. Is she going to pull me out of the program without asking me? Okay, I've got to do something. I made my freedom of speech point. Now let me show a bit of flexibility, "Before we do anything rash, let me ask a question. Is the problem not as much what I said, but rather that I said it in public and it got press coverage? If that's the problem, I'll be happy to avoid comments in public, but I think I should be able to participate in conversations at school and to help organize protests. Would that be okay?"

There was a pause on the other end of the line, a little whispering, a cough or two, and then a quick comment, "That will be acceptable, but please be careful. Another mistake could endanger our staff, our students, and our support." And so my greatest day, although on the brink of becoming a potential nightmare, was finally salvaged. I allowed myself a little pat on the back— I was able to create a compromise solution that allowed me to stand my ground while truly considering another point of view.

Nanu Pakshi had found a solution when all the adults were going off the rails.

To be fair to the AFS authorities, they were navigating a difficult political terrain in the 1960s. It was the height of the Cold War and cultural wars were raging throughout the United States. Coming out of World War II with a commitment to go beyond politics, the nonpartisan stance of the AFS leaders that seemed a bit conservative to my young mind was born of a noble cause to preserve the program in a fractious environment. I didn't fully understand it at the time, but my effort at compromise was based on a desire to see their point of view, intuitive empathy that I had learned as an AFSer.

The Vietnam War continued to play a significant role during the last few months I spent in the United States and long after I left. It came up in heated discussions with other AFS students when we embarked on a month-long bus trip across the United States at the end of our stay in California. We discovered firsthand that what we experienced in California was hardly the norm in small towns and big cities in Arizona, Texas, Missouri, and Iowa. Accompanied by two chaperones, we usually drove for a day and then stayed for two nights in a designated town, usually with host families.

For many of these families in small towns, I was the first Indian person they had ever met. Except for the young men in their social circle who may have enlisted, an Indian girl was as close as they would ever get to meeting a Vietnamese person.

The Vietnam War discussion came to a head in Spearman, Texas, a town with a population of around three thousand people (smaller than the size of SBHS). We arrived on a Saturday evening and as usual were assigned host families. Living in a trailer park, my hosts were of modest means but devout churchgoers. They had never met anyone from India, and they were proud to introduce me to their minister at the Baptist church the next morning. My hosts thought it would be lovely if I wore my "native costume" as most of their neighbors had never seen anything remotely like it. The next morning, dressed in a nice green sari and with a *bindi* on my forehead, I looked my Indian best as we arrived at the church for my first-ever Christian service. We took our seats in the front row so that all the churchgoers could catch a glimpse of the "exotic" girl. After a full year of becoming an integral part of the Santa Barbara society, it was strange to be viewed as if I were from Mars.

The preacher took his place at the podium to deliver the sermon of the day: "The Last Word of Christ." A short stocky fellow, the preacher was dramatic to say the least. Waving his arms vigorously and pounding the podium for emphasis, he interpreted the "true meaning" of the Gospel to his flock: "The last word of our Savior is about conversion, bringing the heathens into the everlasting glory of God's true church, the glorious embrace of Jesus Christ. So that is why the Vietnam War is not just a conflict between democracy and communism. It is also a mission—an American mission—to save those Vietnamese heathens from Hell. Indeed, it is a Christian mission for all of us—to bring the truth to the backward people of Asia, to save them all not just from oppression and poverty but also from eternal damnation in the eyes of God."

This was surely a whole different take on the Vietnam War! It was my first experience dealing with views that seemed completely alien to me. Struggling to keep my seething anger in check, I kept my cool as my hosts insisted on introducing me to the preacher at the postservice social hour. Unlike my usual practice of shaking hands as I had learned to do for the whole year, I bowed to him with my hands together in the Indian gesture of *namaste*. I spoke politely but firmly, "I was struck by your message in the

sermon today. You talked about how all Asians were heathens and would go to Hell. In my religion we have no Hell, and I too am Asian, so I wonder if you could tell me where I would go. Whose Hell would it be?" I thought I was being clever, but he looked confused and fumbled for words. Then he stared at me and changed the subject, "That foreign costume you're wearing, it's a . . . ?" "Sari," I interjected coolly. "Oh yes," he said quickly. "I knew that. That's a nice sari." Channeling the disdain of some Indian intellectuals, I smiled cynically, put my hands together, bowed once again, and walked away with a dismissive shake of my head.

In Santa Barbara, I was accustomed to political arguments around the war, but I had never heard the rationale for the war couched in religious terms. For the first time, I saw the potent but volatile combination of religion and politics; when they were directly joined, the political argument became both emotional and toxic. There was no way to argue another side once it was baked in a religious frame. I would see this play out repeatedly in India and in the United States over the next phase of my life. At the time I remember being quite upset. I couldn't wait to talk with my father about the statement of the Texan pastor and my response to him.

———————

FOR MOST AMERICANS of my generation who came of age in the mid-1960s, the Vietnam War was a defining period in their lives. Looking back, it was a seminal experience for me as well, but perhaps for somewhat different reasons. First, I had a newfound appreciation for India the country, and my role as her citizen, especially outside of the country. Of course, this had come on top of all the frequent questions I was asked about India: "How will India feed its people when its population keeps going up? How do you go to school? Do people have elephants at home?" I was supposed to answer these questions as an Indian, not as a young Gujarati girl from Ahmedabad.

My small speech at the rally had transformed the nascent sense of nationalism I had gained through school trips back home into a passionate belief in "my" country. I realized that the idea of and commitment to one's nation can be clearer and stronger when experienced outside that country: the sentiment of nationalism may not be fixed in time or a place but can evolve over time. It was also my first significant experience in connecting my "Indian-ness"

with a larger sense of the world beyond. I understood the plight of the Vietnamese people by personalizing it in Indian terms. Intuitively, I managed to connect political developments with their cultural roots, leading to my decision to study political science with a focus on cultural history. My encounter at the Spearman church also taught me that political arguments couched in religious terms gave them a moral veneer, making it difficult to develop any rational approach to policy.

Our bus trip came to an end in New York City, the place where we had begun our amazing journey one year and a lifetime ago. Buses carrying thousands of AFS students from all over the world, transformed by their experiences all over the United States, arrived at one of the big armories in New York. I couldn't wait to find Manisha among the throngs of students all looking for their friends, old and new. "How ya doing?" Manisha cried out as she ran to hug me. "I'm real good," I answered, and we both broke out laughing. She had become a real Virginian complete with a southern drawl, and I had become a cool Californian with expressions that were fit for the freedom vibes of the sun-drenched state. We were both excited about "going home" to Ahmedabad but also sad to leave behind our new "homes" in Abingdon and Santa Barbara.

7

The Trauma of Return

S OME OF THE BEST descriptions of returning to one's home country come from the Nigerian American writer Chimamanda Ngozi Adichie in her remarkable novel *Americanah*. Explaining the return of the heroine Ifemelu to Lagos from the United States, Adichie writes,

> At first, Lagos assaulted her; the sun-dazed haste, the yellow buses full of squashed limbs, the sweating hawkers racing after cars, the advertisements on hulking boards (others scrawled on walls—PLUMBER CALL 080177777), and the heaps of rubbish that rose on the roadsides like a taunt. Commerce thrummed too defiantly. And the air was dense with exaggeration, conversations full of over-protestations. . . . Here, she felt anything could happen, a ripe tomato could burst out of solid stone. And so, she had a dizzying sensation of falling, falling into the new person she had become, falling into the strange familiar. Had it always been like this or had it changed so much in her absence?[1]

These words could easily stand in for my first days back in Ahmedabad. The "strange familiar" was exactly what I sensed upon returning to my original "home." It is a predicament best described by James Baldwin: "you don't have a home until you leave it and then, when you have left it, you never can

go back." I was excited about eating my favorite foods, especially spicy curries and pickled mangos, and I couldn't wait to see my siblings. But, I certainly was not prepared to be shocked by things that I had known all my life. The first thing that struck me as our plane landed from Mumbai at the Ahmedabad airport were the odors: stale smells of spices oozed from people's clothes, and even the ground had a strange smell bordering on wet, rotten fruit. Then, it was the airport itself. From the single rusty luggage belt to the light bulbs hanging above the rickety luggage carts, everything seemed dingy and on the verge of breaking down. Was it always like this or had I changed that much? This was decades before Ahmedabad got a brand-new airport and New York airports turned into dilapidated infrastructure nightmares. I was happy to see my own family come out in full force, but it was overwhelming to see thousands of people, some waiting for their relatives and others curious to see a plane landing. I missed the relative anonymity and spic-and-span spaciousness of American airports.

As I came out, I rushed to my family to hug my sisters; they looked at me with bewilderment. I had clearly gotten used to hugging friends and family in America, forgetting at that moment that it was not yet customary in places like Ahmedabad. To make matters worse, everyone started laughing when I opened my mouth: "What happened to your Gujarati? You are speaking Gujarati with an American accent! And how come your English is so weird?" I hadn't spoken a word of Gujarati for a full year except for the few days I spent with Papa. I tried to explain, but I suspect it all seemed a bit arrogant as if I were rationalizing the change because I had been on a special trip to America.

There was no denying that my English was now Americanized. Between Mummy Reed, my speech class teacher, and my numerous speeches to diverse American audiences, I had successfully transitioned to speaking English with a strong American accent. Because I had not had any prior training in pure British English, I didn't have to get rid of something old to adopt a new pattern. In America it had seemed like an advantage in order to be understood and able to fit into a new culture, but back in Ahmedabad it seemed as though I was putting on an air of superiority by "pretending" to be part of my newly adopted country. At the time, the idea of "Indian English," now recognized even by the *Oxford English Dictionary*, was not yet acknowledged. It was either

"Queen's English" (much desired) or vernacularly accented English (definitely not "proper"). A third option of speaking "Americanized English" was not part of the accepted lexicon in the first decades of newly decolonized India.

I wonder if subconsciously I was trying to retain my American English, one of the only evident ways to hold on to my American-ness. As described by Jhumpa Lahiri in her book *In Other Words*, perhaps I was afraid that I would forget my unforgettable experience in America. I was afraid of having my American-self annihilated by the crushing weight of resurgent Indian surroundings. I resonated with Lahiri's fear of losing Italian when she returned to America for the summer after spending a year in Rome: "A foreign language is a delicate, finicky muscle. If you don't use it, it gets weak . . . The manner of speaking [Italian in the U.S.], the sounds, the rhythms, the cadences seem uprooted, out of place. The words seem irrelevant, without a meaningful presence. They seem like castaways, nomads."[2] America was now part of me and I was unwilling to make it a "castaway" experience, even if it meant receiving derision from family and friends.

Manasa Sitaram, one of my graduate students at Columbia University, described this predicament in vivid terms:

> Growing up in a predominantly Indian household in Singapore, I grew up learning multiple languages and speaking across diverse accents. In school, I adopted a strong command of Singlish, and with my international school-going friends a slight American twang developed. For a long time, I struggled with this since the notion of a native language, or a distinct accent that was my own, was an elusive concept. It merely depended on context and convenience. And I saw it as a tool of bonding, a way to get in with a group of people by speaking the way they do, a form of assimilation, if you will. Some people perceive this notion of contextual code switching as fake, as erasure of my native, "authentic" way of speaking. But the reality is that I have known no other mode, code-switching is my native way of speaking. (written correspondence, 2018)

As an eighteen-year-old who had been raised in a monocultural environment all of my life except for one year of living far away from it, I was not yet as sophisticated as Manasa. It hurt when my siblings as well as some friends

saw my accent as arrogant or fake. Within a few weeks, my Gujarati returned to normal but the feeling of being out of place persisted a lot longer.

I also longed for some private time and a room I could call my own. I remembered well how lonely it felt initially to have my own room with my American host family. How I longed for the company of my siblings when I first arrived in the United States! By the time I left, however, I had come to appreciate having the space and time to do as I pleased in my room, keeping all my things together in one closet, and not having to share everything with other siblings. A few weeks after my return to Ahmedabad, it all came to a head. I had brought a nice wooden hairbrush back from Santa Barbara, something quite different from the combs we used in India. I kept it in a drawer away from the hair oil and combs we kept in a communal space. I saw my younger sister Anuradha (Anu, for short) using the hairbrush, and I suddenly exploded, "Don't you understand that this is *my* brush? You can't just pick it up and use it as you want." I screamed and snatched the brush away from her. Anu started sobbing, "Ever since you came back, it's always about what's yours and why no one is allowed to use it. I don't know who you are any more. You think you are different from everyone else and better, but I think you are just being selfish. It's as if you're not a real part of the family anymore." My two worlds, jumbled up and in a constant state of confusion, had just come crashing down over the use of a hairbrush, and I had no capacity to weave a new reality out of the pieces.

Anu and I eventually made up, but there was no denying that I had returned a different person in many respects. Maybe I had come to treasure privacy and individualism a bit more and perhaps I was flaunting my "specialness," not realizing that it translated as "selfishness" in my family's eyes. My individual and independent selves were struggling to coexist with the collective self. I never wanted to push away my Desai roots, but I also wasn't about to reject the transformative legacies of my year abroad. I had changed in some profound ways, but there was no way for my family, except Papa, to understand it. (After all, this was before television arrived in Indian homes and started beaming *I Love Lucy* and the serial *Santa Barbara* on a weekly basis.) It also didn't help that nobody at home or at college showed much curiosity about my experience in the United States, so I didn't have opportunities to reminisce about my American life while going about my daily life

in India. I was trying to live in the twilight zone of hybridity, both Indian and American, without being able to name it or process it, which resulted in a confused muddle both for me and for all those around me.

Amidst the clouds of confusion, one thing that kept me grounded was my Bharata Natyam dance practice. I had to postpone my *arangetram* when I decided to go to the United States. After a year of performing to tapes of recorded music in Santa Barbara, I was happy to get back to dancing with live musicians and complete my official training. Dancing kept me away from other distractions as well. I had broken up with Naresh via a long letter within months of my departure from India, but he was still hoping to rekindle the romance, something I no longer had any interest in pursuing. I avoided encounters with him while seeking the company of new groups of students with whom I could share some experience of American popular culture.

Usually, my new friends were non-Gujaratis, especially Parsees and Christians who had gone to English-medium schools and were more Westernized. Compared to my school friends from Sharda Mandir, they were more familiar with American films and popular music. Growing up, I was proud to have gone to Sharda Mandir for its Gandhian, nationalist ethos; now it seemed provincial and small. As the only person in the group who had been to America, I was of interest to my new friends as well. At parties, where they were used to dancing to Elvis Presley and early Beatles records, I had the crown jewels— Jefferson Airplane, the Rolling Stones, and the latest Beatles (including *Sgt. Pepper*). In America, I was proud to talk about the roots of my Gandhian school; now back in India, I was desperate to find connections with people who would have even a vague idea of what America was about. I looked forward to going to Sunday morning "jam sessions" at the newly opened coffee shop Bankura to listen and dance to the music of my beloved Beatles.

However, I was frustrated with my classes at St. Xavier's, especially because the college did not offer a program in political science, my new passion after participating in the Santa Barbara antiwar protests. In addition, neither my classmates nor my teachers had any interest in being politically active. As television was not yet readily available in India and newspapers didn't cover international news in depth, I tried to keep up with what was going on in America through correspondence with the Reed family and Santa Barbara High School friends. Another big source of news was my father and the

publications he received from the United States and the United Kingdom. Papa made it a point to introduce me to young American Fulbright scholars who came to visit him. (One of them was Howard Spodek, a historian of Gujarat who taught at Temple University in Philadelphia and became a life-long friend of the family.) Papa also gave me articles about leaders of student movements in the United States and France, such as Angela Davis and Daniel Cohn-Bandit, and suggested that I read about the civil rights movement in the United States to get a better understanding of social protests there.

Having seen me in Santa Barbara, Papa had a vivid sense of my life there and the changes I had experienced. A rebel in his own youth, he knew what it was like to be constrained by social conventions. Sensing my rising frustrations, Papa again came to the rescue, suggesting that I follow the advice of several St. Xavier's professors and transfer to Bombay University. As was the case when my mother went to Ahmedabad for her education, it was still unusual for young women to travel to another city for undergraduate studies. Thankfully, my oldest sister Swati had paved the way by pursuing her graduate work in economics at Bombay University a few years earlier. She had stayed with relatives for the two years she was in Bombay, partly because it was the normal thing to do and also because it was far less expensive. In keeping with my newfound independent spirit, I made it clear that I wouldn't follow her example and I would stay in a hostel. Ben expressed concern about my safety in a big city like Bombay without familial oversight, but then I reminded her that she was exactly my age when she herself had gone to Ahmedabad and lived in a hostel more than three decades before. Ben and Papa finally agreed with my decision to stay in a hostel, but I was also aware that this would incur additional expenses. Although there was no way for me to pay for all of my expenses (tuition, living expenses, and housing), I insisted on some contribution by teaching Bharata Natyam at one of the classical dance academies and giving private lessons. This was not a typical thing in India, but I had seen some of my friends in Santa Barbara work after school and save money to help defray college expenses. I felt proud to contribute even a small amount to my educational expenses.

Next was the choice of college. Following Swati's suggestion, I enrolled at Bombay University's Elphinstone College, one of the oldest and most intellectually renowned schools in western India. I was excited about my move

to Bombay (now renamed Mumbai), with high hopes for a lively academic atmosphere in a vibrant city with cosmopolitan flair. One by one, my hopes turned to disappointments. I was unable to find a room in a hostel and ended up as a paying guest in a widow's small apartment for the first few months. And while Elphinstone had a great reputation and a legendary principal, Mrs. Wood, I found the school stuck in an aura of a stodgy colonial institution. It felt as if the British Raj were still alive and well at Elphinstone. The student body was sharply divided into two social groups: the anglicized students, products of missionary school who pined to go to Oxford or Cambridge for graduate studies; and the more Indianized students from Marathi- and Gujarati-medium schools who had no such "foreign" ambitions. The former group—students and faculty alike—looked down on the latter group.

The anglicized students didn't quite know what to make of me: I was a "Gujju" girl (a derogatory term for students from Gujarati schools) from Ahmedabad, but with American English. In their eyes it was okay to go to the United States if you wanted to study science or engineering, but certainly not for anyone who was really cultured and sought to study literature, history, or other liberal arts. On the other hand, the Gujarati friends I met through my Indian dance activities had no connection to the "cosmopolitan" students, products of the famous English-medium schools such as Cathedral and St. Mary. My American side longed to be accepted by the Cathedralites as they seemed closer to my intellectual interests, but most of them had little interest in me. Unlike my friends from English-medium schools in Ahmedabad, the Bombay crowd seemed more hung up about their "pukka" British heritage. My Gujarati friends in Mumbai accepted me more fully, but it felt inadequate. I wondered if I was becoming like the washer man's dog in a famous Hindi proverb, "*dhobika Kutta nahi Gharka, nahi ghatka* [a washer man's dog belongs neither to his home nor to the steps of the river]."

On my first day at Elphinstone, Mrs. Dossal, head of the political science department, asked me a question in class and when I answered, she gave a curt rejoinder, speaking in high English dialect, "Oh my dear Miss Desai, where did you get that horrid accent?" Once again, my audible American identity was a problem, but with an additional layer of complication. The British rulers were long gone but the prestige of their way of thinking and speaking was well and alive at Elphinstone College. It would have been okay if I spoke

English with a Gujarati accent; then I would be simply another girl from a "vernacular" school with a provincial mentality. But to "flaunt" my American English and my American experience was to go for the showy, unsophisticated American culture (a view prevalent in England and in India in the 1960s) rather than "proper" Oxbridge English. In Ahmedabad, there was some envy and perhaps resentment about my American experience, whereas in Bombay it was more condescension mixed with some envy. I wasn't sure if I looked at these experiences with a particularly American eye, but I know I was sensitive to their perceptions because of my American experience.

It also didn't help that Mrs. Dossal's classes consisted of dry renditions of her old lectures, all emphasizing European political philosophers from Machiavelli to Montesquieu and from Descartes to John Stuart Mill, with zero mention of any thinkers from America, China, or even India. Having experienced a larger intellectual universe from my AFS year, enhanced by Papa's insights and periodicals the following year, I was hungry for more. When I suggested a reading group to Mrs. Dossal, perhaps starting with Edgar Snow's work on China called *The Other Side of the River* and Erik Erikson's recent book *Gandhi's Truth*, she dismissed the idea entirely: "Thank you for your suggestion, but we read serious works here. Besides, such topics are not included in the final university exams, so it would be a waste of time."

I recognize now that from the time I returned to India until the time I went to Bombay, I was in a bit of a funk, constantly looking for ways to climb out of my dark cave, which could be described as a "trauma of return." Today, I can see what was happening to me in the years between my AFS life and my new life in Bombay from a different perspective. I was in the early stages of what might be called the multicultural "who am I?" syndrome. Angelika Bammer, a scholar of comparative literature, has described the connection between dislocation and identity well: "The relationship between the experience of cultural displacement and the construction of identity is marked by the historically vital double move between marking and recording absence and loss, and inscribing a (new) presence."[3] As a nineteen-year-old, I was trying to cope with a sense of dislocation without having the capacity to construct a new hybrid identity. My sense of displacement may have been exacerbated by the fact that in the late 1960s, India was quite isolated from the rest of the world and America seemed like a faraway fairyland to most Indians.

I know from my discussions with students in our current age of hyper-connections that the sense of dislocation persists, even if in somewhat different forms. Here is Manasa Sitaram again:

> Having been born in India to a South Indian father and a North Indian mother, and moving to Singapore as a two-year-old, I didn't quite fit in with Singapore Indians who had been there for generations, and having gone to a local school instead of an international one, I wasn't quite squarely in the expat bubble either. So, I was always "foreign" and simultaneously at "home." Then I moved to Tokyo to go to school and became a "true foreigner." But it became equally confusing. I would introduce myself as a Singaporean, only to be met with confused looks. This required further clarification that I was born in India. This unlocked the next level in the game of guess-the-ethnicity (and identity). With one more move to the U.S., I realized that I could emphasize different aspects of my identity through choice of accent I assume or the clothing I wear, but it is not so easy to alter one's mind frame. Just as I got used to thinking that my identity can be in a flux and contextually determined, I have returned to Singapore. It is not clear what comes next, and it feels confusing at times.

Like Manasa, I was inventing various coping mechanisms to deal with my predicament of belonging. My quick assimilation method included trying to speak, dress, and act like an American high school student in the United States and being embarrassed by a father dressed in Indian clothing. My re-assimilation panaceas involved seeking friends in India who could relate more easily to the Western world and moving to Bombay seeking a more cosmopolitan environment. And my ultimate, tried-and-true coping mechanism: keeping busy to avoid inner anxieties in both America and then back in India. In retrospect, I can see that these techniques, while inventive, circumvented the fact that I had lost my moorings and had not yet found a way to ground my nascent in-between identity.

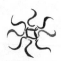

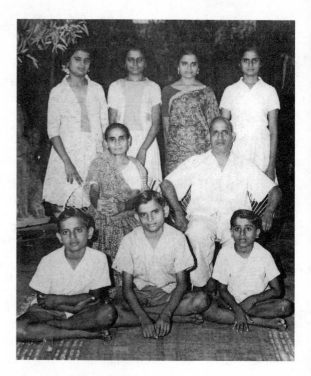

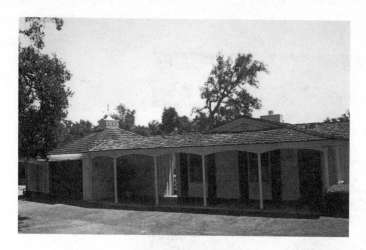

BARBARA NEWS-PRESS

LIFORNIA, SATURDAY EVENING, NOVEMBER 12, 1966 C PAGE A-3

TALKING OVER latest developments in printing are Narubhai Desai, center, an editor visiting from Ahmedabad, India, and Gabriel Renga, News-Press composing room foreman. At left is Desai's daughter, Vishakha, here as an exchange student. The machine is a Monarch typesetter, which uses punch tape to set at a rate of 14 lines per minute.—News-Press photo

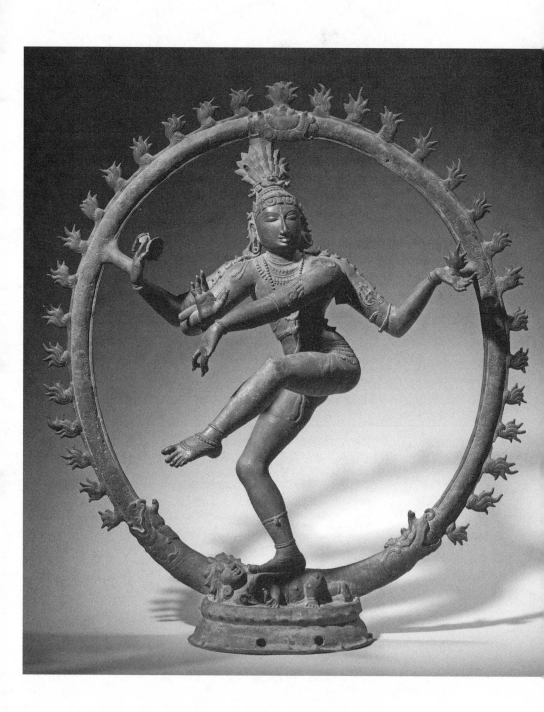

PART III

In-Between-Ness of Belonging

There are parts of myself that remain, parts that slide against the masks of newer selves.

—BHARATI MUKHERJEE, "A FOUR-HUNDRED-YEAR-OLD WOMAN"

8

Attachments, Made/Unmade

HE TERM *double consciousness* was first used in 1903 by the African American scholar and activist W. E. B. Du Bois in his autobiographical work, *The Souls of Black Folk*. He was describing the sensation of people like himself, African Americans who experience the precariousness of living between distinct worlds and dealing with the disjunction between self-identity and the perception of others, especially of the majority culture. When I first encountered the term some three decades ago during the height of the multicultural debates in the 1990s, I felt an immediate attachment to the lived reality of double consciousness.

Ironically, the term perfectly captured my experience during my early days at Elphinstone College. My inner compass was out of alignment. I thought of myself as a strong-willed Indian student matured by an incredible experience in the United States. By contrast, my professors and classmates perceived me as a provincial Gujarati girl with a strange American accent, not one of "them." The disjuncture caused tremendous inner dissonance, but as a nineteen-year-old student in a relatively isolated country, I did not yet have the tools to cope with it.

I had more questions than answers about the seesaw effect of my existence in Mumbai. Why was it more confusing to be in Mumbai than in Santa Barbara? Was it because in Santa Barbara everyone accepted my Indian-ness, whereas in Mumbai no one around me would acknowledge my American

experience? Living away from India for a year, I had acquired a new sense of pride about being an Indian. Why did that flame of nationalism seem to dim now? Was it because I grew more in love with the country while I was far away from it? How could I cope with the flashes back and forth—seeing even simple things like classrooms, food, books, and conversations through a double pair of eyes, Indian and American? I didn't yet have the capacity to understand that this was the reality of living between two worlds. I was trying to be tough and resourceful, overlooking the fact that I was vulnerable inside, tired of being misunderstood, and looking for some magical solution.

Enter Tom Smith, an American Peace Corps volunteer with piercing blue eyes, wavy sandy-brown hair, scruffy beard, and lanky physique; imagine a younger Peter O'Toole in *Lawrence of Arabia.* He showed up uninvited at a lunch I had organized for another Peace Corps guy, a brother of a classmate of mine in Santa Barbara. The three of us met at Samovar, the legendary coffee shop for artists, intellectuals, and students, right across from Elphinstone College. As we sat down, I looked at their slightly wispy faces with bemused smiles and instinctively asked, "Are you guys stoned?" Initially startled, Tom, on his first trip to Mumbai from the village of Palsoda in a remote part of the country, broke into a broad smile, "No. But what an American question! I didn't expect that of an Indian girl. If you'd asked us last night, the answer would be 'yes.' But now, we're just tired and hungry as hell." I liked Tom instantly, especially after we discussed our mutual participation in the anti-war movement.

Leaving Samovar, Tom and I talked about getting together soon. Even so, I was surprised to get a phone call that evening on the singular public line of my new residence, the Scottish Women's Hostel. When I answered, it was Tom, drunk or high on dope, speaking in blurred English, "Oh Vishakha, I've got the metaphor for life. Everyone's a caterpillar. But can I become a butterfly? I'm in desperate need of help. Please, help this pitiful caterpillar fly. Can we meet tomorrow for flying lessons?" I suppose if I'd never been abroad, Tom's booze-addled, dope-infused blathering would have shocked me, but frankly, with my Santa Barbara experience behind me, I found it all rather cute. The following day, I skipped classes and we walked all around Bombay, eventually having a Chinese dinner near Churchgate Station before he boarded the train back to Palsoda.

In a cab to the train station, we gently held hands and I could feel an electric current going through my whole body. I had never experienced such a sensation before. It was as physical as it was psychological. Tom was bright, well read, charming, and enormously attractive. I loved the fact that he had reached out to India, studied Hindi, and given his energies to a small village. How amazing it would be if we could share our India and America with each other!

Because we could only see each other every couple of months, our romance blossomed through letters. We wrote about everything: books we were reading, news about the Vietnam War, my frustrations with the college, and funny stories involving Tom's efforts to convince the farmers to give up growing opium poppies for wheat. I was hungry for the emotional bonding that came packaged in intellectual engagement and romantic sentiments. Passionate about existential philosophy, Tom introduced me to writers like Jean-Paul Sartre, Albert Camus, and Maurice Merleau-Ponty. In a way, through the letters he wrote from Palsoda, Tom became my connection to the West that I had left behind. The fact that we couldn't see each other frequently nor talk on the phone (Tom was without a phone in the village, I could only use a communal phone in the hostel, and long-distance calls were prohibitively expensive), written correspondence kept our romantic flames burning.

Even when we managed to meet in Mumbai, we had to contend with unexpected social consequences. In 1969 the nascent attraction to Indian music and culture, courtesy of the Beatles and the increasing presence of Indian spiritual leaders, which I first encountered in 1967, had now become a popular phenomenon. Young Europeans and Americans arrived in India by the vanload, completing their three-month overland journeys through Europe and west Asia. Young American hippies with long unkempt hair, wearing Indian clothes and plenty of beads, could be seen roaming the streets of south Mumbai. But even hippies were rarely seen with Indian girls. If a Western woman was seen with an Indian man, it was generally assumed that she was a hippie with loose morals and the Indian man was looking for casual sex. So, for an Indian woman to be seen with a white man who didn't dress like a hippie, was a true rarity. Every time we walked the streets or took commuter trains, we were assaulted by lewd comments from men. "How does it feel to have an educated whore?" was one of the more polite slurs we heard from

men who assumed that Tom wouldn't understand them and I, an educated woman, would never respond. When Tom shouted back some profanities in Hindi, I loved watching their faces stunned into silence.

We developed all kinds of ways to find some privacy where we would not attract stares and jeers. Our favorite hideout was the movie theater. Sometimes we saw several movies in a day just to escape the crowds; I recall seeing *Funny Girl* and *Doctor Zhivago* in a single six-hour stretch. One afternoon we went to the caves at Kandivali, a nice private spot outside Bombay; found a perfect secluded nook; spread out our picnic cloth; took out our lunch of fruit, samosas, and a water thermos; and lay down together as Tom hugged me. Suddenly, we heard two men whistling and inviting their friends to watch a "really good Bollywood show." How I yearned for the days at Sagaponack beach where a kiss or a hug was an everyday public occurrence between two consenting adults!

Fed up with constant intrusions in Mumbai, we decided that it was time for me to visit him in Palsoda, a small village some three hundred miles away in eastern Rajasthan near the Madhya Pradesh border. Tom checked with Palsoda's *sarpanch* (chief elder), explaining that we were planning to get married (as was the case), that we would be circumspect in our behavior, and, of course, I would not stay in his two-room house. The *sarpanch's* response was surprising, "Tom saab, you are not from here and you are not from our caste. Vishakhaji is from the city and she, too, is not from our caste. How can we apply our rules and conventions to either of you when you are not part of us? You can do anything you like because you are outsiders and our guests."

The *sarpanch's* comment was emblematic of what A. K. Ramanujan has defined as an Indian way of thinking, applying a contextually driven ethical dimension to one's actions.[1] Early Indian texts describe the ethical aspects of behavior according to life stages, caste or status, and specific exigencies in one's life. What is right for one caste cannot be applied to "outsiders" (other castes, other regions, or foreigners). Of course, a strict set of rules and heavy penalties existed for those of the lower caste in the village if they dared to violate the sanctity of the upper caste. If I had been from the same village and same caste as the *sarpanch* or from a lower caste, the village leaders might well have beaten me and punished my family for my falling in love with a foreigner.

Having already informed my parents that I was serious about Tom, I finally brought him home during the Diwali vacation in November of 1969. Tom connected well with my younger sister Anu and she helped us shape the strategy for informing my parents that we planned to get married right after I graduated from college. Papa, Ben, Tom, and I sat in our Ahmedabad living room and, as planned, I explained our intent. Papa responded, "It's clear that you love each other, but Nanu, you have always thought about going to graduate school in America. I suggest you go to the United States for further studies. Why don't you both continue to see each other and even live together to see how you would feel about being in America as a couple? There's no hurry, you're not even twenty-one yet. After all, your two older sisters are unmarried and pursuing professional paths."

Ben chimed in, "I think it's a good idea if you wait and get to know each other a little better. It is one thing for you to connect in India where Tom, you are a foreigner, but it's quite another for Nanu to learn to be part of your family in America when they haven't even met her yet. I think what Papa's saying is that you could live in the same city while you both complete your education." Papa corrected her immediately, "No, no, I do mean that they should live together in the same house and see what it's like to be a couple. After all, they are merging two cultures together and it's no small thing to do that. It will take a lot of adjustment on both of their parts, so why not have a trial run, so to speak?"

Here was my father in late 1969 in the provincial city of Ahmedabad, suggesting that cohabitation was the best route for Tom and me! When I tell this story to my Indian friends, they are utterly shocked, and my American friends, having fought the battles of cohabitation-before-marriage with their parents in the same period, are equally surprised. But Papa was true to his character. From his fictional and nonfictional writings dating to the 1930s and 1940s, it is clear that he often rebelled against the institution of traditional marriage and promoted alternative lifestyles to pursue true love in the face of social constraints.

My way of rebelling against my progressive parents was to insist on getting married, at home, in a traditional Indian ceremony. Over the next few weeks, before anything had been finalized, Ben sought to dissuade me from rushing into marriage. I remember fragments: "Marriage should be viewed

as a comma in your life, not the period at the end of a sentence. There's a life before marriage, especially for an independent woman, and there's a life after marriage, in which the woman becomes a wife and a mother, but these two aspects must connect. I didn't get married until I was thirty-one when I was very clear about the trade-offs."

I heard her words, but they didn't really register. I was way too young, very much in love, and determined to get married. Only later did I realize that Ben saw me as an independent young woman committed to pursuing a professional life. She was implying that marriage would involve more compromise for me than for Tom. I remember listening politely, but dismissing her arguments as old-fashioned, binary options: independent woman versus dependent wife and mother. I thought in America's new era for women I could have it all: be married, have kids, and pursue a career at the same time.

With our wedding date now set for June 9, 1970, Tom and I embarked on a nine-month romantic interlude that was frantic with wedding preparations alternating with the pressures of studying for my bachelor of arts (BA) final exams. Over the Christmas holidays we decided to take a brief break in Goa, a winter haven for hippies who descended on its balmy beaches taking a respite from wintry Nepal and Afghanistan. Goa was not yet a huge tourist destination for Indians or for upper-end tourists, so the beaches, flanked by coconut lagoons and fishermen's huts, were still relatively empty. Like most other young Westerners around us, Tom and I rented a cheap, simple room in a small house by Calangute Beach, complete with an outside one-hole toilet where pigs roamed underneath snorting up the spoils. We spent most of our days on the beach where young hippies wandered nude, making me feel conspicuously overdressed in a bathing suit, and arousing curious stares from Indian villagers.

Our deliciously romantic getaway was soon forgotten when Tom received the dreaded news: the U.S. government had instituted a new draft lottery system applicable to all American males between eighteen and twenty-six years of age, eliminating all deferments including Peace Corps service. Tom's lottery number (58) was quite low, and he had just turned twenty-five with nine months to go in the Peace Corps, making him eligible to be drafted in the army. The darker side of 1960s America had suddenly clouded our idyllic lives in India. Tom vowed never to serve in the "illegal, immoral, and idiotic"

Vietnam War—a position that won plaudits not only from me but also from my father. Tom had already filed papers for Canadian immigration, but Papa counseled going slowly and waiting for news of his draft status. So, with the wedding around the corner, we all decided to wait, trying to keep calm on the draft worries and focus our energies on the wedding. While shopping for wedding saris and worrying about the uncertainty of my future life in the United States, I also had to remember that my BA exams were around the corner and needed attention. Preoccupied with life after college, I was less focused on studies and academic performance than ever before in my entire young life.

Our wedding at 38 Jawahar Nagar was unusual by Indian standards of the time—light on ceremony, no multiple events over several days, and even lighter on food (only ice cream and light snacks). Aware of the legacy of my parents' famously simple wedding, I also wanted to forego elaborate multi-day functions and keep the wedding to a simple one-afternoon affair to avoid incurring huge expenses. To my delight, we pared down the invitation list to only four hundred people (this was small compared to most upper-middle-class weddings, with attendees sometimes numbering in the thousands).

No one from Tom's family made it to the wedding, but several of his Peace Corps colleagues and a few villagers from Palsoda, including his cook, represented his side. Much to our surprise and shock, almost a thousand guests flooded into our garden on our wedding day—it appeared that everyone had ignored the fact that the invitation was addressed to couples not to entire families. In retrospect, I should have realized that our wedding was bound to attract well-meaning voyeurs: the first wedding in my family and a rare wedding in the city between an Indian girl and a white man. Who could pass up gawking at the unconventional groom and his scruffy Peace Corps companions? We ran out of food in less than an hour, but no one seemed to mind, as there was much to look at and talk about in whispered tones.

I remember being passionately "in love" with the idea of being married, but I was certainly not prepared for all the implications of a marriage. My first shock came a few weeks after the wedding when I picked up my newly issued passport: I was no longer "Vishakha Desai." From now on, I was to be known as "Vishakha Smith" (it was automatically assumed that no Indian bride would keep her maiden name). I was suddenly Tom Smith's wife, not

the daughter of Ben and Papa, and off to live in America, no longer residing in India. In a short three-month period, I had turned twenty-one, graduated from college, gotten married, assumed a new identity, and was about to leave India forever.

As excited as I was about my new life, my body sent a different message, perhaps reflecting inner anxiety. Right after the wedding, I experienced severe stomach cramps and the doctors diagnosed a bad case of amoebic dysentery. We had planned a wonderful overland trip, beginning in Kabul and ending in Reykjavik before heading back to the United States, but Kabul had to be dropped while I got better. I did recover and we began a delightfully rickety adventure through the Middle East and Europe—Tehran, Tabriz, Istanbul, Athens, Skopje, Dubrovnik, Vienna, Munich, Geneva, and Paris—keeping our costs down by following the famous Arthur Frommer book *Europe on 5 Dollars a Day* and recommendations by fellow travelers we met along the way. In most places, we felt right at home as part of the wandering young (mostly Euro-American) tribe of the sixties, just another couple in an age of social experimentation and cultural exploration. We loved encountering new worlds as part of our honeymoon journey—an unexpected candlelit dinner feast with a family in Tehran, folk dances in Dubrovnik, old men on Greek Islands drinking their morning schnapps, traveling hippies sharing cautionary tales about Istanbul jails, and more. Most of the young Western-ers we met were going east, with their final destination being India, just as we were heading in the opposite direction. There was not a single other Indian woman in sight, especially one wearing soft leather boots and suede mini-skirts (all made in India) with a bindi on her forehead (symbolizing marital status) traveling with an American husband. Most of the times, our partner-ship resulted in innocuous stares by local residents and curious questions by fellow young travelers, but occasionally things got a bit scary, such as when we were accosted by a group of Turkish men in Istanbul for my "sin" of being with a Western man and giving up my "traditions."

Despite our exciting adventures, we could not dispel some dark clouds over our arrival in America. For one thing, we had to cut our trip short because Tom had been asked to report for his physical examination for the draft, even though he was only four months shy of reaching the cutoff age of twenty-six. What to do? We decided to pursue two options—filing for

conscientious objector status with plans to immigrate to Canada if that failed, but first having Tom report for the physical exam. The damned Vietnam War was no longer about the peace vigils against a war in a faraway land. It now occupied center stage in our new married life. We had to get to Tom's hometown of Cleveland as soon as possible to sort out the potential nightmare.

As we landed at New York's JFK Airport on our cheap Iceland Air flight, I felt nostalgic about my maiden arrival three years earlier—full of anticipation about the year ahead, all formalities of arrival being taken care of by the well-trained AFS staff. This time there was no one to help as we lugged our bags from the international terminal to one for domestic departures, and no friends with whom to share the anxiety and excitement of a new life. Groaning under the weight of Indian-made backpacks, I was just another spouse of an American husband, part of a couple desperate to make the flight to Cleveland with less than one hundred dollars to our names.

My arrival in Cleveland was a far cry from my first meeting with the Reeds. Although I had heard a lot from Tom about his parents and his difficult relationship with his father, I was not prepared for what I experienced. His father, a stern man with thinning hair, a pointed nose, and piercing eyes, seemed perpetually irritated. He made it clear that he was angry with Tom for going abroad with the Peace Corps without graduating from college (he had one year to go). Now, on top of that, he faced the draft while bringing home an Indian wife. As he saw it, Tom was being irresponsible, and I was part of the problem.

Like Ebenezer Scrooge, he was obsessed with saving money (one of his favorite activities was to save green coupons in a book to use them for getting better cuts of beef) and was annoyed that we would be living in his home while trying to get our feet on the ground. He reviewed all bills carefully and charged us for the two long distance calls I made to my oldest sister Swati, who had just arrived in Albany for graduate work in economics at the State University of New York–Albany. Tom's mother, a sweet woman, tried in vain to minimize the negative impact of her husband but she had little power in the running of the household.

I thought I knew how to become part of a new family, but the Smith family truly trumped me. There were no books in the house, there was little discussion about current affairs (Tom avoided any conversation that dealt with the

Vietnam War as it would enrage his father), and the father set all the rules. Having grown up in an upper-middle-class intellectual household and then becoming a member of the Reed family with similar values, I was not used to being in a family that had working-class roots with very different political and social orientations. I helped out in the kitchen and became friendly with Tom's younger sisters (his brother was away at college, but I really liked talking to him), but it was clear that class was a bigger barrier than our cultural differences. Through my immersion into the Smith family, I learned firsthand about the complexities of class, race, and culture as they played out in American society.

One person who cut through the barriers was Nan, Tom's maternal grandmother who lived with the Smith family. She was not very educated, but with her big heart and hearty smile she could win over any stranger. She welcomed me with open arms and helped ease my rocky entry into the family. Within a month, Nan bought us a used car and helped pay for our first month's rent as we moved to a one-bedroom apartment in a large complex near Shaker Square. Tom got a part-time job assisting the super in the apartment complex, and he was able to return to college.

We still had a big hurdle ahead of us as we awaited the dreaded day of Tom's physical exam required by the U.S. military. In customary Indian fashion, I lit some incense and offered a prayer to any God that might be listening: "please, don't let him get drafted, he's almost twenty-six, and he has already served his country." Tom returned in the late afternoon with a big smile on his face as he told me the story. When the doctor looked at Tom's record, he noted a weight loss of thirty pounds in the previous year. Tom explained, "I was in the Peace Corps in India. Lots of stomach problems." The military doctor smiled devilishly, "Aha, I see that you'll be turning twenty-six in January, four months from now. Let's see, I'll have to write this notation on your file: 'Severe weight loss. Cannot be eligible for draft until weight is regained. At least six months are required.'" The doctor winked, Tom grinned in disbelief, and the sword of Vietnam, hanging over our heads, was finally no more.

With the draft nightmare now resolved, I focused on getting our new one-bedroom apartment settled with some borrowed furniture from Tom's parents and a few used pieces from tag sales in the neighborhood. Our new home looked nothing like the spacious homes of the Reeds or the busy and

expansive Desai household. I worked hard to be a good homemaker, trying to expand my rudimentary cooking skills to include Western style meat dishes as well as Indian curries. Thanks to *Joy of Cooking*, one of our housewarming gifts from my mother-in-law, I learned to identify a pork shoulder from a chicken leg and use an oven to roast meats. And I learned to make chicken biryani from *The Complete Book of Indian Cooking* by Premila Lal, one of the very few Indian cookbooks available in English at the time. Occasionally it felt like I was playing an adult role in a movie about making a new home in a strange land, but I was determined to play the role well. After a few months of being a housewife, however, it was time to look for a job, as much to meet our monthly expenses as to get out of the house.

I wasn't sure how to go about my job search; my one and only visit to an employment agency had not gone well. Asked if I could type, I haughtily replied, "We usually ask secretaries to do that." The manager of the agency reminded me that I wasn't qualified even for a secretarial job without any typing skills. So much for my high academic credentials and accomplishments as an AFSer, as a student body president, and as a professionally trained dancer. None of it really mattered in my efforts to start a new professional life as a young married Indian woman in America.

Ironically and unexpectedly, Bharata Natyam turned out to be my secret weapon. I got invited by the dean of arts and science at Tom's college to give a dance performance. For the recital, I decided to use an approach that had worked well in Santa Barbara: a blend of Bharata Natyam dance segments, accompanied by recorded music with a backdrop of slides depicting sculptures of Hindu gods and goddesses set against ancient temple sites. The performance came off flawlessly and the audience seemed enraptured. People swarmed around me at the reception after the performance as one middle-aged gentleman waited patiently until the crowd thinned out. "Loved your dancing, so refined, so elegant," he smiled quietly as he shook my hand. "We were enjoying a performance and learning about another culture at the same time. You have a great gift. I'd love to have a chance to talk further. I've got an idea that might interest you. Why don't you give me a call? Here's my card: James Johnson, Curator of Education, Cleveland Museum of Art."

Two days later, I was escorted by a receptionist through the galleries of the Cleveland Museum of Art (CMA) with an incredible array of objects and

images from every quarter of the globe. "One of the best art museums in the country, and, as you may know, our Asian collection is our pride and joy." I stared incredulously as we walked through room after room of Indian stone and bronze sculptures, a wondrous treasure chest of my own culture halfway across the world. I stopped briefly before an extraordinary Shiva Nataraja, a dancing image of the Hindu god Shiva and a patron saint of all dancers. It brought me all the way back to my first solo recital and I instinctively bowed with hands together. The bewildered receptionist brought me back to reality, "Time to go now. We're going to be late for your meeting."

"You surely know about the Cleveland Museum," said Dr. Johnson as we sat across from each other in baronial leather chairs in his airy modernist office in the new Marcel Breuer addition of the museum. I smiled politely, trying to conceal the fact that I didn't know the first thing about the CMA or its enormous importance in the American museum world. Dr. Johnson was quite unusual for a museum educator: his degree was in the philosophy of aesthetics and he was quite knowledgeable about the ancient Indian aesthetic theory of *rasa*. "I sensed at your performance that you seem to know a good bit about sculptures. Have you had training in Indian visual arts?" Dr. Johnson asked as I was wondering about the purpose of the meeting. It was the perfect opening for me to talk about growing up with my father's collection of Indian art. I noted that the famous scholar Stella Kramrisch had visited our home and that Papa had lent a few of his prized pieces for her exhibition *Unknown India*, a landmark show focusing on Indian folk and tribal arts at the Philadelphia Museum of Art.

"Just what I wanted to hear," Dr. Johnson grinned. "I'm a great admirer of Dr. Kramrisch. It all fits perfectly. I believe strongly that one of the best ways to enliven art works from around the world is to have spokespeople from the cultures represented in the museum. I am happy to offer you a job as an instructor in the museum's education department. I've already run this by Dr. Sherman Lee, director of the museum and a great Asian scholar. He agrees completely. Would you be interested?"

I was stunned but tried to keep my composure, "That's great. Of course, I accept. But, uh, what am I expected to do?" Dr. Johnson shook my hand with a congratulatory smile, "You're a natural teacher when it comes to Indian art and dance. So, you'll begin doing just that with schoolchildren from the

inner city. After that you can continue to learn more about the art as you teach more students. You can start next week." I didn't realize at the time that Dr. Johnson was leagues ahead of other institutions and several generations ahead of the debates around multiculturalism that became prevalent in the United States in the early 1990s. I was pleasantly surprised that I had landed a job at a place that I knew nothing about before I had arrived that morning. When I left India for my new married life in the United States, I thought I was leaving my Indian classical dance career behind. Now out of the blue Bharata Natyam had paved the way for a promising new professional life at a great cultural institution.

I loved my first job at the CMA. Though the pay was minimal, I felt that I had found my calling. So two years later when Tom and I decided to move to New York City (where he would begin graduate work in philosophy at the New School), I wanted to continue my work in museum education, with a special focus on diverse, underserved communities. I wasn't quite sure how to do that, but with the help of Dr. Lee I was offered positions in several New York museums. I picked the Brooklyn Museum because of its strong commitment to its surrounding communities.

In the early 1970s, Brooklyn was hardly the hip and creative capital of New York that it has become a half-century later. The museum was surrounded by poor African American neighborhoods with pockets of working-class Irish and Italian communities; a perfect location to test the innovative practices of a young, activist museum education department. Reminiscent of the current social upheavals affecting the cultural world, the early 1970s were also rife with social challenges in the aftermath of the country's civil rights struggles and Vietnam War protests. The staff and patrons at blue-chip Manhattan museums struggled to respond to demands for cultural equity with new shows (*Harlem on My Mind* at the Metropolitan Museum of Art is a prime example) but also tried to curtail new trends (unionization of curatorial staff at the Museum of Modern Art). The relatively young education department staff at the Brooklyn Museum embarked on innovative approaches—helping develop a new cadre of art teachers working in tandem with social studies teachers in public schools and developing an after-school drop-in program called "What's Up?" for neighborhood kids. Having experienced a similar ethos at the CMA where I had worked with young kids from public schools,

I was thrilled to be part of the Brooklyn Museum team of socially engaged education workers.

All my colleagues at the Brooklyn Museum had graduate training in art history and were motivated to make museums more egalitarian and publicly accessible. Working with them, two things became clear to me: First, I wasn't alone in my conviction that we needed to make museums more relevant and exciting to all Americans, especially to less privileged communities. Second, mastery of content was as important as commitment to a cause. It was time for me to go to graduate school for Asian art history once Tom had completed his coursework.

Six months into his graduate studies, Tom abruptly announced one day that he was leaving the New School to become a professional photographer. Although I had been impressed by some of Tom's photos, including haunting images of dilapidated Central Park and the defunct Chelsea Piers, his sudden and total switch in career goals surprised me. I desperately wanted Tom to be happy, to revive that buoyant person I had met and married in India rather than the more frustrated, sometimes depressive husband he was in America. I recognized that it must have been difficult for Tom to find his professional footing when my own career seemed to be taking off. I was being treated as a special person in the museum world, valued for my Indian background. But I must admit, even with the experience of my traumatic return to India, it never occurred to me that Tom may also have been in a similar state of confusion about his identity after spending two years in a small village in India. I was being given a special status for my "Indian-ness" in America while no one, including me, gave him any special consideration for his experience in India. The only way I knew how to cope with confusing emotions was to bury myself in work and be supportive of Tom's new venture, wishing for his happiness while avoiding emotional confrontation.

Our emotional dissonance came bubbling to the surface in the spring of 1973 when we discovered that I was pregnant. I was not yet twenty-four, was planning to go to graduate school the following year, and Tom had no steady job. It was crazy to consider having a child. In the age of the women's liberation movement, it was possible to consider alternatives. After all, *Roe v. Wade* had passed in January 1973 and abortion was legal in the state of New York. And so when Tom and I talked, I was certain that Tom would agree with

my assessment that abortion was the right choice. To my utter surprise and dismay, Tom the existentialist agnostic suddenly became Tom the child of Catholic parents: "I'm sorry, but I cannot agree on philosophical or religious grounds. I'm unsure about where life begins—is it at conception or at birth? It's your body and your choice, but if you select killing the fetus, you bear the total responsibility for the decision. I won't accompany you to Planned Parenthood, but I guess I'm willing to pick you up afterwards. That's it. It's in your court. Whatever you decide, you'll have to live with it." I was shocked by the response; no warmth, no understanding, just a sense of cold judgmental distance. I had never felt so alone.

I had always thought I would have children. Coming from a family of seven kids and from a culture that made child bearing a defining feature of womanhood, it was excruciatingly painful to contemplate the decision even without Tom's sermonizing. After agonizing for a few days, I steeled myself to go ahead with the procedure. Even now, as I reveal this terrible episode, I'm short of breath, tears rolling down my cheeks, as I feel for that young woman with no one by her side when she made the heartbreaking choice. Today, when I hear conservative male politicians describe women who seek abortions as "brazen unfeeling killers," "just using abortion as another form of contraception," I think back to that time, one of the most trying moments of my life. These antiabortion activists have no understanding of, let alone sympathy for, the inner turmoil that I felt as a young woman (as do millions of women in similar circumstances) when I decided to terminate the pregnancy.

Our relationship survived but I became more self-protective and assertive, and more determined than ever to go to graduate school. Once again Dr. Lee played a key role, advising me that the University of Michigan was the right choice for me, with a large Asian art faculty and a world-renowned specialist in Indian art, Dr. Walter Spink. With a scholarship from the U of M, I was all set to go to Ann Arbor. Fortuitously, Tom also got a job as a photographer for the *Ann Arbor News* on the strength of his portfolio, so he, too, was happy, at least for a while.

From the moment we arrived in Ann Arbor, I threw myself into academic life, taking four courses and serving as a teaching assistant to the great German scholar Rudolf Arnheim for his popular course on visual thinking. I spent many evenings in the art history library surrounded by academic

friends. Occasional interruptions involved visits to Detroit Pistons basket-ball games when Tom went to photograph them for the newspaper. (We had developed a shared passion for basketball, especially the Knicks, when we were in New York.)

It was increasingly obvious that we were living our lives on separate tracks. Having given up on his own academic ambitions, Tom was sharply critical not only of my graduate student friends but also of the whole "pompous, self-satisfied, and irrelevant" university community. It didn't help that Tom always berated himself for not being good enough, especially as a photog-rapher. He often complained that if he couldn't be like his idol W. Eugene Smith, who had shot the famous *Minamata Series* (portraying industrial waste poisoning in Japan), what was the point? My efforts to buck up his ego were utterly fruitless and I felt perpetually weighted down by his persistent pessimism. By early 1975, Tom was drinking heavily, usually alone at home in the evenings while I was at the library.

Just as things were coming unstuck, my mother planned to visit us over the summer. With no precedent for divorce in the extended Desai family, I felt there was no option but to take a deep breath and postpone any discus-sion of separation until Ben had come and gone.

Ben arrived in Ann Arbor after a three-week trip across the United States with my sister Swati. As much as I tried to hide it, she was distressed to see the deterioration in my relationship with Tom. In a hushed concerned tone, she told me, "Even though you close the door, I can hear the arguments, and even though he hides the bottles, I can smell the alcohol on his breath." I tried to minimize the situation, but as soon as Ben left for India I told Tom that we needed to "take a break." Initially when I rented a small studio apart-ment near campus, Tom took it calmly, "Okay. Just know if you need money, I'll support you just as you supported me in New York." I was touched by his gesture, but I wanted a real separation so I told him that in addition to my fellowship, I had taken out a student loan to cover living costs. Somehow, that was the fuse that caused Tom to explode in anger, screaming exple-tives and throwing objects. On the day I moved out, he remained totally silent. Then, like a sudden bolt of lightning, he started flinging plants out the windows and tossing furniture through the door, screaming obscenities at everyone in sight. I grabbed my clothes and a few appliances, shook my

head in disbelief, apologized to my friends who had come to help, and left as quickly as I could.

With my marriage off the rails, I buried myself in academic pursuits, taking classes, serving as a teaching fellow for the survey course on Asian art, and studying for my master's of arts (MA) exams. On some nights, loud banging on my door announced Tom's presence, alternatively angry about the separation and pleading to reconcile. After a few months, Tom concluded that he needed to "find himself" by going back to India where he had last felt "meaningful," now with the goal of doing photography. I encouraged him to do so, partly because I couldn't think of any other solution to his downward spiral, and to be honest, partly because this would allow me to concentrate on my exam preparations. Although Tom wanted me to visit him in India, hoping we might "rekindle the fire," I had neither the energy nor the money to contemplate the possibility. I suspect I also lacked the will to work on the relationship. I told Tom that with MA exams behind me, I wanted to proceed directly to doctoral work to complete the academic requirements as soon as feasible and couldn't afford the time.

With my permission, my parents welcomed Tom to spend a month with the family in Ahmedabad. So, imagine my shock when I received a letter from Ben describing what Tom had been saying: "Nanu is just not the same person you remember in Ahmedabad. She has become too Americanized. That is the main reason for our difficulties. She is selfishly pursuing her own work and not our relationship, and now she won't even come to India where we could repair and rejuvenate our marriage."

I was furious: "Too Americanized?" Who the hell was Tom, who had spent a couple of Peace Corps years in India, to pass judgments about my cultural identity? Yes, I did focus heavily on my work, not just because I loved it but also because it allowed me to explore my own cultural background more deeply. And it served as a shield from a husband who had become abusive, drunken, and violent.

I wrote a long-anguished letter to my parents about Tom's accusations and was happy to get their reply: "No matter what you do, dear Nanu, just know that we love you without qualification and we will always stand by you. You are our daughter and you always will be. As for Tom, he is always welcome in our home because he is someone you once loved. So, we will treat him with

dignity and hope you will, too. And there might be a chance, when he returns to America, to see if you can renew your relationship."

It was classic Ben and Papa: a declaration of enduring love for me and a carefully crafted compromise for dealing with a crumbling relationship without dismissing Tom altogether. I took it in the dutiful daughter spirit and when Tom returned, suggested that we try to get together while still living in separate apartments. All the old patterns reappeared within a few weeks and I finally said the inevitable words, "Tom, you are the first person I ever loved, and some part of me still loves you, but I can no longer be your wife." He took it calmly, but I spent the next day curled up on a sofa, crying nonstop for hours, wishing it was otherwise, but knowing it couldn't be.

THE FRACTURE IN OUR relationship was less due to cultural misunderstandings and more because of the differing evolution of our cultural experiences. This was less about conflicts arising out of cultural differences and more about cultural expectations of the other person. Tom expected me to be a certain type of an Indian woman; perhaps it was OK to have an "exotic" spouse with an inherent cultural uniqueness as long as that was not a threat to his professional standing. But he was unable to accept that it was through my Indian identity that I seemed to be assimilating into an American life. I also must admit that I gave myself permission to consider the possibility of having a dual identity, but I didn't accord the same to Tom, to accept a side of him that found "home" or a part of himself in India. In the 1970s we had no understanding that our personal issues and misperceptions were caught up in the power dynamics of the countries of which we were part: Immigrants like myself were expected to come to the United States and learn to assimilate. Americans going abroad were expats; they could, and would, remain Americans no matter where they went. Unfortunately, there were few other examples and experiences to learn from, and neither of us had the emotional maturity or reflective capabilities at the time to help us sort out cross-cultural confusions.

Depressed by late night calls from Tom with suicide threats and under pressure to study for my doctoral exams, I didn't act on my intent for several months. Finally, with the exams behind me, I got the courage and went to the Legal Aid Society to get the forms for a no-fault divorce. At first Tom refused

to sign the papers, but finally he unleashed his mean side, demanding that he keep all the art works we had bought together (including works by leading Gujarati painters and some wonderful stone sculptures by Canadian First Nation artists). I agreed to his demands, although they were outrageous, if he signed the papers, which he finally did.

I had no money and had never been in a court before. So I carefully prepared the papers with the help of a Legal Aid counselor and decided to represent myself in court. I was nervous when I arrived at the courthouse and saw that it was full of clients with their lawyers. The whole courtroom went silent as the elderly judge called out my name and barked, "Where's your lawyer?" I replied quietly, "All the papers are in order. I don't need a lawyer." He perused the papers and announced loudly, "Madame, you are supposed to wait for at least three months after you receive the approval from the other party to your request for divorce. Your waiting period is not over yet. You have to come back at the appropriate time, three weeks from now." I was devastated and humiliated, especially as I felt the knowing glances of lawyers piercing me.

As soon I got home, I called the Legal Aid specialist who told me that I was totally correct: in a no-fault case, the three-month stipulation did not apply. He gave me the specific article in the law and the telephone number of the judge with the warning that judges don't like to be told about their mistakes with the strong possibility that the judge might refuse to change the date. But I called anyway, catching the judge on his lunch break, and to his credit he apologized and agreed to sign the divorce approval right after lunch. When he met me in the courtroom it was empty, and I was sad not to have my triumphant moment witnessed by those who had sneered a few hours earlier.

So, that was it. A relationship that had flowered in India, full of romance and idealism, had come to an end in America. I had just turned twenty-seven, and now I was single. Sad about the end of the marriage, I was happy to reclaim my name: Vishakha Desai. I lost love in Ann Arbor but I found contentment by delving deep into Indian art, also in Ann Arbor.

9

Art Connections

I HAD NOT PLANNED to be an art historian, actually, until I began work-ing at the Cleveland Museum of Art (CMA). After all, I had majored in political science in Mumbai and had intended to work in the field of international relations. However, the move away from my initial academic interest in politics to my new commitment to art history wasn't as incongru-ous as it may seem. The synergy between my two passions, political engage-ment and cultural expressions, first became apparent to me through a special program for fifth grade public school kids from one of the most disadvan-taged neighborhoods in East Cleveland. This was my first assignment at the CMA where I would work with the students for six weeks, three days per week, to introduce them to the museum collection through dance and other creative arts.

I thought I was ready when I met my first group of twenty-five students, mainly Black and almost all of them taller than me. As I welcomed them in the museum lobby, my heart sank: most looked utterly bored and some were even snickering and rolling their eyes. Here I was all up for this big event, well prepared with a complete lesson plan and wearing a special sari, staring at a giant wall of disinterest. Worried about what to do next, I led them to the Asian Art galleries, sat them on the floor, took a big breath, and asked a question to break the ice, "Can you guess where I'm from?"

Absolute silence. Then a tall boy, clearly the wise guy of the group, snickered, "Lady, are you from Mars?" Everybody broke into laughter. "Nice try," I quipped, "not quite that far away." The class fell silent again. Finally a petite girl raised her hand: "You're not American. You're a foreigner, right?" "You're right," I said brightly, "I'm an Indian." Hands shot up. "What kind of Indian? Are you Navajo or Apache?" I answered, "Not quite. I come from the country called India, halfway across the world from here." The little girl asked, "If you're a real Indian, why are these other people called Indians too?" "It sure beats me," I answered jokingly and then reminded them of the original mistake made by Christopher Columbus. One thoughtful fellow spoke up, "That's really dumb. After all those years, why are we still making the same mistake? Why don't we come up with a new name?" "Now you're thinking. That's a really good point," I smiled. (The term *Native American* was not yet in popular use.)

None of this was in my lesson plan. But I said to myself, the ice has broken, now's the time to take this to another level. I gathered my students around the magnificent eleventh-century Chola bronze sculpture of Shiva Nataraja (the one that had caught my eye when I first visited the museum). "So," I asked hopefully, "does this sculpture raise questions for you?"

This time there was no holding back. "Why does this dude have so many arms?" "Does each arm do a different thing?" "Is this all about magic tricks?" "Is it sort of a friendly monster?" "My dad has a Swiss Army knife—you can pull out all of the knives and scissors and stuff—it sort of looks like this guy."

OK, Vishakha, I said to myself, Keep it moving, no lectures. "You're right on target. Now we're going to bring the sculpture alive. Watch me. Then you can try it too." I took the pose of Shiva—head still, legs in a controlled bend, left arm in a fluid posture, right arm facing out, expressing *abhaya mudra* (fear not). I remembered the famous phrase from Ananda Coomaraswamy in his important essay on the Cosmic Dancer: "perpetual movement, perpetually poised." I held the position for a minute or so, the kids watching in total silence. Then the wise guy couldn't hold back: "Knock, knock . . . You still there?" The students laughed and so did I.

For the next half hour, the students eagerly tried to hold the Shiva pose, often falling and sometimes almost succeeding, but always serious and

remarkably persistent. "Can you feel it?" I asked. "Like a track runner ready to explode from behind the start lines. Completely still, but you can sense the motion. That's what an Indian dancer can do and it's what the Indian sculptor was doing a thousand years ago." I could feel at that moment that they were with me in mind and body.

Over the next six weeks, we learned about dance gestures and the iconography of Indian sculpture, explored pathways into Chinese landscape paintings, and studied the intended imperfections of Japanese ceramics. The students learned by moving their bodies, writing poetry, experimenting with ink, reading short texts, and discussing the works in the galleries. At the end of six weeks, the students surprised me with a performance in front of the Shiva Nataraja and a big poster describing what they had learned about India.

As my students learned during their museum visits about parts of Asia that they had never known before, they also taught me an important lesson. By example, they illustrated the communicative power of art: its capacity to be of a particular time and place and to transcend the geographic and historical distance at the same time. I had become interested in political science because of the Vietnam War and believed in the necessity of cultural understanding as the basis for avoiding political conflicts. Through my students I realized that museums could be important sites for cultural understanding among diverse groups. By teaching the fifth graders, I learned to go beyond the sheer beauty of art works and become committed to the power of art to engender engagement with unfamiliar forms and ideas. In short, I discovered the potential of museums as institutions for connections and social change, an important part of museum ethos in the United States in the 1970s.

In the current context of social justice movements and protests against museums and other institutions of power, I realize that the efforts of art museums to become more welcoming to less privileged parts of the society were well meaning but perhaps naïve. In response to the social upheavals of the late 1960s and early 1970s, programs such as the one I taught in were born out of an earnest desire to engage with diverse populations but without questioning the power of the institution. It was more like saying, "We have the goods but we are happy to include you in their enjoyment." A powerful statement by the powers that be but not questioning the power itself. As a twenty-one-year-old in my first-ever job, I obviously didn't have any inkling

of the inner dynamics of museums. I was enthralled with the possibility of using museums as civic institutions of change. This realization became an operating principle for my professional life, including my decision to pursue an advanced degree in art history.

Throughout my graduate studies at the University of Michigan in Ann Arbor, my museum experience continued to serve me well. In fact my first job, as a teaching assistant to Rudolf Arnheim, a pioneer in the psychology of art and a distinguished professor, was entirely due to my work as a museum educator. If Rudolf Arnheim helped me better understand the psychological dimensions of seeing a work of art, it was Walter Spink, a renowned scholar of Indian art, who taught me to focus on the specificities of time and place in understanding works of art. With a small goatee, thick black-rimmed glasses, thinning hair, and a slightly stooped gait, Walter looked like the stereotypical absent-minded professor with an easy banter. His passion was Ajanta, the fifteen-hundred-year-old Buddhist cave temple complex in south central India, the same site that had left an indelible impression on me as a twelve-year-old on a school trip to South India. Now by some divine intervention I had made the acquaintance of the Ajanta guru, Professor Walter Spink.

Hidden in a deep valley overgrown by forest and vines, Ajanta had remained invisible for more than a thousand years. It was finally "discovered" in the nineteenth century by a British officer on a hunting expedition and was now considered one of the world's greatest architectural monuments. With meticulous scholarship—checking chisel marks on unfinished doorways and noting the slight changes in painting styles from one cave to another—Walter challenged the prevalent view that the main (Mahayana) phase of construction took some two hundred years. He argued successfully that Ajanta was carved quickly, within a short period of thirty-five years in the late fifth century, a singular contribution to the field of Indian art.

In his graduate seminar on Ajanta, Walter wanted us to seek answers to the basic questions about art and architecture: When was it made? How was it made? By whom? For whom? How did you reach such conclusions? No question was too small, no detail to be overlooked in the pursuit of answers. Each student selected one of the Ajanta caves to study for the semester—I was delighted to get Cave 19, an elegant *chaitya* (worship hall), the very cave that inspired my schoolgirl poem. We examined the photos of our caves during

each seminar as Walter admonished us, "Think of yourself as art detectives. Find the clues. Use the magnifying glass. Look where you least expect to find something. Jump on anomalies. Question existing scholarship."

At first I found Walter's approach frustrating and a bit too nitpicking, but over time I realized that the details were crucial to understanding art. After hours of peering at the faces, robes, hands, and feet of the Buddhas, and carefully studying the inscriptions about King Harishena, the patron of the site, I was transported to another time and place, experiencing India's glory in a bygone era. Slowly but surely I was adding a layered nuance to my earlier art experiences: in our Ahmedabad garden, in the CMA galleries, in the Brooklyn Museum's education department, and now in the art library in Ann Arbor. By the late 1970s, I felt that deep understanding of art and its potential for cross-cultural connections were at the core of my existence.

———

IRONICALLY, MY ALL-ENCOMPASSING engagement with Indian art could not have happened in India. My high school teachers did their best to dissuade me from "wasting" my life on the arts and humanities. My Elphinstone College professor in Mumbai dismissed any political history that was not British or European. In the 1970s, if you really cared about Indian art history, you were best advised to study abroad. Even in contemporary India, the arts and humanities are waging a losing battle against family preferences and government budgets that prioritize technical job skills and salaries. In the last few years, a discernable movement has finally emerged toward giving liberal arts education its rightful due. A few strong art history departments now exist in India, but hardly enough, and these programs are usually overlooked by the most accomplished students.

———

UNLIKE MANY ART HISTORY scholars who preferred to train their students primarily for academic careers, Walter respected my desire to go back to museum work, but he argued that a doctorate would give me more options down the road. Naturally, Walter urged me to specialize in his own arena—early Indian art, something related to his beloved Ajanta. I agreed with his logic to complete the doctorate, but chose an emphasis on Indian

painting, a much later period in Indian art history. I had fallen in love with the small, vibrant court paintings from later Indian history through a seminar with Dr. Saryu Doshi, a visiting professor in my second year of graduate school.

Saryu's class on Indian painting from the Mughal and Rajput courts from the fifteenth through the nineteenth century opened my eyes to the rich and complex interaction among the Muslim emperors of Delhi, Agra, and Lahore and the Hindu court rulers in Rajasthan, Madhya Pradesh, and Punjab Hills. Saryu's teaching followed the prevailing taxonomic tradition of the field—dating and provenance of paintings based on their styles and chronological sequences: How to date the earliest known Rajput illustrations of the *Chaurpancasika—Fifty Verses of a Love Thief* (written by twelfth-century Kashmiri poet Bilhana and almost as racy as *Lady Chatterley's Lover*)? How to distinguish the early seventeenth-century paintings from the court of Mewar versus Malwa? While I found some of these questions to be dry and even superfluous, the sheer beauty of the works was intoxicating: the complex battle scenes from the late sixteenth-century Mughal *Akbarnama*, the brilliant abstractions of eighteenth-century *Ragamala* illustrations from the Rajasthani court of Bundi, and illustrated love poems from the small court of Basholi. I loved the fact that many of the paintings were related to historical, literary, and religious texts and others suggested complex cultural and political interactions among different rulers.

In the summer of 1977, I finished my doctoral exams and embarked on my doctoral research focusing on the earliest illustrations of a great literary manuscript, the Rasikapriya (Connoisseur's Delights). I had received a fellowship for dissertation research and was scheduled to go to India for a year when I received a call from my friend and Brooklyn Museum colleague Linda Sweet who now headed the education department at the Museum of Fine Arts (MFA), Boston. She asked me to join her team as the head of exhibitions resources and academic programs. At Walter's wise suggestion, I accepted Linda's offer on the condition that I would get a four-month sabbatical (on my doctoral fellowship) to go back to India to work on my dissertation research.

The 1978 India trip was my first long sojourn to India since 1970 (excepting a brief trip in 1974). I had left India as a young married woman and

I was now returning as a professional trained in America, older and divorced. My fieldwork took me to a wide variety of sites in northern India, producing a series of profound and unexpected encounters with art and architecture. As a newly single woman past the conventionally desired marriageable age, my social interactions with friends and strangers in India, on the other hand, were awkward.

My primary mission was to visit Rajasthan in northwest India—that magical land of deserts and mountains, ancient kingdoms and sandstone palaces—in search of documents in royal libraries and museums that could shed light on the origins of Rasikapriya paintings. No teacher or scholarly work really prepared me for the daily challenges of fieldwork, operating alone in an unfamiliar part of India. Like most doctoral students doing fieldwork in a strange land, I felt like a solo actor in an improvisational theater—reacting instinctively to changing circumstances, switching roles at a moment's notice, watching every word I said, and all the while watching the time, never forgetting that I needed a successful result in a short time. I was trying to complete the fieldwork in four months, a task that normally took a whole year. As an Indian woman now working in an American museum, quite rare at the time, I had additional complications. The language I spoke and the clothes I wore for my research work mattered because they signified how Indian or American I would be perceived.

In order to get my work done, I learned code-switching, to go back and forth between two personae: a Gujarati girl who spoke "authentic Hindi" (with decent pronunciation) to be understood by the Rajasthani staff at museums and libraries, and an Indian woman who was a professional in an American museum, speaking Americanized English, to be respected by the heads of the institutions. I learned that it was important to wear Indian saris for significant meetings in both Rajasthan and Delhi, making me look like an older, mature Indian professional. On the other hand, when I needed to persuade curators and bureaucrats to show their paintings or documents, I emphasized my American credentials; I worked in a major American museum and had limited leave period to get my research done. I was happy to have endless cups of tea, but I didn't have infinite amounts of time. Code-switching, as my graduate student Manasa described it many years later, had now become part of my life.

Occasionally, I had to resort to multipronged approaches, all at the same time. One such incident was my research trip to the Udaipur court library. Armed with a nice letter from the Maharana of Udaipur, I arrived bright and early on a hot sunny day only to be told that opening the library vault now required three people with special keys because of a recent court case regarding a theft in the library. "So," I said, trying to conceal my exasperation, "let's get the three officials together." "Oh, that cannot be done," the guard replied curtly, "one of them is sick and another has gone to his nephew's wedding." After listening patiently, I spoke in clear-cut Hindi, "Bhai, I am here for only a short while. I am on leave from my job in a big museum in America. What can we do to get the *chaukidars* (watchmen) here? Can you tell me where they live? Is it possible to get the principal secretary to the Maharana here to sign off on the procedure so you don't get in trouble?" To make a long story short, things suddenly began to happen, perhaps because of my tone and my invoking a higher official. Within hours I was in a rickety three-wheeled auto rickshaw, bringing back the sick man (he didn't seem that sick to me), while the official was bringing the third guy from the wedding. *Click-click-click. . .* the vault was opened and I was able to photograph and study the fabulous set of Rasikapriya paintings dating from the 1620s, a crucial part of my dissertation.

This "three keys" episode was an important revelation: I realized that I could both own and utilize the two parts of me—the American part and the Indian part—while still feeling that the two parts were separate most of the time. Only much later did I sense complex psychological patterns emerging inside me in the place where the two parts were interacting—sometimes fusing in creative ways, sometimes feuding in difficult circumstances, sometimes offering sparkling insights, and sometimes leaving me confused and powerless. Later still, I recognized that I was probing into the inner realm of the millions of us with hyphenated identities, a place where sometimes, just sometimes, an inner predicament can yield an outer sense of clarity.

The dissertation trip also allowed me, a budding Indian art professional, to revisit familiar sites with new eyes, sparking unalloyed joy combined with unexpected dissonance. I first noticed this during my visit to the Taj Mahal. I had been duly impressed when I first saw the great monument on one of my high school trips, but in my new incarnation as an art historian, I fully

expected to be disappointed. Not to be swayed by the global fame of a tourist destination, I was ready to dismiss the Taj Mahal as "too perfect" a monument. So, mirroring the heavy clouds and drizzling rain in monsoon season, I was feeling grumpy and a bit snobby when I arrived at the outer gate of the Taj. As I approached the outer gate, I was happy about one thing: the weather had left the site deserted and I could take a quick look without being distracted by beggars, hawkers, and camera-clicking tourists.

As I entered the gate, the rain had subsided to a soft mist; I fumbled with my umbrella before casting my eyes on the Taj Mahal. "Oh my God!" There it was—the Taj Mahal in quiet splendor—gleaming white marble against a grey sky, nary a shadow on its dome and graceful towers, framed by two red sandstone buildings on each side, rows of tapered green chinar trees gracing the elegant water-fountain path. "It's just perfect," I said to myself. "Perfect proportions, perfect marble, and perfect inlay . . . just plain perfect." Not a very thoughtful or enlightened response for a budding scholar, but my feelings of awe overpowered all intellectual ruminations. The Taj Mahal epiphany exposed a basic paradox in my experience with art history: Is it possible to be a *rasika* (true lover of art) and an objective scholar? Can the two roles complement one another? Or does each side tend to obstruct or even dismiss the other?

This conundrum intensified with my visit to Varanasi, one of the oldest living cities in the world and one of the holiest sites for Hindus. My goal was to visit Bharat Kala Bhavan, a distinguished museum at the sprawling and somewhat dilapidated Banaras Hindu University (founded in the early twentieth century as an alternative to the British universities prevalent at the time), and to meet the great literary scholar Professor Vishwanath Prasad Mishra, who had published the definitive study of the Rasikapriya in Hindi.

Cramped by piles of books and articles, Professor Mishra's office transported me to the scholarly world of pre-British India, not unlike my mother's family home in Surat. As I entered, the elderly professor with thinning white hair and thick dark glasses slowly looked up from his *gaddi* (a small mattress on the floor with big white cushions) and invited me to sit next to him. Knowing that I was a relative newcomer to the study of the subject that he had spent decades perusing, he came right to the point, "I understand that you are studying the Rasikapriya. Have you ever recited the text? The

beauty of this wonderful verse poem is in its amazing alliterations. It's one of the earliest poems written in Braj, a vernacular that emerged from Sanskrit in northern India and kept the richness of the classical language. You must read it aloud to feel its literary power."

Professor Mishra slowly lifted himself from his *gaddi*, limped to an antique wooden and glass cabinet, and reverently extracted a hand-sewn manuscript. "It is right here," he said as he sat down, "Chapter Four. It's about the visible and the invisible visions of lovers. I'm sure you know the verse describing the hidden love of the *nayika* [heroine] for the *nayaka* [the hero who symbolized Krishna]."

Oh dear friend!
You gave me an oath and turned my ears to Krishna's sweet name,
I know not from where he came and found a place in my eyes,
I left all shame and allowed my eyes to meet my mind [where he stayed],
What will I do and where will I go, now that he has found a home in my
heart?

I was stunned not just by his musical recitation but also by the revelation that the poet had intended the text to be read aloud. Professor Mishra had followed the manuscript meticulously, giving emphasis to special vertical marks above specific words so that the verse emerged with a singing power, at once hypnotic and profoundly visual. I couldn't believe that I had never once considered the oral impact of the text and its relationship to the visual image. Professor Mishra was a scholar of the "old school" who had devoted his life to seeking the *rasa* (aesthetic essence) in the text, making a powerful point to a slightly smug "new school" art historian. I realized that the narrow scholarly focus of art historical pursuits had drowned out the quest for understanding the real meaning and power of the work in a fuller cultural context. I was studying Indian art, but in a two-dimensional way; Professor Mishra showed me a third dimension.

That evening, my inner tensions deepened further when I met Anand Krishna, a distinguished scholar of Indian art and a former director of Bharat Kala Bhavan, the university museum I had visited earlier. Whether it was serendipity or perhaps a message from Professor Mishra, Anandji

spoke with polite firmness, "You need to go to Vishwanath Temple, not because of your interest in Indian art history but more because you come from a good Hindu family. I know that your mother is a good Vaishnav and a follower of Shri Nathji. Although Vishwanath Temple is dedicated to Shiva, it is one of the most ancient living sites in India, and you need to go there to pay your respects."

The next day, I walked the narrow streets of the ancient city of Varanasi, pushing my way against the throngs of pilgrims seeking spiritual blessings and mourners carrying deceased loved ones for cremations on the banks of the sacred Ganges River, along with young boys playing cricket and cows and dogs meandering through the narrow streets. I couldn't escape the question "who am I?" While I was nominally a Hindu, I hadn't given much thought to the religion since my childhood days. I made my way to Vishwanath Temple with mixed emotions.

Anandji had made special arrangements—I would visit the temple's inner sanctum for the evening *aarti*—prayers that involve the lighting of lamps and garlanding the *lingam* (phallic symbol representing Shiva), thus taking *darshan* (having direct experience) of the deity. When I first saw the temple, the art historian in me immediately deemed it an "unimportant monument." After all, it was no more than three hundred years old, quite young by Indian art historical standards. Renovated frequently, it had no distinguishing architectural features. The "expert" taxonomy was finished: The temple was "located" in time and style. What more was needed? With a jolt, I remembered Anandji's admonition, "You will be there as an Indian, almost a pilgrim, not to study the temple's iconography, but to experience its magnetic power." Leaving the blinding fluorescent lights of the outer courtyard, I was engulfed in darkness as I entered the inner sanctum illuminated only by oil lamps. As per Anandji's instruction, I was seated at the threshold of the inner sanctum right next to the head priest, which was highly unusual for a visitor and even rarer for a woman.

My quiet reflective mood was then shattered by loud moaning sounds coming from behind me. I turned slightly and saw several men blowing on conch shells—calling the throng into readiness for worship. Slowly the deep male voices began rhythmic Vedic chants, the sounds rising and falling, reverberating off the thick stone walls. As the chants subsided, the room was filled

with the tinkling of small handheld brass bells against the larger booming sound of ceiling brass bells. This was followed by the deep sounds of Vedic chants by a larger group of men who now gathered all around the inner sanctum with the commencing of the *aarti*, the traditional ritual of lamp lighting to see the sacred image and be seen by the god. Together, the sounds were so elemental and the flickering light of the lamps so magical that they literally went through my skin into my belly, piercing my heart. As tears rolled down my cheeks, I could hear soft sobbing from others around me.

As I departed the temple and the ecstasy subsided, I was left with two profound feelings. The first was a sense of loss—loss of the role of ritual in my life and loss of the comfort of a community with shared beliefs and values. Notwithstanding her extreme devotionals, Ba, my maternal grandmother, had represented something special about India, something that I had observed but never internalized. For the first time since leaving India almost a decade earlier, I profoundly felt the loss of belonging—of being part of something larger than myself, of being part of a community where I didn't always stand out and where I didn't always have to explain who I was or where I came from.

The second feeling was doubt—doubt about how I was approaching my art history profession, seeking to be an objective observer of forms without much attention to their usage. A chilling analogy came to mind: Was my professional side starting to mimic the old scientists who collected butterflies, killing them and mounting them with pins through their hearts rather than experiencing them as the living, flying, beautiful creatures that they were? I didn't realize at the time that such questions of the "living and divine" energy of nature versus the "objective scientific inquiry" of the observable world were at the heart of the early Enlightenment debates at the Royal Society in England. Unlike my Enlightenment predecessors, I didn't seek to resolve my doubts: they would linger for a lifetime, motivating me to incorporate them into my chosen field and myself.

IN BETWEEN MY STUDY trips to different parts of India, I made sure to be at home in Ahmedabad as much to share my insights as to get the emotional grounding I so sorely needed. I loved talking with Ben and Papa about my experiences. Ben was happy that I was reconnecting with the spiritual

dimensions of India, and Papa was thrilled that I was digging deeper into the country's history by doing primary research through old archives. Ben also worried about my solo travels on Indian trains and encouraged my youngest brother Saptarshi to join me. My favorite times with him were when he would jokingly point out the garbage dumps at archaeological sites and inquire about their dates, "You know, they are as important as the old stuff you are studying!" When I left home at age seventeen, all my brothers were young boys. Ten years later, for the first time, I had the joy of getting to know them as grown young men capable of "protecting" me on Indian trains while pulling my leg. A newly single woman, I cherished the full embrace and warmth of my parents and siblings, even while some relatives and family friends expressed their dismay in hushed tones at the breakup of my marriage and doubts about my future as a divorced woman.

After these emotionally comforting and intellectually enriching times in India, I landed at Boston's Logan Airport on a cold fall evening with no one to meet me, just a row of taxi drivers hoping for a fare and a tip. I couldn't help but recall when my entire family was at the airport waving goodbye to me on my initial AFS trip. I felt truly alone. How ironic: When I returned to India after a year in Santa Barbara, all I wanted was the privacy of my own room. Now coming back to Boston, I dreaded opening the door to my dark Beacon Street apartment knowing there was no one to join me for a meal or to listen to my stories. All I had was work, and that's what I would throw myself into.

I loved my work but I was now aware of its institutional hierarchies. In American art museums in the seventies and eighties, the director was king, setting the goals and finding the gold, and the curators were princes and princesses, determining the exhibitions, assembling the art objects, and determining new acquisitions to the permanent collection. We educators were the more lowly heralds, developing a narrative understandable to the public. I saw museum education as a noble pursuit, but I was acutely aware that to make a systemic difference, one had to have curatorial authority. I also longed to work directly with the great painting collection at the museum to pursue my scholarly interests.

It so happened that the MFA was planning a major renovation of its Asian wing and had been without a curator of Indian art for a decade. Jan Fontein,

the director of the museum, asked me join the Asiatic art department as the keeper of Indian, Islamic, and Southeast Asian art, while continuing my work in the education department. Now I had the opportunity to work with the wonderful collection of Indian art assembled by the legendary Ananda Coomaraswamy, with the responsibility for reinstalling the Indian, Islamic, and Southeast Asian collections as part of the renovation of the MFA's Asian art wing. Stunned and flattered, I naively accepted his offer on the spot, thus losing the chance to negotiate for a higher salary and appropriate title. I was gleefully doing two jobs for the price of one, so busy that I had zero time to fret about inner anxieties.

By the early 1980s, I was moving full speed ahead as a curator, an educator, and an academic, working on the reinstallation of "my" galleries, finishing my dissertation, and teaching a course in Asian art at Boston University. For the public opening celebrations, I arranged a special Hindu ritual (*puja*) reminiscent of my Varanasi temple experience, complete with chants and bells echoing through the museum as if bringing "my sculptures" into live worship. Ben and Papa came for the occasion and attended my lecture on Buddhist connections in Asian art. Happily, I told my parents that I would soon finish my doctoral thesis and we laughed when Papa asked, "Will I have to call you Dr. Nanu from now on?"

With the galleries reinstalled and my dissertation completed, my next task was to organize a major exhibition, *Life at Court: Art for India's Rulers, 16th–19th Centuries*, as part of the nationwide Festival of India supported by both the Indian and U.S. governments in 1985. The exhibition was designed to get away from the traditional separation of Mughal and Rajput paintings in secular and religious terms and explore the political and cultural interactions among the Muslim and Hindu rulers prior to the arrival of the British. In addition to the small exquisite paintings barely the dimensions of a letter-sized piece of paper, the exhibition also included some three-dimensional objects—an inlaid *huqqa* (water pipe), a jade dagger, a glass bowl, a brocade coverlet—seen in the paintings. The idea was to re-create the opulent court life of premodern India and to remind viewers that the tiny images actually revealed an expansive world.

I worked long hours to research the works to be borrowed from more than twenty public and private collections from around the world, and I was

really excited about the innovative but complex exhibition design developed in collaboration with the talented museum designer Tom Wong. The whole gallery was to be painted charcoal grey with tightly focused light shining on the paintings and objects to illuminate their jewel-like brilliance. The center of the exhibition was a platform with a setup similar to a tent, complete with a rare seventeenth-century floor covering, an eighteenth-century bolster, and several mannequins in royal clothing surrounded by a rare enameled *huqqa* and several other inlaid objects. All paintings were to be shown through openings cut to exact size in plywood panels to hide the mishmash of individual frames from diverse collections and to suggest that they were pages from larger manuscripts or albums. Indian paintings had never been displayed like that before. For the display system to work, every single picture required exact measurements to fit in its prepared place and had to arrive far enough in advance to allow us time to install the large panels and create a seamless whole.

Everything hinged on rare paintings and objects from India, to be coordinated by the National Museum in New Delhi. With a few weeks to go, I had received all the loans from American and European collections but nothing from India. I began making panicked nightly calls to colleagues at the National Museum to catch them during their morning office hours, but each day I heard the same response, "Don't worry, Dr. Desai, the shipment is on its way." Finally, four days before the exhibit's opening, two couriers arrived with the shipment, but it was missing four paintings and two important objects! The senior courier from Delhi delivered the bad news, "Madam, the expert committee called at the last minute and decided those six works were national treasures and could not be sent abroad."

Furious about this last-minute change that I was not informed of, I called the director of the National Museum, Dr. Laxmi Sihare, known for his gruff behavior and short temper but also a trusted colleague. Fed up with all the demands associated with loans for the Festival of India, Dr. Sihare barked at me, "What do you expect me to do? We have worked day and night to get the things to all the American museums in a timely fashion. But all we hear about are problems, no gratitude, and no reciprocity. I have been working hard to get important paintings from American museums for a major exhibition to come to India, but do you think I get any respect? All we get as loans are

third- and fourth-rate Western as a reward. You should be grateful that you have gotten as much as you already have."

I tried to keep my cool. How could I placate the irate director and get what I needed? "Dr. Sihare, I understand your frustration and I completely agree with your assessment that such cultural collaborations should have some sense of parity and mutual respect." I then shifted to my Indian mode, "As an Indian, I am deeply grateful for what you have done. We have the same cause—teaching Americans about Indian culture. We have planned an innovative design that would make you proud to present the best of India in the West. I know you are planning to attend our opening party. Is there any way that we could get at least two of the six works?" Perhaps a shameless ploy, but it worked. Two days later, on the morning before the opening reception, Dr. Sihare showed up at the MFA with two paintings in a small suitcase.

The opening reception was a grand affair. I was happy not to be the only one wearing a sari at an opening for the first time. The members of the Indian advisory committee, formed to train museum volunteers and develop related community programs, had shown up to the celebration in richly embroidered saris and beautifully tailored *sherwanis*. This was long before such community alliances became common features of "outreach efforts" at major museums; perhaps for the first time, members of the Indian community felt that they had a role to play in a prestigious cultural institution. Meera Bajpai, the wife of the Indian ambassador to the United States, was our guest of honor. She expressed her enthusiasm in a toast, "The exhibition is beautiful and re-creates the splendor of premodern India. The presence of so many Indians tonight also reminds us that India is now part of America. And through your programming, you make it vividly apparent that Indian culture is vibrant and living." It felt good: Different parts of my professional self—a curator, an art historian, and an educator—had coalesced in my museum life. Deep engagement with Indian art had provided an anchor to my American life, creating a deeper sense of my Indian identity as I navigated a new life without an American husband.

In the early days of Indian immigration in the 1970s and 1980s, I had become a sort of informant on Indian culture for a primarily American audience. With *Life at Court* and related programs, I felt that I had expanded the field of "cultural informants." A member of the Indian advisory committee

remarked at the opening of the exhibition, "We knew the museum had a good Indian collection, but we never thought we were welcome here. We satisfy our longing for India and things Indian through community functions and family gatherings, far away from our professional life where we must learn to be like Americans. You are fortunate to have your Indian identity as part of your professional life and to serve as an intermediary between our two worlds. Now you have opened the door of a major institution for us to feel proud of our Indian heritage and share it with our American friends."

10

Between Being and Becoming

B Y THE MID-1980S, my professional identity as an Indian scholar and an educator was well established. All the activities at the Museum of Fine Arts (MFA), Boston kept me intellectually satisfied. I had good friends and I was always busy with work and social engagements, but they didn't keep away the profound sense of loneliness and confusion about belonging that permeated my downtime.

Knowing that I was going through a rough time, Papa suggested that he and Ben come for a visit. "Besides wanting to see you," he said, "I have another mission. I want to explore the places and people Gandhi was inspired by, right in Boston, and see if that would help rekindle his message in his home country where it is on the verge of extinction." Soon after they arrived, Papa pulled out a list of sites he had assembled, "It's for our study tour to be called 'Gandhi's Boston.'" First on the list were Plymouth Rock and the Plimoth Plantation, the recreated Plymouth Bay Colony: "Freedom from tyranny and freedom of religion," Papa said proudly, "both Gandhian principles." Next was the site of the Boston Tea Party: "No taxation without representation . . . that's why Gandhi went on the Salt March." And then, Old North Church: "One if by land, two if by sea," Papa smiled, "it sounds like the codes we used back in the Independence Movement." And finally, Walden Pond: "Thoreau was a big influence on Gandhi—simple living, respecting nature, and civil disobedience."

It was a joy to see my father invigorated at the sites in Boston even at the height of his disappointment about India. The visits resulted in a series of editorials in his weekly Gujarati column. He wrote in one:

> I wrote once that Gandhi lives in the world. He lives in the civil rights move-
> ment of America, in the experimental protests of Donald Dici in Italy, and
> in the silent protests in Switzerland against the conservative practices of the
> pope. I feel the presence of Gandhi at Walden Pond for different reasons.
> Gandhiji reminded us to keep the windows of our cultural home open while
> keeping our foundation strong. Today we have banished Gandhi from our
> country, but he lives across the world in experiments inspired by him and
> inspirations he took from the world.

Once again, it was my father who provided an alternative to my cultural predicament; the idea of belonging need not be place based. Like ideas, people can also find their footing in multiple settings. I was not yet receptive to such a profound idea.

My confusion around questions of identity was further exacerbated by the desires of my siblings in India to come to America. With a 3 percent growth rate and the employment rate hovering around 2 percent, the Indian economy had hit rock bottom. Frustrated with the corrupt "license Raj"[1] bureaucrats, members of the educated middle class were giving up on India and seeking successful careers in the West, especially in the United States. With the liberalization of the American immigration policy that favored family reunification visas, some 30,000 Indians per year were now coming to settle in America. My siblings were not immune to the prevailing sentiments. When my parents returned to 38 Jawahar Nagar, my younger siblings peppered them with questions about moving to the United States: "How can we get out of India? Do you think that Nanuben could help us get to the United States? We know from our friends that if she gets U.S. citizenship, then we can apply under the 'family reunification' provision of the American immigration laws."

I, too, heard from my younger brothers Abhijit and Saptarshi about their desire to come to America. But the situation posed a huge dilemma for me: On the one hand, I wanted to be helpful to my siblings. Having more of them in the United States would also help alleviate some of my loneliness. But it

would require my renouncing of Indian citizenship in order to become a U.S. citizen.[2] This seemed like a huge cost to pay. How could I give up my Indian passport, my ultimate badge of Indian identity, just when I was questioning my solitary American life? I had been furious when Tom accused me of "being too American," and now my family was asking me to "become American."

Frustrated by my own confusion about belonging and nonbelonging, I was equally skeptical about my siblings leaving their own familiar surroundings and lifestyle. I wrote a long letter to Abhijit and Saptarshi, expressing my concerns based on personal experience: "It's hard to leave the comfort of belonging to a singular culture. My experience tells me that in the best of times you could be part of the two worlds, but at other times you may feel homeless, belonging nowhere. You will no longer have the option or the confidence of belonging solely to one place, something you have been accustomed to your whole life."

In retrospect, while I was surely telling the truth I must admit I was also hoping that they would make the decision for me by staying home and allowing me to keep my Indian citizenship. It's also possible that I wanted them to stay at home to preserve my own remembered feeling of "home" that was full of kids and friends from my childhood. My argument, however, had a major flaw. I didn't take into account the fact that by the 1980s, huge numbers of Indians were settling in America and creating their own communities. If my siblings came, they had the option of becoming part of an Indian community right here in the United States. When I first arrived in the late 1960s and again in 1970, I simply didn't have that choice; there were not enough Indian immigrants in the country at that time to build any sense of a familiar community. I was projecting my early experience onto their possible arrival in the mid1980s, overlooking the fact that America was becoming more "Indianized," which offered more options for planting Indian roots in the new land.

I caved to the entreaties of my family and applied for U.S. citizenship. Although I was ambivalent while filling out the application, the citizenship interview test was so amusing and annoying that I forgot my inner anxieties. The immigration supervisor, assuming that I was barely literate, spoke slowly, disdainfully, and loudly: "THIS IS VERY IMPORTANT. I ASK QUES-TIONS. YOU GIVE SHORT ANSWERS. IF YOU DON'T KNOW THE ANSWER, SAY 'I DON'T KNOW.'"

"Excuse me," I interjected, "I understand your English perfectly without you shouting. I've been in the United States for over a decade, I went to an American high school, did my graduate work at the University of Michigan, and am now working at the Museum of Fine Arts." I could see by her annoyed demeanor that she was going to make me pay for my seemingly haughty behavior. Quietly but sternly she proceeded, "Seeing that you're so prepared, we'll start with the last three questions; be sure to keep your answers short." The interview continued. Q: How many branches are in the federal government? A: Three; executive, legislative, and judicial. Q: What is the Bill of Rights? A: The first ten amendments to the Constitution. Q: How many amendments in all? A: Twenty-six. The first ten plus sixteen more added later.

Of course, I never told her that in addition to memorizing the Immigration Department booklet I had also taken a course in American history and government at Santa Barbara High School. Nonetheless, she had succeeded in making me feel like an outsider.

At the Oath of Citizenship ceremony at Faneuil Hall a few months later, I marveled at how so many immigrants looked utterly joyful. They were genuinely excited by the prospect of becoming full citizens in their adopted country. Most were happily waving American flags and some were even wrapped in the stars and stripes. I couldn't blame them even if I couldn't share their joy. Many of them were escaping economic or political hardships in their home countries and toiling away at menial jobs as undocumented workers in America; these new citizens of America could finally come out of the shadows and declare their rightful presence in their adopted country.

I was decidedly more ambivalent than my fellow new Americans. I realized that unlike many of them, I had a choice. Having been married to an American, I had the much-desired green card and an opportunity to become a naturalized citizen three years after marriage. Now I had given up my Indian passport to help my Indian family and it didn't feel joyous in any way. I didn't yet have the political awareness that Alessandra Foresto, a Peruvian writer, expressed in a poignant essay: "I'm the definition of what it means to be an American. I'm an immigrant with a complicated background and I wish to honor what this country gave me by being a standout citizen and fighting to make this an even greater place than it already is. My American passport doesn't make me any less Peruvian and my Peruvian passport doesn't make

me any less American. I'm both and unique, and that's what this country is all about."[3] I had not yet resolved the implications of taking on a marker of a new citizenship with all of its dimensions: legal, political, and psychological. Legally speaking, I had paid my allegiance to the United States, but psychologically I had not let go of my Indian identity.

In my usual way, I rationalized the decision, convincing myself with a neat set of arguments: "Surrendering my passport is not giving up my Indian-ness. In fact, I'm doing this for a very Indian reason, putting the interests of family ahead of myself." The next argument focused on others' perceptions: "Even if I tried to erase my Indian identity, many Americans would never let me forget it." Looking at my brown skin and Indian eyes, I always get the tell-tale questions, "Where are you *really* from? How come you speak English so well?" (Questions that continue to haunt people of Asian descent even now, occasionally resulting in "go back where you came from.") And there was the practical rationalization: "Traveling will be so much easier with an American passport. Now I can get visas without all the hassle of an Indian passport." The most powerful argument I made to myself was also the most positive one: "I am doing this responsibly. If I get American citizenship, there are responsibilities that go with this act. I will finally get to vote in American elections even though lots of Americans don't do that." The truth is that as a newly single woman in the United States, my sense of emotional attachment was still more aligned with my Indian-ness. I had not yet made the transition from being an Indian in America to becoming an Indian American.

My change of citizenship paved the way for three of my siblings to come to the United States—Anuradha (Anu), Abhijit (Munna), and Saptarshi (Nanak). So by 1984, the Desai clan in America had grown from two to five including me, with only two siblings (Falgun and Chitra) and their families remaining in Ahmedabad. I loved the idea of having my siblings close by, but occasionally the reality of their presence proved to be more irksome. Following in the tradition of the popular Spanish phrase *Mi casa es su casa*, it was expected that newly arrived family members would stay with Swati or me until they found their way in the new country. Having become accustomed to an independent life, it was not always easy to get back to familial responsibilities. To be truthful, I had not yet resolved the inner conflict between the "American me" who prized privacy, and the "Indian me" who always felt

selfish for not doing more for the family. It took me a while longer to recognize that this would be the essential predicament of a bicultural existence; there was no way to resolve the dichotomy, one just had to learn to live with it, and thrive through it.

If my inner life became a bit more muddled with the arrival of my siblings, my external United States–focused life became more active through political participation. In an effort to become a discerning voter, I began to look for ways to get involved with the Democratic Party. Through Indian volunteers that I had brought to the MFA during the Festival of India, I discovered that several were active in the Massachusetts Democratic Party and working to support Governor Michael Dukakis. I began to attend a few gatherings, both to learn about the American political process and to meet more Indians in America. For the first time, I heard some of the fundraising activists and political advisers describing themselves as "Indian Americans" and including themselves among "Asian Americans."

Previously, I had paid scant attention to the Asian American political movements because they seemed to focus solely on East Asians who had been in the United States for a long time. But the Indian Americans in Boston were not deterred by their relative newness in the United States. In fact, they were determined to make their mark and take their rightful places alongside other Americans in the power structure of their adopted country. Talking with them, I had a revelation: Not just an Indian in America, I can be Indian and American at the same time. I started reading about the Asian American movement in the United States and its origins in the civil rights movement of the 1960s. I began to realize that the potential of having a hybrid identity was at the heart of the American experience. For me, the very idea of hybridity opened my eyes to a place where my Indian-ness and my American-ness could coexist and make contributions to both countries, even if in very different ways.

Around this time, Governor Dukakis nominated me to the board of the Massachusetts Humanities Foundation. It was my first experience with a political appointment. Much to my surprise, I thoroughly enjoyed the engagement, which involved going around the state, reviewing proposals from local historical societies and community cultural organizations, and learning about early American history while expanding perspectives about its more contemporary cultural realities.

I will never forget the large gathering hosted by Old Sturbridge Village with academic discussions about pre-Revolutionary America. My eyes wandered out of the conference room windows to the scene outside—a re-created late eighteenth-century life with wagons, blacksmiths, a muffin peddler, and a town crier. It occurred to me that Sturbridge Village represented an immigrant community in a country where the only non-immigrants were Native Americans or American Indians. This thought brought back memories of my first encounter with the African American students at the Cleveland Museum and my subsequent forays into the confusion between "feather" Indians and "dot" Indians.

Just as I was becoming comfortable living with what a social scientist might call my "hybrid-identity-in-perpetual-flux spectrum, in America," along came an offer that would require a wholesale shift back to India. A year after the Festival of India, I was back in Delhi for a conference on Indian paintings and paid a courtesy call to Dr. Laxmi Sihare (my sparring-partner-turned-angel in *Life at Court*). Without any preamble, Dr. Sihare came right to the point, "I know how strongly you feel about the need for more professionalism in Indian museums as *sine qua non* for us to expect full reciprocity with Western museums. Which reminds me, I want you to come to my home tonight. A car will pick you up at your hotel at 6 p.m."

Typical Dr. Sihare. This was an order and I was supposed to follow it even without knowing the purpose of the meeting. I arrived at Dr. Sihare's elegant Lutyens-designed home,[4] a high-ceilinged spacious place filled with masterpieces by Indian modern painters and lined with books about major Western art and artists. After offering me tea and biscuits, he began, "You keep talking about the dismal state of museums in India, but you have to realize that it is up to all of us to change that. Why don't you come back to India and work with me? You know I'm tough, but I'm committed to changing the National Museum and setting an example for the whole country. You're a daughter of freedom fighters, and you have had great training in the United States. I need you and India needs you to come back. I can hire you as deputy director and make sure that you will become the next director of the National Museum after me. You'll never have such a big opportunity to make a difference in our country's cultural future."

Wow! I didn't know what to say. It was an incredible honor to be invited to play a leadership role in India's most prestigious museum. Dr. Sihare knew that I shared his views on the need for massive changes in the museum field.

But I had not expected such a concrete offer right out of the blue. I told him that I was deeply moved by his kind offer and that I would seriously consider it in the weeks ahead. "Please do," he replied, "and just know that I want this to happen and the right answer is 'yes.'"

On the return flight to Boston and for weeks afterwards, I contemplated the Sihare option again and again. In one short moment Dr. Sihare had given me more professional recognition than I had ever experienced at the MFA Asiatic department. Even after receiving my doctorate and organizing a highly acclaimed exhibition, I sensed a pervasive feeling among my male colleagues in the department that women were to be secretaries or research assistants. (There had never been a female curator in the Asiatic department before me.) At that point, I also didn't know how to ask for what I deserved. Like many women at the time, I believed that if you did good work, people would naturally reward you for it. Dr. Sihare had not only acknowledged my scholarship and my professionalism but had even thought about my career path. Professionally speaking, it was a no-brainer: I could make a major difference in a big country by going to one of its most important museums. How could I refuse his offer?

But then my hybrid-identity meter began flickering in the direction of my American self, raising lots of win-lose questions. Could I actually work as a professional in India after having been trained as an American museum professional? I had witnessed firsthand the evident dysfunctionality of Indian museums: many members of the curatorial staff of the National Museum resisted Dr. Sihare's directives and were downright hostile to him. Would I be able to make a dent in that morass of inefficiency?

And there was the question of lifestyle. I had become accustomed to my independence and the diversity of American culture. I loved listening to Miles Davis, Bach, and Beethoven as much as I enjoyed the great Indian vocalist Kishori Amonkar. I was a fan of Mark Morris and Twyla Tharp along with Balasaraswati and Birju Maharaj, legendary Indian dancers. I loved sushi and Thai massaman curry as much as chicken tikka masala. Was I willing to give up all of this? My cosmopolitan lifestyle was simply unimaginable in the relatively isolated India of the late 1980s. I knew that if I accepted the job I would be quickly ensnared by the expectations and conventions of Indian society. And then there was the prudish side of India—the fact that I was a divorcée in my thirties would create major social barriers, to say nothing of the behind-my-back chatter.

In short, I knew I could maintain my Indian identity in America but could my American identity possibly survive in India? Professionally my identity was firmly rooted in my Indian-ness, but psychologically and personally I had to acknowledge that now there was an indelible part of me that was American. I relished what it offered me: life free from highly stratified and socially constraining conventions, a way of thinking and being that allowed for diversity of adventures and experiences, and connections and relationships spanning the globe.

But then another voice would take over: How could I be so selfish to think about my lifestyle and not rise to this challenge that had huge potential to make a difference in the cultural life of India? Wasn't Dr. Sihare right in reminding me that people like my parents had devoted their lives to the making of independent India and that people of my generation also had the obligation to correct independent India's wrongs?

I talked to my father about the offer and my confusion around it. He had just been diagnosed with Parkinson's disease and I was aware that his opinion could be colored by his emotions. I was deeply moved by his reflection: "This is a tough decision to make. It would be wonderful to have you back in India, you could make a huge difference in the Indian museum culture. But I also know that we need people like you who can spread the message of Indian culture not only in America but also across the world. I have seen you in your role at the Boston Museum and I know the contributions you make there. You have a unique perch now. The ultimate decision will be yours to make, and I have no doubt you will make the choice that's right for you." Papa's answer brought tears to my eyes. He didn't once mention his physical condition and, more importantly, he didn't make me feel guilty about not immediately choosing the Indian option.

I realize now that when my American side and my Indian side disagree, my first instinct is to find a compromise and avoid an "either-or paralysis." So I called Dr. Sihare and asked if I could come for a trial year, taking a leave from the MFA to see how it worked. This would allow me to keep my American citizenship until I was sure that it was the right job for me before renouncing it to resume Indian citizenship, which was required for such a position. Dr. Sihare had no sympathy for my dilemma: "Vishakha, I'm not given to grey-area thinking. It's a matter of black and white. Make your choice. If you

decide to come, then I'll know you came from that spirit of Indian national-ism your parents instilled in you. If not, I think it's unfortunate for India and for you, but I'll wish you well." I thought for a moment, took a deep breath, and made my decision: "I'll be honest, Dr. Sihare, this is the toughest deci-sion I have ever faced. I had hoped you might be willing to do it on a trial basis, but I understand your reasoning. Given that it's a matter of making a quick clear-cut decision, I feel that I must keep with my work on India at the Boston Museum." I don't exactly remember his reply, but I do remember his cold voice and his abrupt sign-off.

I was beginning to feel comfortable with being Indian and American at the same time and I was unwilling to let go of that hybrid identity, a quintessen-tially American part of my life. I felt that moving back to India would forcibly scrub away my American-ness, especially back in the 1980s when India was much less worldly than it is today. I was unwilling to pay that price even for the biggest possible prize of my career.

A year later, the complexity of my bicultural identity resurfaced again when I escorted a group of Boston museum patrons and professional colleagues on a trip to experience "Vishakha's India." It was the first time I had brought to India a group of people deeply connected to my American life. They were not just tourists but patrons and volunteers I had taught at the museum, and colleagues with whom I had worked closely for almost a decade. It was one thing to teach them about Indian art in the climate-controlled galleries of the museum, but quite another to have them come face to face with the noisy, dusty, messy realities of India. It was one thing to get them to appreciate the elegant beauty of the stone sculpture of the goddess Durga in a meticulously curated gallery installation, but quite another to see such an image being worshipped in the dark cavernous inner sanctum of a South Indian temple.

Not until we arrived in Ahmedabad did I realize the depth of my personal stake in their experience. Ahmedabad is not a typical tourist destination, but the group wanted to see my hometown and meet my family. Knowing that the city was neither picturesque nor very traveler friendly, I was nervous about having the Boston group visit my scruffy city and especially about hosting a lunch at our idiosyncratic home. I had loved growing up in our ramshackle home, but seeing through my "American eyes," I was worried. What if they needed to use our old-fashioned bathroom facilities? What if they didn't like

all-vegetarian Gujarati food? What if the bus couldn't navigate the narrow streets of Jawahar Nagar? I kept pestering my younger sister Anuradha who was in Ahmedabad at the time, "Are you sure we have enough mineral water? I don't want the group to get sick. What kind of decorations will we have on the outside porch? Is the backyard dusty? Do we have nice tablecloths to cover all the rented tables?" Anu told me that I was like "a nervous mother before her daughter's wedding" and tried to reassure me, "Papa has hosted many foreign dignitaries and I'm sure everything will be fine."

My worst fears were realized when we registered at "Ahmedabad's best hotel." After staying in magnificent palaces in Rajasthan and enjoying five-star facilities on the trip, I was chagrined to encounter the shabby lobby and dingy rooms of the Ahmedabad hotel. Nobody complained but I kept making excuses, "Ahmedabad is a commercial city but not yet ready for the tourist market. It was famous in the old days for elegant monuments and great estates. Even Emperor Akbar came here." What I didn't tell them is that Akbar's son Jahangir called Ahmedabad, *Gardabad* (the city of dust).[5]

My spirits lifted the next day as we went to the Gandhi Ashram where Gandhi created the Satyagraha movement soon after his arrival from South Africa. Peaceful in its simplicity, the ashram on the Sabarmati River with its unassuming housing units and a brilliantly designed museum was practically empty on this sunny morning. As we stood under a shady tree near Gandhi's living quarters, I spoke to the group about the ashram and my father, "I feel like I am a part of the history of this place. It's here that my father came as a young man and argued with Gandhiji about socialist ideals. One of my favorite trips to the Ashram occurred only five years ago, when I had the opportunity to interview my father for a video project. He borrowed a small spinning wheel from the caretaker and started spinning cotton. He made me feel the power of the Gandhian message in those few precious moments. He transported me to his India of those earlier days, an India with a moral conviction and a clear message that was heard around the world. And it all began here in my hometown." As I spoke, I couldn't hold back the tears and I noticed that several in the group had moist eyes as well. Now my embarrassment about Ahmedabad was replaced with a rising sense of pride.

By the time we arrived at 38 Jawahar Nagar for lunch, my American friends couldn't wait to talk to my parents and see the home I had lived in as a child.

Ben, Papa, and Anu had done wonders: our backyard looked lovely, decorated with colorful folk textiles from the family collection and special potted plants bought just for the occasion. My sister-in-law Shruti had worked closely with caterers to produce a delicious Gujarati lunch of vegetable pulao, yogurt curry (the recipe that had been a disaster on my first week in the United States), roasted millet bread, stuffed baby eggplants, cucumber-mung bean salad, and fresh fruit *kulfi* (an Indian form of ice cream). The group loved the food and many asked for seconds.

Papa was in great form as he welcomed the group and talked passionately about his current cause, the persistent famine conditions in the western part of the state: "Staying in five-star hotels with ample amenities, you see one side of India, but it's important for all of us to remember that there are people who have to walk for miles to fetch a semiclean pot of water." Way ahead of his times, Papa highlighted the looming Indian water crisis and connected it to the environmental degradation of the country. My American friends, moved by his words and blown away by the visit, pooled their resources and gave Papa a ten-thousand-dollar check for the foundation dealing with the water crisis. They bowed to both my parents and thanked them for an "unforgettable experience" and "giving us Vishakha as our link to India and to the family's Gandhian values."

My Boston friends gave me an incredible gift in return. They helped my two worlds come together in a deep, personal way that I couldn't possibly have imagined when I first went to Santa Barbara as a young student. They also articulated my raison d'etre: to be a bridge between India and the United States as an insider and an outsider, feeling deeply Indian but also unabashedly changed by the experience in my adopted country.

When I think about my hyphenated existence, I am struck by how my outside world and my inside world are constantly in flux. Sometimes when I'm in India, my American side temporarily disappears; and often when I'm in America I can forget that I'm Indian. Almost never do I feel that I'm exactly in the middle, both Indian and American at the same time. Instead, it's much more like a spectrum of colors or keys on a piano, a wide array of choices to be made in response to a specific situation. As Susan Faludi wrote in her recent memoir *In the Darkroom*, I have come to realize that identity is neither fixed nor neutral. Rather, it's something we take on or shed, depending on

the circumstances. But it is neither completely under our control nor clear-cut.[6] The late Bharati Mukherjee once described the immigrant experience as "old parts that slide against the masks of newer selves. The fluidity of sliding and the variability of masks never go away."[7] When things are on a roll, it's great to have such a wide band of possibilities. When things are dark and difficult, I can find myself in a quandary with no compass to guide me.

———————

BY EARLY 1989, I had learned to be comfortable in my hyphenated, hybrid identity, but my professional life had come to a fork in the road. I kept busy at the MFA, but the once-bright petals seemed to be withering on my museum rose. The world of art museums, to which I was initially attracted as places of wonderment and social change, was losing its lure in an increasingly commercialized age. The closer I examined museum establishments, the more I felt that directors and curators were more focused on rich patrons, expensive acquisitions, and block-buster special exhibitions than on educating and engaging all parts of the society. I felt like I, too, had become part of the soulless system.

As usual, I found it easier to seek alternative solutions than to confront issues head-on. I was particularly happy to teach at the University of Massachusetts–Boston (UMass) as it allowed me to engage with students of diverse cultural backgrounds. Many were children of immigrant parents; often the first in their families to go to college, and with the exception of a few Asian American students, most had no exposure to Asian cultures. It was exciting to introduce them to the wonders of the Taj Mahal and the majesty of China's Forbidden City in the darkened classroom with beautiful Kodachrome slides. This teaching time was a pleasant reminder of my experience with East Cleveland public school kids at the Cleveland Museum.

I also taught a seminar on "Art Museums as Institutions of Culture." The seminar allowed me to use my experience of museums as well as engage with important critiques of the institution that were prevalent at the time. My teaching had an edgy quality as I questioned the balance between the possession of important objects and the interpretation of the art works for the larger audience.

I had initially fallen in love with the idea of an art museum as a powerful social tool for connecting diverse groups of people through art. I had experienced firsthand what museums could do, and I was frustrated that they no

longer attempted to fulfill their potential as I saw it. Through the seminar, it was almost like discovering that even gods have clay feet.

My academic role allowed me to release some deeply felt conscience issues arising from my museum role. Earlier in my curatorial career, I had loved the acquisition process of scouring the commercial galleries and auction houses of New York and London to chase after that "special work" that would be just ideal for the museum's collection. As a daughter of a compulsive collector, this part of the job suited me well, justifying my own passion for works of art without feeling guilty for spending huge sums of money.

The perfect example of a "great buy" was a two-foot-tall exquisite bronze sculpture of the goddess Uma from the great Cambodian temple site of Angkor, dating from the late tenth century. With a gentle smile, delicate eyes, and a softly striated skirt contrasting with her smooth naked upper body, the Khmer Uma was a perfect image of an incredible humanity. By all accounts, this was one of the finest Cambodian bronze sculptures to come on the market in a long time. With the enthusiastic approval of the director and the acquisition committee of the trustees, the Khmer Uma was purchased by the museum and I had the pleasure of installing the elegant sculpture in our gallery of Southeast Asian art.

I couldn't wait to show off my latest "acquisition" to Ben and Papa when they arrived in Boston for one of their periodic stays. The night before their visit to the museum, I talked excitedly about the Khmer Uma, which triggered a question from Papa about the atrocities committed by the Khmer Rouge: "Isn't there a film about it? I would like to see it." We immediately went out and rented *The Killing Fields*. Not surprisingly, Ben and Papa were deeply moved by the horrors committed in the name of political ideology.

Papa was the first one to connect the human atrocities seen in the film and the work of art we were to see the next day. He observed that we didn't see anything about Angkor art in the film. "What happened to the great monuments and works of art associated with them during this period?" Papa's question made me a little uneasy. I told him about the stories of the Khmer Rouge military as well as Thai soldiers and dealers hacking stone sculptures off the walls and stealing smaller objects and selling them in the art market. The dealer had assured me that the "Boston Uma" had been in a private European collection for some time, but one had to acknowledge that it, too, could have been easily pillaged from a temple during the time of war.

By the time we went to the museum galleries to see the Khmer Uma the next day, I was no longer in the same triumphant mood as when we had acquired the piece for the museum. Upon seeing the diminutive piece, Papa commented, "What a beautiful piece from a land so torn apart today." Ben, true to form, asked, "How much did it cost?" Museum policy stipulated non-disclosure of the actual amount, but I did give her the "six-figure number" as a range. She stared at me astonished, "That's a lot of money! Just imagine how many hungry Khmer children you could feed with that money!"

The Khmer Uma episode felt like a battle cry inside of me. My lifelong commitment to art objects as windows into other times and cultures for the benefit of a broad range of audiences was now tarnished by questions of ownership and ethics. Over time, the tension between the potential of art to connect across cultures and its role as the symbol of elite powers and the questionable processes by which objects were collected would become a rallying force for the whole museum field. By late 1989, it had caused me enough anguish to contemplate a change in my professional life.

I began to think about a new possibility: shifting to the academic world full-time while keeping my affiliation with the museum as a guest curator with a focus on special exhibitions. Great idea, I thought: Professor Desai could explore Indian art for students, while Curator Desai could remain connected to the museum community through exhibitions but avoid the thorny issues of acquisition and ongoing operations. When I discussed the possibility with the department chair and the dean of arts and sciences at UMass, they not only endorsed the idea but also enthusiastically agreed to create a new tenured position for me. I was pleased that the museum director also agreed, as I was in the middle of organizing a major exhibition of Indian temple sculptures for the museum. I was energized by the possibility of starting an academic life without losing my museum affiliation.

I was beginning to realize that living between worlds, personal or professional, was where I felt comfortable.

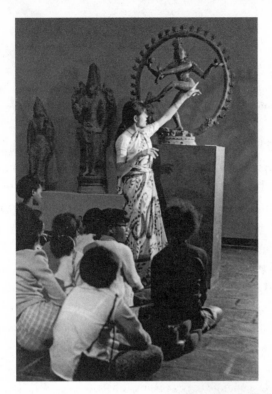

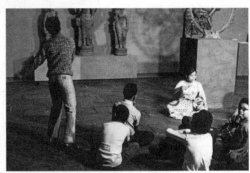

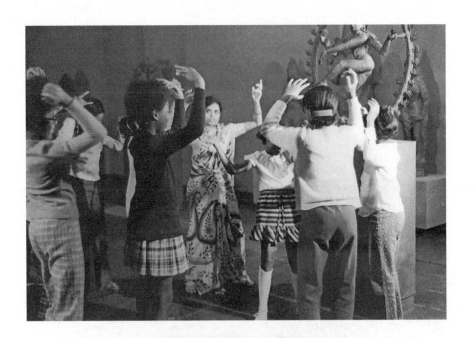

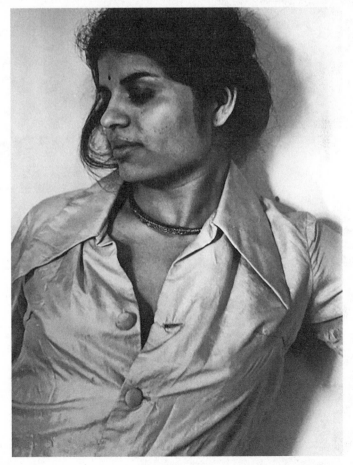

PART IV

Expanding the Circle/ Back to the Center

Yaseen. Elliason. Viet. Nguyen. All American names, if we want them to be. All of them a reminder that we change these United States of America one name at a time.

—VIET THANH NGUYEN, "AMERICA, SAY MY NAME," NEW YORK TIMES, MARCH 10, 2019

11

Expanding Identities

BY EARLY 1990, I had concluded that like the women described in the psychology books so popular at the time, I was one of those "smart" women who made foolish choices in their romantic relationships. There was something calming about such an acceptance: it freed me up to delve deeper into my new intellectual interests. It was easier to focus on work and avoid the anxiety of searching for true love.

Untethered from the physicality of objects in museums, I was increasingly interested in the broader social and political contexts of art and museums. My mind was buzzing with questions: Why are there almost no works by twentieth-century artists from Asia in most American museums? Why is premodern Asian art so favored in the Euro-American art world as the only "authentic" expression of the ancient cultures of Asia? What was the genesis of such attitudes?

Through the writings of anthropologists such as James Clifford, I began to understand that the preference for premodern art and the exclusion of twentieth-century Asian art from the Western art historical canon were inextricably tied to the colonial history of the nineteenth and early twentieth centuries. The glorification of the splendors of ancient India while decrying its "decline" in the more recent past was central to justifying British colonialism: once a glorious civilization, the subcontinent had become merely a shadow of itself, incapable of self-governance. Historians of Asian art, myself

included, had unthinkingly bought into the Western academic and museo-
logical notions born of colonial attitudes: only ancient Asian art was good art
and new Asian art—considered a poor imitation of Western modern art—
wasn't worth the curatorial or scholarly effort.

I should have known better. I was used to the easy comingling of tradi-
tional art, folk textiles, and works by contemporary artists in our own home
in Ahmedabad. But I had not questioned the discrepancy in my own study.
It was disheartening to acknowledge that I had participated in perpetuating
the historically determined but false separation of the past from the present
in the museum world. Now as a museum professional and a scholar, I felt a
responsibility to help redress this imbalance. I resolved to incorporate the
study of Asian modern and contemporary art into my upcoming seminar on
museums at the University of Massachusetts–Boston (UMass). I scoured the
Museum of Fine Arts (MFA), Boston library and recognized that it would
take a strenuous effort to build a reasonable bibliography. Just as I was getting
ready to pursue my new academic interests, I got a call from my old men-
tor Dr. Sherman Lee, the director of the Cleveland Museum of Art (CMA):
"Asia Society in New York is looking for a new director for its galleries. I'm
the head of the search committee, and I wanted to see if you would consider
being a candidate for this important position."

In the field of Asian art, Asia Society occupied an important place. Always
a high point of my New York visits, it was one of the few institutions com-
mitted to presenting important, high-quality exhibitions of traditional Asian
art. Its publications, both the exhibition catalogs and the scholarly journal
Archives of Asian Art, were treasured items in my library. The Society had a
wonderful collection of Asian masterpieces that came from its founders Mr.
and Mrs. John D. Rockefeller III, but it was not a big collecting institution. As
a multidisciplinary organization, Asia Society placed arts in the broader con-
texts of history, culture, and contemporary affairs. Given its unique empha-
sis on all aspects of Asia, I got excited about the possibility of developing
an exhibition program of modern and contemporary art without getting
mired in the thorny issues of acquisitions. However, the reality of my situa-
tion made the decision complicated. I had just agreed to go to UMass with
tenure while curating a special exhibition at the MFA. I called Dr. Lee back
and explained my predicament, but he allayed my worries, "You don't have

to declare yourself as a candidate, but I think you should at least consider talking to the search committee."

As a "noncandidate," I was unusually relaxed in my meetings with the Asia Society search committee. After a brief discussion about my background, I quickly focused on my main priority: "Judging from my resume, you may conclude that I'm a suitable candidate for you because of my training in traditional arts. But, I'm much more excited about the potential of developing an exhibition program in the field of contemporary Asian art. The institution is already engaged with the contemporary political and economic affairs of Asia. Why not add contemporary cultural expressions to the portfolio?"

I noticed that the senior staff on the committee, especially president Robert Oxnam, smiled and nodded, but other trustees seemed surprised and even shocked by my suggestion. One stifled a cough and informed me politely, "You know that Blanchette Rockefeller, wife of our founder John D. Rockefeller III, doesn't like modern Asian art. She thinks that it's basically derivative of Western modern art and will not be received well by New York audiences." Before I could defend my position, Dr. Lee quickly changed the subject. I sensed that he was not totally against the idea, but he redirected the conversation by asking a pertinent question, "I understand your interest in presenting contemporary arts of Asia, but are there qualified curators? Most of the Asian art curators in this country are trained in traditional arts. Who would make the necessary judgment about the quality of art in such exhibitions?"

I stood my ground, "That's a fair question. But the truth is that we haven't really looked for them, either. My preliminary study shows that the art scene in Asia is alive and well, with some very talented artists and there are regular exhibitions all over the Asia Pacific region. I'm sure if you make the commitment, it wouldn't be difficult for a new director to identify a group of scholars and curators to help shape such an effort." I made my case forcefully, surely guaranteeing that the committee would look elsewhere for a new director. But somewhere deep inside my heart, I was also excited about the possibility of developing a much-needed robust program of contemporary art.

Soon after I returned to Boston, my phone rang: "Vishakha, Sherman here. You were terrific at the meetings. So I'm calling to tell you that you are our first choice; it's your job if you want it, and you will have an opportunity to develop a contemporary art program as long as it's not at the expense of

traditional arts." As I listened to him, I felt vindicated: My argument about addressing centuries-old colonial prejudices had won the day. When Asia Society President Oxnam called me with the offer, I asked for a month to think it over. I talked with my academic mentor Walter Spink and with the MFA director Alan Shestack. Both gave me the same advice, but for different reasons. Walter argued that I would make a much bigger difference to the field if I went to Asia Society. Alan advised, "Take the Asia Society directorship now while you're young and full of energy, then turn to teaching and guest curating at a later date." I was relieved that the UMass dean, Richard Freeland, was very understanding, suggesting that I take a leave for two years to see how I liked the new position and living in New York. I had a guaranteed return ticket as a professor if the Asia Society venture didn't work out. I decided to give it a try.

Arriving in New York, my highest priority was planning a sustained exhibition program of traditional arts with new approaches and a robust new initiative of contemporary art exhibitions. As I saw it, it was not enough just to present the Asian art of our time to pay homage to contemporary creativity, it was also necessary to question the "essentialist" perspectives on Asian art that privileged the "authentic" and "pure" expressions of the premodern, precolonial Asia. The very idea of "Asian-ness," unbounded by geography or time, had to be interrogated. Only then could one challenge the notion of seeing Asia as the "other," "exotic," and "far away." This meant that in addition to presenting art from Asia, we also needed to look at art created by artists of Asian origin living elsewhere, especially if they were exploring the questions of their bifurcated, fluid identities.

The issues of multiculturalism and diversity were swirling around the art world and in society at large in the early 1990s, and young Asian American artists were making their voices heard. With the first phase of economic globalization in full force, Asian regions once seen as alien and far away were beginning to bump against the Western world in ever-closer proximity. It made sense to organize our inaugural exhibition of contemporary works on Asian American artists while we prepared for a more ambitious foray into the contemporary arts from Asia.

With Margo Machida as the curator, we planned the inaugural exhibition, *Asia/America: Identities in Contemporary Asian American Art*, exploring the

experiences of the cultural "in-between-ness" by immigrant Asian artists as a key source of their artistic creativity. Although fully supported by the leadership of the Society, I faced tough criticism from some long-time patrons of traditional art and several senior curators from other major museums. They bought my moral argument about the need to look at contemporary artistic expressions from Asia, but why Asian American art? A feisty collector argued, "Why start with Asian American art? Let's face it, they are American and belong at the Whitney [Museum of American Art] or the Museum of Modern Art, not the Asia Society."

I was uncharacteristically stern in my response, "That's like saying that just because I live in America, sound 'American,' and wear Western clothes, I no longer have deep Asian roots. Ironically, my looks immediately mark me as an Asian, an Indian, and I am constantly asked how long I have been in this country or why I speak English so well. This is also true of artists who are questioning their sense of belonging. They explore the complexity of their fluid bicultural existence and make visible the liminal space between Asia and America in their creative pursuits. It seems entirely appropriate that we give space for such important explorations of Asian-ness in America."

Clearly, the exhibition had struck an unintended powerful chord deep inside me. Now I was no longer just an interpreter of a faraway culture from a bygone era but a full participant in the expressions of here-and-now. The artists in the exhibition gave form to my specific experience of living a bicultural life in America while connecting me to the multilayered, multidimensional experience of Asians in America.

Several works in the show such as an installation by the Korean American artist Yong Soon Min, entitled *Dwelling*, spoke to me directly. A diaphanous Korean dress (*hanbok*) hung from the ceiling, with dry branches suggestive of physical architecture gently visible through the dress and lit from within; a stack of books, in Korean and English, mainly of personal significance, was placed underneath the dress while the words of the contemporary Korean American poet Ko Un gently floated inside: "To us . . . a birthplace is no longer our home. Nor is home the place where we grew up." Yong Soon's *Dwelling* made visible my own sense of fluid belonging and complemented the highly personal essay I wrote for the catalog, "Whither Home? Predicament of a Bi-Cultural Existence."

The exhibition traveled to five cities across the United States, attracting large crowds and often leading to unexpected emotional responses. "I didn't know that I would see my story reflected in an art museum," remarked a teary-eyed, middle-aged Chinese American engineer in Minneapolis. It also sparked heated discussions, especially among artists: "Should artists be defined by their ethnicity? After all, the white artists are not always asked about their ethnic or cultural roots. Is this yet another form of ghettoization of artists? Why should they be seen at the Asia Society and not at the Whitney biennial? Why are such identity questions raised about artists of color when the same questions are not asked of mainstream artists shown at the Museum of Modern Art?" Underneath these questions lay the desire to be taken seriously in the mainstream American art world. If the 1970s had been based on the desire to open the doors of cultural institutions to new audiences, the multicultural debates of the 1990s were about representation of the diverse groups of people who made up America. Now the demand was to be seen at mainstream institutions and to have a seat at the artistic table. The raging debate about the very power structure of art museums, now ever present in cultural conversations, was not yet part of the art world's infrastructure. I was pleased that the exhibition had been catalytic in creating such a robust and honest dialogue. Margo and I hoped that this exhibition would inspire other such efforts by organizations big and small. However, as the first major national show of Asian American art, it bore the burden of high expectations and palpable fear that it would remain a singular effort, not one of many. Many questions arose from that fear.

The show marked an important passage for me. Now I was "at home" in New York—the world's multicultural city where most people came from elsewhere. I felt a new sense of belonging that went beyond ethnicity and geography, reminding me that identity isn't formed in a vacuum. It changes and evolves based on shared experiences in newly local geographies. Art had expanded the notion of myself, not simply as an Indian American but as an Asian American, enriching my American experience by sharing it with fellow immigrants of Asian heritage.

While the Asian American art exhibition was on the road in 1993, the preparations for the inaugural show of contemporary art from Asia were in full swing. I traveled throughout Asia and was thrilled by the lively art scene.

The artists were excited about the possibility of a major exhibition in New York, but, much to my surprise, some curators and scholars were more reluctant. After the fall of the Berlin Wall and collapse of the Soviet Union, the left-leaning curators, especially in India and Indonesia, were initially skeptical about the interest coming from an American institution: "Why now? Is it because Asia is finally becoming economically vibrant that America would like to look at the art that it has willfully neglected? With America remaining as a sole superpower and promoting capitalist values around the world, it will devour talented artists and corrupt the art scene." Politics and art were colliding in a way that I had not experienced before. I was not really prepared for such skeptical comments verging on personal attacks. As much as I understood their criticism, I could only repeat my genuine intention to redress the imbalance of Asian art representation in American art museums. Initially, I did lose some curators but all of them changed their minds over time and became strong partners.

In the fall of 1996, Asia Society opened the first international exhibition of its kind in New York, *Contemporary Art in Asia: Traditions/Tensions*, featuring more than seventy works from five countries: India, Indonesia, Korea, Thailand, and the Philippines. Curated by Apinan Poshyananda, a young and brilliant Thai scholar with a Cornell doctorate, the exhibition was purposely designed to go beyond the traditional categories of subregions such as South Asia, Southeast Asia, and East Asia. The goal was to engage with the art works at the intersection of the seemingly binary definitions of local/global or traditional/modern from countries that were less familiar to American audiences. *Traditions/Tensions* was to be followed by another major exhibition of contemporary Chinese art.

The exhibition was a huge eye-opener for New York audiences: a wide variety of paintings, sculptures, and video installations by twenty-eight artists from five countries, many of them large scale and created specifically for the occasion. A sprawling endeavor, the exhibition was shown at three venues: the Asia Society galleries, the Grey Art Gallery at New York University, and the Queens Museum. While some of the artists, such as Indian artist Nalini Malani, were already stars in their home countries, there were also many rising artists who went on to become international stars. They engaged with specific historical moments in their country's past as well as reflected

on the immediate globalizing present. Whether using traditional techniques or commenting on contemporary politics, most of the artists agreed on one thing: They would not be drawn into the facile debate over whether their works were "authentically Asian" or "Western inspired"—many of them thought that they were either both or neither.

Holland Cotter of the *New York Times* gave the show a huge boost with his lead preview article in the Friday Art and Leisure section, featuring a half-page photograph of the Indian artist Ravinder Reddy's sculpture of a female head. Cotter strongly endorsed the show and sharply dismissed those who sneered at contemporary Asian art in his opening paragraph:

> Contemporary art in India? There is no contemporary art in India." An academic friend tartly reminded me a few years ago. How could an avant-garde art exist anywhere in the "timeless" cultures of what we monolithically call Asia? If it did, it couldn't be any good—too Western, too Asian, too little of one or the other. Her assertion was understandable. But it proved wrong. In New Delhi and Baroda, Calcutta and Madras, new art in nontraditional forms, pitched to an international mainstream market, is being produced as you read these words; art schools are flourishing, a network of galleries is growing. The same is true across much of Asia.[1]

The *Times* preview did the trick. The attendance at our venues jumped and the New York art world took notice. Asia Society was credited with changing the perception of Asian art because of the sheer scale of the effort. The exhibition traveled to Canada, Australia, and Taiwan, further cementing the Society's global leadership role in the new world of contemporary Asian art. More importantly, it paved the way for redefining the field of Asian art.

Contemporary art symbolized another kind of "home" for me. Through these projects, I felt that diverse bits and pieces of my life began to fit into an expansive mosaic. They linked together my dual interests in art (originating in the Jawahar Nagar garden) and politics (beginning with the Vietnam peace vigil in Santa Barbara) in ways that felt organic. Through artists in Asia and America, I found comfort in being part of a larger community of in-between individuals who used their liminality as a fertile ground for creative imaginings. They expanded my sense of belonging and gave voice to my feelings

of occasional rootlessness. When I first came to Asia Society in 1990, I was beginning to feel comfortable across a horizontal axis—whether Indian or American or anything in between. But as of the late 1990s, I was feeling comfortable in another way: it was less about being bicultural and more about experiencing a larger reality of an intercultural world.

———————

I LOVED MY NEW job and had very supportive colleagues, especially Bob Oxnam, the Society's president. I really respected him not just for his knowledge of China and Asia but also for his passion for combining scholarship with public education. We quickly became professional partners and good colleagues, developing new projects and collaborating on fundraising efforts.

A year into my tenure at the Society, Bob and I found ourselves in Seoul at the same time. I was there to meet with artists and curators of contemporary art and to work on a major exhibition of eighteenth-century art for the Society's forthcoming Festival of Korea; Bob was on a fundraising mission. After a formal dinner at the U.S. ambassador's residence, we decided to have a drink at the hotel to debrief and ended up talking about personal matters for the first time. I told him about my divorce and then jokingly revealed an Indian astrologer's prediction that if I didn't find someone by my forty-second birthday, I was doomed to being forever single. According to the astrologer, I needed to wear a yellow sapphire to help strengthen my chances, but I jested that I couldn't afford such an expensive purchase on my Asia Society salary. Bob smiled and declared, "As your supervisor, it's my job to keep you happy and thus I must find a suitable match for you. At the very least, we have to make sure you can buy a yellow sapphire." We both laughed and raised our glasses—mine with wine, his with Diet Coke (he had given up drinking the year before).

When we returned to New York, it was clear that something had changed in our relationship. Our strong sense of camaraderie was now intermingled with mutual attraction. With Bob being separated from his wife, we could contemplate seeing each other socially. Both of us were cognizant of the dangers of a workplace romance, but Bob had a novel idea: Why not inform the Society's board leadership about our situation? And why not let them know that he was planning to step down in the near future in any case? I could

see the merit in his idea, but I worried that if it backfired I would be the victim. After all, there were plenty of stories of workplace romances turning out badly, especially for the woman. I remembered well the famous case of the Bendix Corporation in 1980: a rumor of an affair with the CEO William Agee eventually caused Mary Cunningham, the woman in question, to quit her job. Bob felt that it was at least worth a try to first talk with our board chairman John Whitehead before we started seeing each other socially. "That's great news," Whitehead exclaimed, "I have the highest regard for both of you. I'm in favor of romance on the job. It simply means that both of you are working hard and neither of you has the time to meet other folks. There's no need for you to step down for this reason. Of course, we will keep the news private until you are ready to go public, but I will share it with senior board leadership."

What a relief! We could now begin to see each other quietly without the fear of rumors getting to the board leaders. It felt so good to be with someone who shared my passion for public education about Asia and enjoyed my love of hiking, traveling, cooking, and just hanging out together. Bob's ever-present humor made our life full of joyous surprises, such as his gift of a gold necklace with a yellow sapphire. As I admired the beautiful stone, Bob said with a smile on his face, "Just so you know, this is a selfish gift. I want protection from those powerful rays your horoscope guy mentioned."

About a month into our nascent relationship, Bob came to my apartment for dinner and over dessert he turned to me, held both my hands, and said, "I can't tell you how happy I am to have met you. It's wonderful to find a partner with whom I can share so many aspects of my life. I know things seem pretty normal, but I need to share something with you that may be unsettling. I would completely understand if after hearing me out, you should decide not to pursue a relationship with me."

Bob hesitated for a moment, letting the mood quiet. Still holding my hands, he gently continued:

> I've been diagnosed with a condition called "dissociative identity disorder," commonly called "multiple personality disorder." It's directly related to severe abuse in my childhood. I'm in very intense therapy three times a week. You should know that it's not a genetic disorder. It's caused by abuse not heredity.

My therapist has told me that I'm not dangerous except possibly to myself. There's no doubt it's serious, but with proper treatment, and once I can revisit the original cause of childhood traumas, the prognosis is good for a less troubled life. I wish I didn't have to tell you, but I know you need to know.

How could I have missed this? Just when I thought I had met someone who was really together, it was completely the opposite. I had seen the movie *Sybil* and was shocked to see Sally Field suddenly shift from being a teacher to becoming an angry kid. Were there signs in Bob that I should have caught? Yes, I suppose so. One morning he awakened babbling like a little boy looking for his animals, but then he quickly shifted to being an adult ready for work. I thought it strange but also sort of cute. And then there were occasional bursts of anger that seemed to come out of nowhere. "Oh my goodness," I said, trying to hide my shock, "So, Bob, when those mood shifts occur is that really you or is that someone else inside?"

"You've got it right. When at work, it's me, Bob, that you see. But the childlike jokester is Bobby. And the angry one is Tommy. I'm so sorry that you have had to face that kind of occasional anger. Anyway, each of these personalities is quite distinct, and for the time being, without connection to each other. The whole purpose of therapy is to break down the walls between personalities so that we can begin to function in a more holistic way, aware of all parts inside."

I was somewhere between stunned and curious. "So tell me," I said as calmly as I could, "why does such a thing occur?" As I listened intently, his answer made perfect sense to me: "When a young child before the age of four or five is severely abused—physically, emotionally, and sexually—he or she has very limited resources to withstand such horror. Either the kid is completely damaged for life, or a smart kid figures out a way to compartmentalize the abuse. A part of him could be highly functional, burying the other part deep into the recesses of his mind, pretending that it was not happening to him."

We sat in silence for a few minutes holding hands. I don't quite know why or how, but I could really feel for the child that was abused through no fault of his own, and I could feel the warm-hearted nature of Bob, the adult that I had come to love. I drew him closer, hugged him hard, and finally said,

"I love you even more for being so honest with me. I want to learn more about the disorder and what I can do to help." My first order of business was to learn more about multiple personality disorder (MPD)/dissociative identity disorder (DID). We saw the movies *Sybil* and *The Three Faces of Eve* and talked late into the night about DID therapy and how it related to Bob's case. I devoured several books on the disorder and its treatment that I found in a specialty store in lower Manhattan. Several times a week, Bob offered a synopsis of what was happening in his therapy sessions with Dr. Jeffrey Smith.

Now that I was beginning to understand the disorder, I could see its various manifestations, good and bad. When I returned from one of my long trips to Asia, Bob surprised me at the airport wearing a tuxedo and a chauffeur's hat, holding a Nirvana Limousine sign and a bouquet of roses, grinning with delight. This was pure Bobby, a young personality with a devilishly charming sense of humor, grinning at other chauffeurs who were stunned that the "Nirvana guy" got to kiss his passenger.

But there were also flashes of anger that seemed to be triggered by the smallest of causes. One evening, returning from a dinner at a Chinese restaurant with a doggie bag in hand, I casually mentioned that I had talked to a friend about our budding romance. Out of nowhere there was hissing and yelling: "How can you keep talking to more people about us? You sound as if we are already a married couple!" This was unadulterated Tommy; he threw the bag of leftovers on the street and stomped away. I had never experienced such anger directed at me; I completely shut down, unable to speak or fight back. A few minutes later, Bob came back apologizing profusely, "When Tommy comes out, I have no control over his rage, and it happens so quickly that all kinds of bad things get said. I'm really sorry. I know this is not an excuse, but I know this is one of the really bad side effects of DID." As deeply hurt as I was by the moment of anger, I reminded myself that it was only a fraction of my experience with this complex man that I had fallen in love with.

Gradually I learned that the DID inner system is very dynamic, capable of reshaping itself as therapy progresses. I watched an amazing transformation as Bob, the disciplined but exhausted workaholic public figure, morphed into Robert, a more contemplative, less grandiose personality. Robert and I connected even better than Bob and I; our conversations became richer and

more nuanced, filled with expressions of shared feelings and common values. Robert soon became the "dominant personality" (a DID term) without being domineering like Bob. Robert, acknowledging that Bob had burned out, was ready to handle stepping down from the Asia Society. He planned a less regimented institutional life—writing a novel, hosting a PBS series on China, teaching, and some business consulting.

The change, however, didn't always mean smooth sailing in calmer waters. Rather, it was constant zigzagging and tacking to adjust to unexpected gushes of headwinds. One such occasion, what ocean-going sailors call stark terror, occurred on a wintry night after one of Robert's weekly therapy sessions. White-faced with shock and barely able to describe what he had experienced, Robert blurted out, "There's this awful person inside me. She calls herself 'Witch.' She's dark, mean, even vicious. She activates Tommy to do cruel things. She hates everything and everyone, especially you. Smith thinks she's the embodiment of those who abused me when I was a little kid." I took a deep breath and said as calmly as I could, "I want to meet this Witch . . . right now." Robert's eyes began to flutter, his eyes narrowed angrily, and a raspy, shrill voice shouted, "You think you are going to save Robert? You think you love him? There's no way that Robert will be happy with you. He's bad and he's always been bad. You think you are some super-human being and it will be different this time. Let me tell you, it's always bad and it will end up being bad again. You better get out of this while there's still time. I'll make sure that I destroy your love."

I stood up from my chair, stared at Robert/Witch, and spoke sharply but calmly, "You think I'm scared of you? Not a chance. You can't do anything because I'm not afraid. I love Robert and you're not going to take that love away from us. So go ahead—shout and snarl all you want. I'm not going away." With one long hiss, the Witch was suddenly gone and Robert re-emerged, blinking his eyes as if just waking up. "You met her?" he asked. "Yes," I said quietly. "She was as mean as you said. But I stood my ground. I refused to listen to her nasty comments about you and us." "Oh my God," Robert said with genuine fright, "weren't you scared?" I replied, "She's trying to destroy us, and that I won't tolerate. It's your job to deal with her. It's my job to deal with us." After that moment, it was clear that Robert had a steadfast ally in dealing with the darkest forces within him, an ally who, unlike the therapist,

was always at his side. Over the next few years, Robert's inner system transformed as it coped with the Witch, who turned into a benign figure called Wanda playing a nurturing, meditative role for the whole inner mechanism.

After the Witch episode, our relationship went to a new place, deeper and quieter. I sensed that Robert was now able to make a commitment to me without being sabotaged from within. We joked that since I was not yet forty-two, Robert and my horoscope man had offered up a pretty good birthday present for both of us.

The next step was to introduce Robert to my parents and the family in India. Both of us were excited about that first meeting, certain that in spite of our cultural differences, the shared experiences and values of our families would be a promising match. Having heard the progressive tales of my father and mother, Robert was looking forward to talking to Papa about his own background in the famous Oxnam liberal tradition: Robert's grandfather, Methodist Bishop G. Bromley Oxnam, was the first president of the World Council of Churches and a fierce opponent of the right-wing propaganda of the McCarthy era. His whole family was steeped in the tradition of ecumenical embrace and deeply moved by the Gandhian tradition of nonviolence. I couldn't wait to introduce Robert to my parents. From my difficult divorce through various broken romances, Ben and Papa had been incredibly supportive. I was sure that they would be happy and relieved that I had finally met the love of my life.

I arrived in Ahmedabad a few days before Robert was due to come from Manila where he had gone for work. It began well: Robert presented a beautiful wooden sculpture from Manila that he had bought especially for Papa and he spent time with my young niece Anokhee, teaching her to play with an ostrich puppet he had bought in Manila. I was happy to see that Robert bonded easily with the rest of the family.

Then Papa suggested that it was time to go to the living room for morning tea. We typically had tea and breakfast in the backyard. Something in his voice suggested that this was not a casual request. As soon as we sat down, before anything was said, he called Ben to join us. The drama that unfolded had clearly been worked out in advance—Papa spoke, but Ben kept whispering in his ear telling him what to say. What transpired was the most unwelcoming "welcome speech" imaginable: "We realize you love our daughter

and it seems like a good match, but Vishakha's mother and I are concerned that you have been married before and have two children. What would be the impact of your divorce on your children? How will your divorced wife react to your marriage to Vishakha? How will she handle the relationship of your children to you and to Vishakha? Are you sure that divorce is the right option for the sake of your children?"

I couldn't believe what I was hearing. My progressive parents had always welcomed all my American friends, boyfriends included. Where did this come from? I was totally blindsided. Robert looked as if he were facing a firing squad and I could tell that he was annoyed. As he mentioned later, "I was expecting a love-in and instead it was colder than my doctoral oral exams." Keeping his anger in check, Robert calmly replied that his children were grown up and capable of making up their own minds. Besides, he had stayed with his wife for almost twenty-seven years mainly for the sake of his children, and had tried to make it work but it was futile. Robert also assured them that I was not the cause of the breakup as he had already separated from his wife when we got together.

I was furious. This was no way to welcome a guest, especially one that would soon be their son-in-law. Why the hell did they do this, so completely out of character for the always-welcoming Desai clan? How could they not think about how Robert would respond to such an interrogation? Robert told me later that he almost walked out of the house right then. It was only his love for me and his utter surprise at the interrogation that kept him there. When my sister Chitra heard about the episode, she let my mother have it.

It took me a while to realize that at the heart of their questioning was their cultural belief in the sanctity of family and a deeply held value that once they had children, all couples had an obligation to keep the family together even if the relationship was less than desirable. Unlike the American ideal of marriage in which love between two partners is seen as the primary emotional requisite for the relationship, for my parents, as progressive as they were, once married with children, the sanctity of the marriage was inextricably intertwined with the fate of the family, especially children. In their view, it was OK to marry an American or even live with one, but it was far less acceptable if the relationship involved a potential family breakup with their daughter as the cause of it all. Ben's feeling about the issue was so strong that it didn't

occur to them that hitting Robert with all of this within an hour of his arrival at our home was inappropriate behavior in India or in America. Even Robert's explanation of staying together as a family for the sake of the children had fallen on deaf ears. As far as my mother was concerned, the sacrosanct belief in the cause of the family trumped all other considerations. Decades later when I saw David Henry Hwang's play *Soft Power*, I was reminded once again that this stereotyping of staying together for the sake of the family regardless of romantic unhappiness is as prevalent in China as it is in India.

It took us a while to get things back on track. Robert and Papa eventually became great companions. Having lost his own father who died of lung cancer at the age of fifty-nine, Robert felt that in Papa he had found a father again. His relationship with Ben evolved more slowly. The real turning point came six months after the infamous interrogation, when Ben proved to be an ardent supporter of the relationship.

I had always thought I would have a child someday once I had found the right mate. Now almost forty-two and with a life partner, I wanted to consider having a child but Robert was more hesitant. It was Ben who gave me the critical advice:

I know how strongly you feel about having children. But remember, different people are placed on this earth for different reasons. There are many women who can give birth to children and provide a good home for their family. But there are only a few who are given the gift and the responsibility to make a larger difference in the world. You should not define yourself solely by the decision to have children. I think it's far more important to have the right partner than to focus on the abstract notion of being a mother. After all, you are almost forty-two, and you have not felt the urge to be a mother strongly enough to do something about it. Besides, you have lots of nieces and nephews who can be part of your life. You are also fortunate to have finally met a person who is your equal in more ways than one. Together you can make huge contributions by providing deep understanding of the two oldest civilizations of Asia. So why not focus on your wonderful partnership and your important work?

Ben, who had devoted her entire married life to the well-being of her family, actually gave me the permission to imagine a life without having my own

children. Yes, it hurt for a while, but she also provided a way for me to enlarge my sense of family through my nephews and nieces, now ten strong, along with their expanding families. When Robert heard about the episode, he was happily surprised: it was the beginning of overcoming their initial awkward encounter.

We were married at the Boathouse in our beloved Central Park on a foggy fall day in October 1993. We arrived by gondola from the Bethesda fountain just as the heavy fog lifted, revealing brilliant colors of late fall trees backlit by gentle afternoon sun. From the wedding vows—poems from Rilke to Kabir and from Philip Larkin to Hopi blessings—to classical Indian music and solo guitar, from Indian delicacies to a lovely wedding cake, and the collection of guests, it was a true multicultural occasion, filling our hearts with joy.

Now that I was married to Robert, it meant that I was committed to a lifetime of coping with an ever-evolving identity that Robert called "Robert et al." As our marriage evolved in the 1990s, it was Bobby who became more and more dominant, sometimes challenging Robert. I connected most easily with Robert. Dealing with Bobby, with his childlike humor, boundless energy, and constant demands for attention, proved to be more challenging even if often appealing. I still had to deal with occasional angry outbursts from the depressive Tommy, but it was Bobby who had a pent-up desire to express his creative and playful urges. He often pushed me to "come out and play" and occasionally resented my inability as well as lack of time (this was at the height of my work on the *Traditions/Tensions* exhibition). He also told me point blank that I was "too adult, too rational, and without a good sense of humor."

There was some truth in what Bobby saw. When we met as two successful professional adults, my relationship with Robert was based on intellectual connections and shared values. As Robert went through therapy and years of intense emotional ups and downs, I often served as his nursemaid. I had to be the super-adult holding things together, a duty that suited me well. My caretaking role with Robert allowed me to be self-sufficient, hiding my own vulnerabilities and avoiding my emotional needs. Bobby's analysis was right, but his words stung.

Bobby's new passion was inline skating at the famous Skater's Circle in Central Park where he would skate for hours, especially on weekends. He

learned all sorts of tricks and became famous for balancing water bottles on his head while skating. I loved watching Bobby playing with young children, but I felt a pang of jealousy when I saw him dancing with attractive young women. Pretty secure in our relationship, I typically let my momentary envy pass.

In August 1997, I was halfway around the world in Perth, Australia, to give a series of talks for the opening of the *Traditions/Tensions* exhibition. As usual, I phoned Robert for our daily conversation when I was on a trip; but this time, after multiple attempts I got no answer on our home phone. (This was in the era before cell phones.) I was quite concerned, especially because we also used these calls as a hotline when he was depressed and even suicidal. Finally, I got through after a couple days of trying: "Are you all right? I tried many times. Why didn't you pick up the phone?" "I haven't been home," he replied sheepishly, "but something amazing has happened. I met a young woman Rollerblading and she's helped enormously in allowing Bobby to become a real person. She's young and really into yoga. I have been at her place for much of the time, including overnight. But please don't get mad. It's not a threat to our relationship. You can even meet her because then you'll understand. I think you'll like her."

I could barely hold the receiver as I felt my whole world crashing down. I was furious, hysterical, and deeply sad, all at the same time. On my long return flight from Australia, a million thoughts ran through my mind: How could I have been so confident in our relationship? Is this what I get for being a supportive, understanding spouse? I was there for him in the darkest of days, and now that he is feeling better the first thing he does is hook up with a woman young enough to be his daughter! Was this just a classic case of a middle-aged man looking for an excuse to have an affair? Was this just a passing phase? Should I split from our marriage, or do I try to understand this new Robert/Bobby interaction and modify my behavior accordingly? Robert could have just lied to me, but he didn't—doesn't that mean something? Could we ever recapture the trust in our relationship?

As it turned out, the Robert/Bobby relationship with the young skater came to a quick conclusion; the woman was looking for a serious romance and Robert broke it off. The crisis was over, but how to move forward? I believed Robert and the newly energized Bobby when they said they really

wanted to make our marriage work. I talked to Robert's therapist about what all this meant in his DID healing process. I was surprised by two of the therapist's conclusions: First, he saw a silver lining in Bobby's emergence as a stronger force inside Robert's system. Second, he wondered if I needed to do some work myself, especially moving beyond the caretaker role in dealing with Robert. I thought long and hard about that. Maybe I had learned my mother's reasoned, rationalizing approach too well. Maybe it was easier to be the emotional anchor than to reveal my own vulnerabilities. Maybe it was time to allow our relationship to become more reciprocal, letting us both heal in new ways.

I came to realize that I had my own equivalent of Bobby inside—a little girl whose hurts and hopes were always treated at arm's length, almost never with an embrace. Perhaps I could learn something from Bobby who had an uncanny ability to sense my feelings before I became aware of them. I had to acknowledge that my inability in accessing deep feelings had played a role in our rupture. I had unthinkingly replicated my mother's role as a problem solver and the rational center of the family. Having left India as an adolescent, I also had to learn to take care of myself during times of stress. It had served me well in the professional realm, but this independence had acted as a barrier in my personal relationships. Robert, especially Bobby, had given me a gift, a reason to explore and acknowledge the multiplicity of feelings at the innermost recesses of myself.

WHEN ROBERT PUBLISHED his psychological autobiography in 2005 (*A Fractured Mind: My Life with Multiple Personality Disorder*), both of us faced a lot of questions not just from the press but also from friends and colleagues. One of the most perceptive reactions came from the great diplomat and then Asia Society chairman Richard Holbrooke, "Vishakha, I wonder if you were able to accept Robert's disorder and find a way to love him because there is something in the Indian tradition of accepting gods with multiple arms and heads, often with different meanings. Perhaps, this allows you to accept the possibility that people embody diverse dimensions. Perhaps it has made it easier for you to hold both good and bad together without making judgments."

Holbrooke had it exactly right: multiple manifestations, often with seemingly contradictory impulses, are deep forces in the Indian tradition even if their currency is currently less celebrated. Nowhere is it more evident than in the image of Shiva, described aptly by Wendy Doniger as an erotic/ascetic,[2] a god of destruction who is also worshipped in the form of a phallus for his procreative powers. Shiva is also worshipped as Ardhnarishvara, embodying the form of half male and half female, reminding us all that we all have male and female energies within us. The Witch-turned-Wanda in Robert reminds me again and again that it is possible to experience nurturance from my male husband, as it is possible for me to be powerful in my professional life without giving up my femininity. Indeed, there was some truth to what Holbrooke intuitively understood: as a child growing up in a tradition-oriented progressive household, and as a student immersed in Indian culture and philosophy, it was possible for me to be open to Robert's experience of multiple selves and learn from it in profound ways.

Robert has coined a term for what he sees as the goal in DID therapy—"cohesive multiplicity"—the ability to accept all parts of our personality and to provide a space for them to flourish with the help of one another. Although he developed the term as an alternative to the older notion of "integration" into a single personality in his own healing process, it has tremendous resonance for all of us. At a deep personal level, how do we give weight to the darker parts deep inside ourselves without letting them overwhelm us? For those of us who live at the interstices of multiple belongings, it raises another question: How do we hold all of our cultural parts together?

DURING MY FIRST DECADE at Asia Society in the 1990s, I learned to give credence to manifold aspects of myself, personally and professionally. Through Robert, I learned to appreciate the multiplicity that we all embody within us at an individual level and through our cultural experiences. Through artists and their works, combined with Robert's concept of "cohesive multiplicity," I have found a conceptual framework for my life of fluidity between differing values and divergent cultural predilections. These experiences have allowed me to understand the famous saying of the violinist Jascha Heifetz: "To be a great musician, one needs to be simultaneously on the stage and in the

balcony." For me that means envisioning new belongings without uprooting from the old, to be inside and outside at the same time, to be able to participate in and reflect on new settings. Sometimes these multiple belongings collide uncomfortably, but often they flow into one another, creating new unimagined possibilities.

12

Death and Life in the Diasporic Family

I F THE 1990S were about expanding vistas of new belongings, they were also about deepening connections to my immediate family. This was not always so. In the first decade of my life in the United States, as was true for most Indians in America, I had no immediate family save my oldest sister Swati. In the early decades following the 1965 immigration reform in the United States, most Indians came as students, leaving their families behind. Given the centrality of family life in India, it was natural for the newcomers in a strange land to form new familial bonds with other members of the diaspora. Celebrating important festivals, sharing meals on important occasions, and building temples and mosques, all familiar themes in immigrant novels, were key parts of early Indian immigrant experiences.

However, this was not my story. Unlike the Ganguli family in Jhumpa Lahiri's popular novel *The Namesake*, I had not sought out the comfort of my compatriots in this new land that I called home. For me, family was firmly rooted in 38 Jawahar Nagar and I continued to have connection with Mummy Reed. I sought new connections and made friends, but I did not attempt to re-create familial relationships. By 1990, however, five of the Desai children were living in the United States, and now it was time to create new family traditions outside of 38 Jawahar Nagar. We found numerous ways to stay connected, from weekly calls to annual reunions, often planned around special

occasions. Indeed, as is true for most Indian families, we took advantage of important life passages—marriages, births of children, major illnesses—to come together and strengthen our bonds.

Robert and I were delighted that all members of the United States–based Desai family were able to attend our wedding, but our greatest disappointment was Ben and Papa's absence on this important occasion. Papa's Parkinson's disease had made it impossible for my parents to travel as before, but they were with us in more than spirit throughout our wedding day. Before the ceremony at the Central Park Boathouse, my sister Anu created a makeshift altar at our apartment: a photograph of my parents, surrounded by images of the Hindu god Ganesh (the destroyer of all obstacles), the Buddha, and Gandhi. They were all graced with a hand-painted *swastika* (well-being) symbol to mark the auspicious beginning of our new life. Unable to speak by phone because of the time-difference constraints, we asked for their blessings at the altar of symbols sacred to us, infused with wisps of incense and brightened with the small wick of an Indian oil lamp.

As soon as we returned from the wedding, we called Ahmedabad. Ben gave her heartfelt blessings and said kind words about "partnership in our commitment to make a difference in the world." Typical for Papa, he was barely audible through his tears: "So very, very sorry not to be able to be there on your special day." The most emotional part came as he sang in his faltering voice a Gujarati song from the famous play *Malela Jeev* (*Connected Souls*): "Your minds and hearts have been intertwined for ages, so now you reconnect on this earth in this lifetime, because you are meant to be." Papa's voice was weak, but his emotions were so palpable that even Robert, who barely understood a word of Gujarati, was in tears.

A few weeks after Robert and I returned from our honeymoon in southern Spain, we were awakened by a frantic call from Anu in the middle of the night: "Papa has had a massive stroke. He has been rushed to the hospital. Doctors are not optimistic and we have been urged to make plans to get to Ahmedabad immediately." "How could this happen? He's only eighty-one. He was making such good progress," I kept repeating to myself in between sobs. Robert finally broke in, "My dear Nanu, I know it's hard to hear this news. I'm totally in shock too, but we've got to get it together. We need to get

on tonight's flight out of Kennedy and we need tickets for the whole family. With your connections at Air India, you are the only one who can make this happen. I know how you feel, my love, but we all need you now."

Robert's voice calmed me as I tried to absorb the shock: Was it possible that I would never again be able to talk to my ever-curious, always-emotional father? At a moment like this, Ahmedabad felt unbearably far away. All the advantages of expansive belongings felt like empty concepts in the face of losing my beloved Papa. Unfortunately, there was no time to reflect on such colliding sentiments of belonging. I had a job to do. After several calls, I managed to arrange for all the tickets from my Air India contacts—not an easy task since it was the busy season of Diwali (Hindu New Year).

Upon arrival we were treated to the early morning sounds of firecrackers, the ubiquitous feature of Diwali celebrations, which brought tears to my eyes and triggered warmth in my heart: How Papa loved to buy a bushelful of firecrackers every Diwali! Now he lay silently in a small private hospital, oblivious to the joyous sounds of firecrackers. In the waiting room and on the front steps of the hospital, we were greeted by more than one hundred members of the extended family and friends, literally keeping vigil, sharing stories over cups of tea and snacks, and ready to help at any moment. The entire community had come together to offer unconditional support. As Atul Gawande describes in his wise book *Being Mortal*, when his grandfather reached old age in India there was no need to reserve a spot in a nursing home or arrange for Meals on Wheels. Surrounded by the community and assisted by one or more children, it was assumed that the older generation would be taken care of by the younger ones. As Robert remarked later, the United States may be the desired place of residence when you are a productive adult, but at the end of life there is no substitute for India where you can be surrounded by different generations of the family.

At least that was the case in many Indian cities three decades ago. Now with scores of Indians settling abroad, there has been a steep rise in elderly parents living by themselves or in assisted-care facilities. For older Indians, the absence of family as they age is a stress far greater than the pain of immigrants who leave family to seek greater fortunes abroad. All important life occasions feel incomplete without the presence of family. Lahiri poignantly describes this predicament in *The Namesake* when Ashima Ganguli gives

birth to her son Gogol: "Without a single grandparent or parent or uncle or aunt at her side, the baby's birth, like most everything in America, seems haphazard, only half true . . . She has never known of a person entering the world so alone, so deprived." In a way, the gathering of a larger community of family and friends at my father's side in his last days was a perfect example of what Ashima Ganguli would have desired to commemorate the birth of her first son. I couldn't help but recognize the sense of solidarity such conventions provided, cognizant of the fact that I couldn't count on such support in the United States.

Lying motionless on his hospital bed and breathing with the help of a tube, Papa appeared to be peacefully asleep. Everything was silent and still except for the soft pumping of the breathing machine, Ben's whispered incantations, and the quiet comings and goings of the hospital staff. The nurse who came to bathe him encouraged my mother and anyone else who was visiting to help her with the daily caretaking chores. For the first time in my life, I massaged my father's chest, back, arms, and legs, touching his once-powerful muscles and smooth skin, which were now softening and shrinking day by day. A giant of a man in his heyday, Papa now looked like an innocent boy totally dependent on the doctors, nurses, and family as he clung to his fading life.

Ben was the focused priestess of the hospital room, ready to do anything that could prolong Papa's life. Sleeping only a few hours a day and barely eating, Ben constantly but softly recited religious verses from her well-worn texts, desperately wishing that her focused energy would bring Papa back to consciousness. Some of us tried to tell her that even if Papa came out of his coma, he was unlikely to be anything like his former self. She spoke firmly as her eyes tightened around the edges, "It's too early for him to go. I'm willing to take care of him no matter what condition he's in, as long as he opens his eyes to look at me once again. Do you remember the story of Savitri in Mahabharata? She brought her husband Satyavan back to life with her dedicated penance and concentration. She's my model. I must concentrate my mind every single moment of the day so that I can transmit my energy to your father."

I had always thought of my mother as the rational one, a stoic figure who accepted fate while she kept her faith alive. In the traditional Hindu view,

death is not a final cessation of life but rather the transfer of the soul from one body to another future form. I had expected Ben to accept the inevitable passing of the soul and the end of the physical form with a degree of equanimity. Her ferocious determination to bring Papa back to life, referring to an example from the ancient text, was a big surprise to all of us. A year later when I asked Ben about her efforts, she quietly acknowledged, "I know it was my ego at work. I thought I could bring him back with my determination. I wasn't ready to accept the reality."

After a week it was clear that Papa wasn't getting any better. The hospital physician and my doctor brother Abhijit advised that the best course of action was to take my father off the ventilator and bring him home. Ben agreed to take Papa home but only with the breathing machine. Now the United States–based Desai family was in a quandary: we didn't know how long Papa's struggle would continue and we all had obligations back in the States. Abhijit's wife Julie was about to deliver twins, and my youngest brother Saptarshi's wife Parul had just given birth to a baby girl. I had to get back to New York for a major international conference.

At moments like these, the distance between our Indian and American lives seemed unbearably cruel. There was no way to stay back indefinitely, and yet returning to our daily lives in a faraway land seemed so trivial when it meant leaving behind our comatose father and our mournful mother. Reluctantly, we all flew back to the United States except for Anuradha, with our heavy hearts remaining in Ahmedabad.

The night after I returned, Anu called: "Papa went peacefully this morning. I even detected a gentle smile when I spoke in his ears that Abhijit and Julie had just given birth to twin boys." The next morning, sad and slightly bedraggled after only a few hours of sleep, I opened a conference on the future of Asia's great cultural heritage, speaking as calmly and frankly as I could:

Last night, I learned that my father passed away at age eighty-one. He had been in a coma for three weeks, so it wasn't unexpected, but it still sends a shock of sadness through me. My father was a fighter in India's Independence Movement, and a great journalist and author. He also loved art and instilled in me the love for the cultural heritage of India. His love for wooden fragments from old palaces and neglected stone sculptures from ancient temples was

instrumental in generating my passion for preservation. Today, my father is no more, but I am proud to say that his legacy lives on in this very gathering.

The audience rose in a standing ovation as my eyes welled with tears.

After Papa's death, my mother decided to compile a book of remembrances celebrating his life. My favorite stories came from his grandchildren who revered him less for his accomplishments and more for his loving spirit and boundless playfulness. My nephew Vishrut described the sheer joy of playing *tabla* (Indian drum) on Papa's balding head, tapping out little rhythms as both of them giggled with delight. My thirteen-year-old niece Antara remembered how Papa sang her favorite song about a young girl: "I look at a bird and wonder what it would be like to have wings and fly way up into the sky, hiding in the clouds from demanding mothers." Mourning her beloved grandfather's death, Antara concluded, "I only pray that if I am to be reborn on this earth many times, I will always want Nirubhai as my grandfather."

Papa loved Antara in return. She, her younger sister Anokhee, and their parents—my brother Falgun and his wife Shruti—lived with my parents at 38 Jawahar Nagar. So Papa had ample opportunity to spoil Antara and Anokhee with candies and caresses when they were young. He rejoiced in Antara's accomplishments especially at Sharda Mandir, which was now schooling a second generation of the Desais. A teenage superstar, Antara was beautiful and accomplished, a graceful dancer and a confident public speaker.

At age sixteen and on the brink of her highly competitive, statewide high school examinations, Antara worked herself into a near-frenzied state in the hope of scoring well enough to earn a coveted seat in medical school. When she began to complain of back pain, everyone assumed that it was caused by acute tension. Her mother offered massages and hot baths; the doctors prescribed painkillers and more sleep. Nothing worked and the pain became unbearable. My brother Abhijit, always the family medical adviser, urged Falgun and Shruti to insist on an MRI because the x-ray results were negative, and he promptly called one of his doctor friends to arrange for the tests. Upon viewing the MRI, the doctors took Antara directly into exploratory surgery.

I arrived in India for some Asia Society–related work and immediately went to Ahmedabad for the weekend. By the time I got home, Antara was

back from the hospital. As usual she was surrounded by family and guests, all assuring her that now that the operation was over, everything would return to normal. However, I knew something was terribly wrong based on the anxious looks on her parents' faces. When I insisted on meeting with them privately away from the ever-present throngs of family and friends, Falgun could barely speak as Shruti sat in a state of shock. Antara had Ewing's sarcoma, a rare form of cancer of the bone or soft tissues, generally found in children and adolescents. This type of cancer was usually located in the arms or legs (as was the case with Teddy Kennedy's son), so doctors would typically amputate the affected area and remove the cancer. But since Antara's cancer was in her back near her spine, it was impossible to operate without causing permanent paralysis or even death. The Indian doctors had determined that the best treatment would be in the United States and urged Abhijit, who was already researching various hospitals and treatments, to bring her to America if at all possible.

Falgun continued, "Shruti and I are not telling the family or Antara that she has cancer. Given the fear associated with it, it's best to keep it secret from the relatives in India." Shruti, shaking with fear, finally blurted out, "There's no way I am going to the United States. How would I survive there? I wouldn't have my own siblings around me for support. All of you are busy leading your own lives. I'd be taking care of Antara by myself in an unfamiliar hospital. Everything would be new and strange. I simply can't imagine how to make this work. We're not going to America. We will do what we can here in Ahmedabad and leave the rest to God."

I sat in utter shock—partly at the news of Antara's life-threatening illness but equally at Shruti's vehement response. The American side of me couldn't believe that Shruti wouldn't consider coming to the United States and doing whatever was necessary to save her child. And how could they not tell Antara about her serious condition? This secrecy violated every canon in Western medicine and psychology. However, in an Indian context, their responses— reluctance to share the news with Antara and the family, Shruti's concerns about handling it alone in the United States—were absolutely on target. It was inconceivable that she would face the most serious condition endured by her daughter in a strange land without her extended family. I looked into the fear-filled eyes of my brother and sister-in-law. They desperately wanted a response from me. What could I say?

Slowly, I let my Indian voice take over, tempering without entirely losing my American concerns: "Dear ones, what a tragedy—not just for dear Antara, but for both of you and for all of us. I am totally shocked, just like you. But this is the time when you must rely on the strength of the family. You must think of this as a difficult voyage with all of us in the same boat. Antara needs all the strength we can muster. Shruti, I understand your feelings, but please know that you won't be alone. We, too, are your siblings, your family. Antara must urgently come to the United States along with both of you. Her life depends on it. And I do understand why you haven't told her about her cancer yet. Cancer is a scary word in India. It's scary in America too. But in America, when we hear the word *cancer*, we immediately think about how best to treat it. In so many cases, doctors can control it or even cure it. But I will follow your guidance and we'll all wait until you are ready to tell Antara about the diagnosis."

I held Falgun and Shruti's hands as if we had a solemn pact, but I could tell from Shruti's trembling fingers that she was frightened, as much about her precious daughter's life as about coping with this horrific tragedy in unfamiliar surroundings. It was clear that we, the Desai family in the United States, would need to be by Shruti's side once we brought Antara to America. Now there was no time to waste. The international Desai family crisis management system responded to a red alert. Coping with all matters of logistics, Abhijit arranged for Antara to be treated at Cincinnati Children's Hospital, nationally recognized for pediatric oncology and with extensive experience in Ewing's sarcoma. With a base in Cincinnati, Abhijit and his family could offer a perfect support system aided by scheduled visits from the rest of the United States–based family when Antara was in the hospital. Through my connections at the U.S. embassy, I was able to arrange for visas on an unusually short turnaround time without having to take Antara to Mumbai, and we were soon on our way to Cincinnati.

Finally, after letting her settle in Cincinnati for a day or so, it was time to tell Antara the truth. Because her own parents felt unable to talk to their daughter about this threat to her life, the task fell on Abhijit and me. As we talked with Antara, she understandably became more and more upset, "Why me? What have I done wrong to deserve such a punishment? What kind of God would cause such a thing to happen to a young girl like me? Will I die right away, or do I have some time?"

I'm sure all cancer patients express these unanswerable questions, but when they come from one of your own, it is unbearably painful to witness. Abhijit the doctor, rather than the brother or the uncle, took over at this point. I suddenly had a new appreciation for my "little brother." He was frank and yet comforting at the same time, "I don't want to minimize the seriousness of this disease. But the first thing we need to do is to have a full round of tests and then determine the treatment. Yes, it's a serious form of cancer, but it's treatable. And the Cincinnati Children's Hospital is really good. So the only thing we can do now is to give it our best shot. But much will depend on you. You've got to be strong and determined. The treatment will not be easy; the doctors will give it their all. But we're a team and you're our star player. OK?"

Abhijit's words comforted Antara, easing her mind for a moment about the big questions, but fretting about what most teenagers worry about: her appearance. "I've heard that cancer patients lose their hair. Will I lose my long hair?" Abhijit nodded calmly, "Probably. But it will certainly grow back." Later, Julie, Abhijit's wife, consoled Antara with a lovely answer, "We'll cut your beautiful braided hair. Then you can keep it as a memory, but even more, as an inspiration for the future."

There was nothing felicitous about Antara's illness, except perhaps the timing. By the late 1990s, most of our family had immigrated to the United States, and the ease of phone calls allowed instant communication between India and the United States, replicating to some extent a feeling of a communal gathering at a traumatic time. Through the Make-A-Wish Foundation, we were able to get unlimited phone cards for Antara to be able to talk to her friends and family at any time of the day and night. (How radically different it was from the time when I broke my ankle in a ski accident during my exchange year in Santa Barbara! We had to schedule a call to my parents, which took three days, and it was the only call I made to India during the whole year.)

It turned out that Antara's condition was even more serious than we imagined: the tumor, roughly the size of a golf ball, right next to her spine, seemed to have metastasized to a spot near her heart. This required not only total body radiation and chemotherapy, but also an autologous bone marrow transplant. The treatment process took almost a year and racked up medical

expenses of a half million dollars or more. Of course, as an Indian citizen, Antara had no health insurance policy valid in the United States. We pooled what we could and created a successful fundraising drive (long before the age of crowdsourcing on social media), raising almost three-hundred-thousand dollars from both Indian and American friends. We also created a schedule of visits from Desai family members across the United States so that Shruti always had a family member by her side when Antara was in the hospital. Julie and Abhijit turned their home into a base camp, housing a small army of visitors and enlisting family and friends for all tasks related to Antara's extended hospital stays.

With our organized family network, we were attempting to re-create a feeling of an Indian support system for Shruti and Falgun. At the same time, Antara's illness also brought out the best in the American form of neighborliness. Many of Abhijit and Julie's neighbors took turns making food and taking care of their young children. The most amazing act of generosity came from Fred Hersch, a well-known jazz pianist and a close friend of one of the neighbors, but a complete stranger to our family. He offered a free concert at a beautiful hall in downtown Cincinnati to raise funds for Antara's medical treatment. I was fortunate to be in Cincinnati when he performed on a fall Sunday afternoon. Listening to his soulful piano playing, I kept thinking about the wonderful Vedic phrase about the magnanimity of those who can treat the whole world as family. Fred was the perfect example of that generosity.

A critical moment in Antara's treatment was the bone marrow transplant some six months after she had arrived in Cincinnati. A dangerous procedure, it required essentially killing the entire immune system to harvest the good bone marrow and rid the body of the rest, in the hope that the good marrow would take hold and render the patient free from cancer. When we learned that more patients died from transplant complications and resultant infections than from the cancer itself, I asked Antara's primary doctor whether there was any other possible treatment. Her answer was illuminating and chilling, "We've made huge advances in fighting all kinds of cancer, but we're very far from where we should be. Just imagine this—what we require to fight Antara's cancer is a very fine needle. Instead all we have is a big, clunky hammer. We're destroying a whole system in order to save it. Someday, with

stem cell research and DNA studies, we'll be able to do a highly focused treatment, but right now this is the best we've got."

A few days after the transplant, we received potentially life-threatening news: Antara had developed a serious infection, aspergillus, one of the fastest growing and most dangerous fungi that can attack patients after a transplant. The doctors were dumbfounded because Antara had been kept in a carefully sealed environment. They checked and rechecked all the standard transplant procedures; everything seemed perfect. One doctor asked Antara, "Was there anything out of the ordinary?" She answered, "Nothing I can remember. Except maybe when my mother put the special ashes on my forehead." The doctor said, "Special ashes?" Shruti interjected, "Yes, from a temple, the priest had offered the ashes to some relatives. They sent them to give blessings for a speedy recovery." The doctor replied as calmly as he could, "I'm sorry to tell you. But those ashes are most likely the cause of her infection." Shruti was aghast; the very thing that was supposed to have helped Antara was now a possible cause of bringing her to the brink.

In addition to taking strong antibiotics, Antara had to undergo the painful process of having the fungus scraped from inside her nose on a regular basis, as doctors struggled to keep the infection from spreading further. It happened to be my turn to be with Shruti at the hospital during this procedure. The situation was dire; I had no words to console Shruti and I could do nothing to spare Antara's excruciating pain. When Antara looked in the mirror, she could see that her nose was slightly crooked, further wrecking her self-image. I felt that Antara, who had been a brave fighter, was now close to giving up. Abhijit told Falgun and Shruti that there was little more that the doctors could do other than pray that the fungus subsides.

It was agonizing to watch Antara as she seemed to near the end with her willpower rapidly slipping away. Her primary oncologist, a wonderful female doctor, was clearly concerned and gently asked, "Antara, I know it's tough, but how are you feeling?" Antara, usually soft-spoken, erupted with anger, "I just can't take this anymore. Tell me why I should hang around for one more day. Every day is the same, more pain, and more bad news. Why should I fight, and for what? I'm ready to leave this world. Enough is enough." The doctor replied softly, "Antara, you know I always tell you the truth. You're in the most dangerous phase right now. I cannot predict the outcome. All the

doctors have tried their best. Now it's in your hands. You're courageous, a real fighter. So, it's up to you whether you want to continue to fight or give up."

Antara's demeanor suddenly changed. She raised her hand, just the way Papa used to gesture for reassuring emphasis, and though her voice was weak she spoke with perfect clarity, "Thank you and all the doctors. I know you've worked so hard to get me to this point. How can I let you down? I promise to fight on, not just to save my life, but to make sure all your work won't be wasted."

Wow! I burst into tears with a gentle smile. It was almost as if she was channeling Papa when he refused to buckle to the British jailkeeper. That day was the turning point. Against huge odds, Antara not only won the battle over the fungus, but also against the cancer itself. Almost a year later, she returned to India with little hair sprouting on her head but wearing a lovely shoulder-length wig of black hair. Somewhat frail but devoid of cancer, Antara was ready to reconnect with family and friends in India and begin her studies to become a top-flight physical therapist (the medical school dream had to be discarded in the cancer crisis).

In her near-death experience, Antara brought us closer as a family regardless of our physical distance. Ever since I had left India the first time at the young age of seventeen, I had gotten used to taking care of myself, at least emotionally. Now, I had a newfound appreciation for the comfort I took in knowing that one could always count on family, especially during the most vulnerable times. Antara's illness also reinforced my belief in the goodness of the larger world where artists like Fred Hersch could care for total strangers and do their part in making the world a better place. Living through the death of my father and the resurrection of Antara's life, I felt blessed to be able to get deeper into my intimate relationships just as I was beginning to expand my circles of belongings.

13

Perceptions and Problematics of Belonging

WHEN ANTARA RETURNED to Ahmedabad, she was the same age as I was when I returned home after my AFS year in 1967. Much had changed in the intervening three decades, but one thing remained constant: the trauma of return. By 1997, India was increasingly part of the global economic system, but the cultural shifts had not kept pace with economic changes. Antara and Shruti had been transformed by the dramatic alterations to their lives during their year in the United States but there was no way to convey to the larger society the profound psychological shifts they had experienced.

After a year of open communication with the doctors in America, Antara and Shruti were quite dismayed by the refusal of Indian doctors to share any information with them, treating them as if they were incapable of understanding complex medical jargon. Antara's boyfriend, someone she had known in school and with whom she had stayed in constant touch throughout her illness, had decided to end their relationship, possibly after learning that she could no longer bear children. The cruelest was the mocking response of one of her professors, "Your parents must have desired a boy when you were born. Otherwise who would want such short hair?" Shruti was furious: "No one would make such a comment in the United States. I had forgotten how Indians could be not only intrusive, but downright rude!" Regardless of their growing prosperity, frequent communication with

the outside world, and deeper connections to the West, social attitudes in tier-two cities such as Ahmedabad had not changed perceptibly in the late 1990s. Antara's encounter with her teacher at her college was a telling display of the prevailing cultural attitudes.

————————

AT THE BEGINNING of the new millennium, young Indians continued to come to the United States in increasing numbers but with an entirely different mindset. Now, these confident twenty-something Indians knew they could get a superb education and good jobs in the United States. But they could also return to India and find employment in globalizing Indian companies or in the Western multinationals that were setting up shop there. They could even become independent entrepreneurs and dream of amassing wealth quickly in India. In short, they had options that were simply unimaginable to the earlier generations of Indian immigrants.

Our energetic nephew Vishrut was a classic example of the new generation of Indian arrivals. By the time he arrived in New York in 2000 to go to business school, he knew he could count on us, members of the extended family in the United States, and had already been in touch with his Gujarati friends in the city. Through his extensive informal network of Ahmedabad friends now in New York, Vishrut had mastered the rudimentary but free Internet phone call system, making it easy to talk to his family and his girlfriend Reema every single day.

In some ways, I was jealous of Vishrut. He had it easy. He didn't have to deal with the discomfort of encountering an unfamiliar place with exotic customs. American television shows and Hollywood films, now readily available in India, along with photos and videos of relatives and friends from all over the United States had made America instantly familiar. He didn't have to struggle finding yogurt in supermarkets and he could even get his beloved *paan* (betel leaf) or the best *kulfi* (homemade Indian ice cream) at Patel Brothers in Jackson Heights. This easy sense of familiarity, even if somewhat superficial, made culture shock much less obvious. He was older than I had been when he first arrived in 2000. With his identity fully formed in India and his experience fully supported in the United States, he certainly didn't have to deal with the big questions of identity or acculturation in a new environment.

At least, so it seemed to me until I found him crying one evening after he had just talked to his parents. "Nanumasi, this is really hard! I simply can't imagine how you could have come here at such a young age, lived with complete strangers, and not just packed up and gone home! I know I am lucky to have you here, but I really miss home, the smell of that earth, the constant flow of friends and family, and even the messy traffic." I cried with him as I hugged him, not so much as his experienced Americanized aunt, but as the fellow traveler remembering the initial tremors of nonbelonging in an unfamiliar terrain. Even with all the advantages of instant communication and easy access to familiar foods, his emotional rupture was just as palpable. Recalling the sense of foreboding in my early days as an AFS student, I hugged him, "I know how much you hurt. The only thing I can say is that it will get easier. You'll learn new things that, hopefully, will compensate for the sense of loss you now feel." What I didn't say was that no matter how much India was part of his life even in New York, he would never be the same again. For better and for worse, America would now occupy a part of his heart forever, nudging out the exclusivity of India.

I remembered how much I had learned about myself and my new surroundings through unusual experiences, such as eating my first lobster and seeing my first ballet performance. And so, Robert and I decided to take on the role for Vishrut that the Reed family had played in my life more than three decades earlier. We rented great film classics such as *Dead Man Walking* and *Seven Samurai*. Our choice of food ranged from the great Korean vegetarian restaurant HanGawi in Koreatown to the neighborhood Mexican restaurant, Gabriela's. A vegetarian by choice (by now, most members of my family ate some meat), Vishrut was game for trying different things as long as he could use a generous amount of chili sauce to make it spicy. I joked that you could take an Indian anywhere as long as there was some chili powder around! After all, Vishrut was in good company: the great conductor Zubin Mehta is known to carry a bottle of chili powder to all corners of the world just to spice up his meals.

Once Vishrut moved to his own apartment in Queens, he searched online to find local cricket teams consisting of Indians, Pakistanis, Bangladeshis, Jamaicans, and Guineans. Like Robert, Vishrut did everything with focused passion—he joined a team, became its captain, suggested strategies, and arranged

schedules. Within weeks, his teammates—mainly Gujaratis, with a sprinkling of a few north Indians and Bangladeshis—became his primary social group and his new "adopted family." A year later, now married, Vishrut and his lovely wife Reema spent many weekends with his closest cricket buddies and their wives and girlfriends. We loved seeing them on weekends that didn't conflict with the cricket schedule, but their primary social life centered on their Gujarati friends.

For early Indian immigrants like myself, there were simply not enough Gujaratis around to find comfort in the familiar. I had changed from being an Indian living in America to becoming an Indian American in a decade. For Vishrut, there was a different option: He could participate fully in his American professional life during the day and remain exclusively within a strong Indian milieu during his nonworking life.

Being American by weekdays and remaining Indian by weekends was not unusual for a large majority of Indian immigrants by the early twenty-first century for two reasons. First, for most people working in corporate or mainstream America, the idea of diversity in the workplace meant that you could have a different ethnic background, but you were expected to adjust to prevailing corporate norms developed in the image of white American male leaders. (I once asked a Bangladeshi American corporate executive how much of his Bangla self he brought to work. Stunned by my unprecedented question, he thought for a moment and quietly replied, "Maybe 5 percent?") No wonder so many South Asian immigrant families spend so much of their social capital on feeding their Indian identities. I learned from Vishrut and his colleagues that I was uniquely blessed in being able to bring my whole self—Indian, American, and everything in-between—to my professional life. Ironically, this allowed me to explore my identity in a wide variety of contexts rather than being forced to feed the Indian psyche in short bursts of weekend activities.

Second, the essential features of globalization—communication and the constant flow of people—had made it possible for Vishrut and his friends to remain solidly local in the most global of cities. He could be an Indian in America without having to deal with the messy hybridity of being an Indian American, and he could contemplate returning to India (as he did ten years later) with many of the comforts that he enjoyed in New York.

Within the United States–based Desai family, as is true for many immigrants, there is a full spectrum of choices in the way we conduct our lives,

ranging from living a multicultural cosmopolitan life with occasional inter-jections of Indian experiences to having a predominantly Indian social life complete with elder parents who have emigrated to be with their children and grandchildren. On the Indian-American spectrum, we have numerous shades; one size doesn't fit us all. Regardless of our specific choices of lifestyles in the United States, however, Ahmedabad continues to serve as a magnet for the family: we all return on a regular basis, not only for special occasions but also just to get a dose of 38 Jawahar Nagar and bustling Ahmedabad in our veins.

An important part of our connection to Ahmedabad has been its special place in India's history as the birthplace of Gandhi's unique brand of non-violent independence struggle. Following the success of the Oscar-win-ning movie *Gandhi*, I proudly described my hometown as Gandhi country: "Remember the scene when Gandhi comes back from South Africa and establishes his first Ashram? That's *my* city." I had seen the film with my par-ents in Ahmedabad and Papa had spent a whole day reliving and analyzing the main events scene by scene. When I asked him if he was disappointed that it was not perfect, his answer was illuminating, "If this is the way the world will learn about this unique historical moment, we should rejoice rather than wish for a better rendition." I was never prouder of being a Guja-rati than at that moment, feeling that the voice of Gujarat would now echo all over the world thanks to the movie. A month later I personally experienced the impact of the movie when an Irish American installation staff member at the Museum of Fine Arts, Boston came into my office unannounced. Hav-ing just seen the film the night before, he couldn't wait to shake my hand, "I had no idea that your country produced such a giant of a man and brought the British to their knees without firing a single shot against the enemy! My ancestors come from Ireland and I know the unending tragedy of violence in that country with no resolution in sight. You should feel really proud to be from a place that can send such a powerful message to the world." At that moment, I was a proud Gujarati.

That Gujarati pride came crashing down on February 28, 2002, when tele-vision screens the world over projected images of ultraright Hindus torching Muslim sections of Ahmedabad. One of the worst ethnic riots in the history of independent India that some have called ethnic genocide, resulted in more than fifteen hundred deaths along with horrific incidents of rapes and mass

torture. In one week of cruelty, my Ahmedabad, the conscientious city of Gandhi, had become what some were calling the "Nazi Capital of India."

The first to be recorded and televised live all over the world, the 2002 massacre was the latest gruesome iteration of "communal violence" in India. In many ways a direct legacy of colonialism and the resulting Partition of the subcontinent, riots between Hindus and Muslims have occurred throughout the young history of independent India. Gandhiji, a strong opponent of Partition, saw it coming when he asked, "How do you divide a country when in every city, town, and village there are Hindus and Muslims living together for a thousand years?" His question went unheeded and he paid a heavy price for his views: a right-wing Hindu extremist, a forerunner of the extremist group responsible for the 2002 atrocities, gunned him down.

Ahmedabad had suffered from riots before, but we had always thought of them as aberrations, worthy of fighting such behavior and rising above them. I remembered the Hindu-Muslim riots in the 1960s, when Papa risked his own life to enter the Muslim communities to show his solidarity with them and to try to restore calm. In 2002, however, it seemed that a large majority of Hindus, including members of my own extended family, accepted chief minister (now prime minister) Narendra Modi's line that somehow, the mainstream English-speaking national media were out to attack "Gujarati pride." With a few exceptions, most Gujaratis sought to rationalize the riots as a "spontaneous response" to the torching of Hindus on a train on its way back from the holy city of Ayodhya, which was the site of a major riot in 1993.

Right after the riots, someone blindfolded all of the public sculptures of Gandhi in Ahmedabad. It was a visceral expression of the sentiment felt by at least some of us Gujaratis who were shocked as much by the atrocities following the Godhra train burning as by the "rationalizing responses" to it. Perhaps a gesture to spare Gandhi the horror that had befallen his beloved city, the blindfolding also suggested that the community and its elected leaders had become blind to the values of the most famous of Gujaratis, the father of the nation. The blindfolding statement was a powerful reminder of Gandhi's memorable phrase: "If everyone followed the policy of 'an eye for an eye,' then the whole world would be blind."

I have asked myself why I felt so crestfallen by the 2002 riots. They were horrendous, no doubt, but I felt personally betrayed. Growing up in early

independent India and steeped in the ideology of nonviolent struggle through my parents, I had believed in the idea of India always reaching for its higher ambitions: a multireligious, rules-based democracy with respect for all. I was proud to be a child of independent India that enshrined these values in its constitution and tried to live by them, even if imperfectly. My Indian identity and my Gujarati pride were entwined with such values. Now that pride and that identity had developed huge fissures. I felt sad for myself, for my parents who had dedicated themselves to living those values, and for the country that was built on such ideals.

INDIA'S SOUL WAS SOILED by the 2002 riots, but its economic might was ascendant everywhere, including in the United States. At Asia Society as well, there was newfound interest in the business potential of India, which meant more programs with rising CEOs like Narayana Murthy of the software giant Infosys and established leaders like Ratan Tata. As a senior leader of the organization, I was happy to take on expanded responsibilities that involved attendance at such programs as well as the oversight of the total renovation of the Society's Park Avenue headquarters. I worked closely with president Nick Platt and our architect Bart Voorsanger to envision a new design that could match our expansive programmatic vision.

However, my leadership role didn't spare me occasional condescending jabs from the engineers and workers on the job. Some comments were about my gender: "I know you mean well, but you must understand this is a highly technical job and you may not understand all the details." Others were about my ethnicity: "Back in India, you probably didn't encounter the advanced technology of a circular staircase that we can make here." Once again, others reminded me that my identity was not just based on *how I felt about myself*; it also involved *how I was perceived by others*. I was often pigeonholed into a type; there was no escape from being seen solely through my visible ethnicity even if that was not my exclusive reality.

The question of how I was perceived became quite evident in the next phase of my professional life. In 2003, Nick Platt announced his intention to step down as the president of the Society the following year. By this time, I had vastly expanded my portfolio, I had a proven track record, and I had the

most seniority after Nick. A few trustees privately reached out to gauge my interest. Robert also urged me to seriously consider the Asia Society presidency, noting that I had far more institutional experience than he had when he was tapped to become the president at the young age of thirty-seven. When I asked him about the search process, he replied, "Remember, like you, I was also the inside candidate. But in my case, there was no search at all. The board leaders simply made up their minds; two of them asked me over lunch if I'd do it, and that was it. I think they would approach you the same way."

I listened carefully, weighing the pros and cons, and then revealed some doubts: all five previous presidents were white men, generally from the diplomatic world, with the only exception being Robert, who had an academic background with policy expertise. There had never been a woman president, certainly not of Asian origin nor with primary expertise in culture. It just seemed realistic to assume that the board, especially the older white male members who happened to be some of the biggest patrons of the institution, would have a hard time jumping through three separate hurdles all at the same time.

A week later, I got a call from Richard Holbrooke, chairman of the board, asking for a meeting in his office. "As you know, Nick is stepping down next year," he began. "You've done a fantastic job at Asia Society. You know that I'm one of your biggest fans. I'd like you to be a candidate, the only inside candidate. I'm putting together a search committee as we've decided to conduct a global search. It will take some time. But I really hope that you will seriously consider being a candidate."

I tried to work up a smile, but said flatly, "Thanks, Richard, for your kind words. I'll get back to you soon." When I got home I took no pleasure in telling Robert that I was right in raising doubts; the job was not offered to me as it was to him. He was surprised and apologetic for raising my hopes. A week later I informed Richard that I was taking my name out of the running. He tried to convince me otherwise but when he realized I was firm in the decision, he said, "I'm really disappointed, but please know that you're a key player in this organization. Promise me you won't leave when the new president is hired." I told Richard that I couldn't promise anything, I wanted to keep my options open, fully aware that it would also depend on the selection of the new leader.

By early 2004, the search committee had come up with two candidates: a soon-to-be retired ambassador and a university president. Several trustees

were quite concerned that neither candidate had the requisite combination of Asia expertise, fundraising capabilities, and strategic vision to take the Society to new heights. Some of them reached out to me directly. "It's crazy that you're not in the running," one of them said. After a series of conversations, I finally agreed that I would be happy to talk to the search committee at the end of the process if they were not satisfied with the two finalists. Thoughtfully, several trustees on the search committee asked me what I perceived to be the barriers to my selection. As much as I thought of myself as a qualified candidate, I acknowledged that there could be unconscious biases turning into unspoken obstacles: Indian ethnicity, female gender, and cultural expertise seen as "soft" rather than policy. One of them said, "So those are the tough questions that must be asked and we will ask them."

I met with the search committee following their discussions with the two finalists. Right off the bat, some members of the committee bore in with sharp questioning: "Since you're an Indian American, how do you think Pakistanis and Chinese would feel about your Indian background?" I answered carefully, "As you know, I have worked with officials and professional colleagues in both countries and have strong connections in Lahore and Karachi as well as in Beijing and Shanghai. I'm committed to balanced programming across all Asian countries, with special emphasis on Pakistan as well as China. But I don't for a minute underestimate the potential challenges. I look to those of you with deep connections in these countries to help me out." The next question was about my being the first female president of the Society in the context of the patriarchal Asian cultures. I pointed out that many South Asian countries, including India, had already experienced female leadership. Besides, my two decades of professional experience in Asia had taught me that the best thing was to be myself with a strong awareness of the cultural nuances at play. "Of course, if required, I can always take one of you guys along to meetings," I jokingly concluded.

The final question was perhaps at the heart of my candidacy as it dealt with my academic background in culture. "You've done a great job in the arts. But the Asia Society president has got to speak for the whole institution, including on business and policy issues. Can you see yourself doing that?" My answer was honest but perhaps also slightly defensive, "As you know well, I love my work in the cultural field, but I have always defined that in the

broadest context, trying to show how art illuminates society, politics, and even economics. In fact, that was one of the attractions of the Asia Society when I first joined as the museum director. It comes from my early love of policy and my undergraduate degree in political science. It's worth remembering that while all previous Asia Society presidents specialized in diplomacy and policy, they also had to stretch to represent the arts. I hope you will trust me to be able to do the same in the other direction." I was right to worry, but I was also pleased that I could address all the biases directly and honestly. I guess I was getting used to being a "noncandidate" candidate.

In 2004, it shouldn't have been so exceptional to have a woman of Asian origin become the head of an institution dealing with Asia, especially a woman with fourteen years of solid experience. But one must remember that there were no female heads of major international relations organizations at the time, and definitely no one who was not white. The "bamboo ceiling" dealing with gender and ethnicity was well and alive for Asian American women in many parts of American life.

Within an hour, Richard Holbrooke burst into my office: "Congratulations, Madame President! I must tell you that you were my choice all along. You handled this beautifully. I can't believe that you even outmaneuvered me!" "Coming from a great diplomat like you I will take it as a compliment," I laughed, reminding him that it wasn't some grand strategy on my part. Bantering was an integral part of my relationship with this brilliant man who eventually became "my mentor and occasionally my tormentor," to quote another of his mentees, ambassador Christopher Hill.

Famously media savvy, Richard immediately fashioned a press release about my selection as Asia Society's next president. With the best of intentions, he proudly declared that the board didn't select me because I was "a woman or an Asian American, but because I was the best candidate." Richard meant it as a compliment, making sure the decision was gender- and culture-neutral, but for some reason his remark didn't sit well with me. It finally occurred to me that his well-meaning comment was actually misplaced. There was an implication in that comment that a white male heading the institution, a normative practice, was gender- and culture-neutral. A day later I gently chided him, "I know you meant well, but please know that as a woman of Asian origin, coming from an arts and culture background, I will

be a different kind of president. I want to use all of those distinguishing char-
acteristics to enrich my role as the next leader of the Society." It was my way
of claiming all parts of my identities and establishing the fact that leadership
is never neutral, it is entirely dependent on one's background, experience,
and skills. To his credit, Richard never repeated the statement.

Much to my surprise, I was awakened early in the morning by a telephone
call from my mother: "Nanu, there is a big photograph of you on the front
page of *Divya Bhaskar* (Gujarat's leading daily). They say you have been
appointed as the president of Asia Society. I knew the discussions were going
on, but why didn't you call me with this good news?" I couldn't believe that
she had already heard the news! I had no idea that the *New York Times* article,
first published online, would be picked up overnight and instantly translated
into Gujarati (as it was in many other Asian languages). It was clearly the
newspaper's way of claiming pride in my Gujarati identity.

Her momentary irritation aside, Ben was clearly pleased that the article
was on page one. Then she proceeded in typical Ben fashion, "You know Papa
would have been very proud of you to hear this news. But remember, your
new role is not about power but about responsibility. Don't forget the mes-
sage of Gandhiji that your father lived his life by: it's more important what
you will do with that authority than the fact that you have this new position."
"But Ben," I said, "How about you? Are you proud of me, too?" She deflected
my question. Ah me! Yet again, I had to accept Ben's inability to express real
feelings, especially when it came to giving compliments. Anyway, she did say
that Papa would have been proud. I guess that was progress.

Within days, congratulations poured in from around the world, and many
people even sent comments and suggestions. Some Indians wrote with delight,
such as the one who had "assumed that the first Asian to head the Society would
have been Chinese." Another Indian offered advice: "Don't be too India-cen-
tric, but don't abandon India either." Several other Asian Americans wrote with
pride: "I can't believe it. An Asian American heading a blue-chip Rockefeller
organization." Another gave me a little lecture: "Now that you are the first
Asian American to head a major international organization, you must diversify
the dialogue at the Society, bringing in new voices from the community. Now
you represent all of us." As I later told Robert, when he became president of
the Society I bet no one said that he had the responsibility of representing the

whole Euro-American group! So why did I have to represent all Asian Americans? In conversations with other colleagues of color in leadership positions, I have learned that this is a pretty common phenomenon; we are asked to hold the burden of a whole community on our shoulders. The only way this will stop is if such appointments become routine rather than exceptions.

After the news of my presidency became public and even before I assumed the new position, my first port of call was China. The decision was symbolic as well as strategic: China was increasingly seen as a global power and discussions of a G-2 relationship involving two global powers, United States and China, were making the rounds in policy circles. I needed to begin making new contacts and get up to speed on the policy dimensions of the U.S.-China relationship, arguably the most important bilateral relationship of the century. Equally importantly, I wanted to send a signal that as an Indian American I would give focused attention to the rising superpower and not necessarily show preference to India.

Robert was teaching at Beijing University (Beida) at the time, so he arranged a useful set of meetings on campus and with other foreign policy experts in the city. He also consulted with his students and with our dear friend Yuan Ming, a distinguished international relations scholar, about an important question: my Chinese name. They decided on Ding Wenjia—signifying someone of high culture and taste—and the cards with my new Chinese name were ready for me on arrival. It was nice to notice that the name produced smiles and nods from sophisticated Chinese scholars and government officials alike.

In my official discussions with the Chinese, I took pains to point out that as the incoming president of Asia Society, I was committed to all of Asia and all aspects of U.S.-Asia relations cutting across policy and business as well as arts and culture. I also reminded them that Asia Society had taken China seriously from the very early days of the opening between the United States and China, and I intended to continue that practice. But no matter what I said, I could tell that lurking behind the Chinese smiles were puzzling looks about who I really was.

Finally, it came out in the open at a banquet hosted by a retired diplomat who now headed a prestigious think tank connected to the foreign ministry. The guests included other former diplomats as well as scholars of U.S.-China

relations and specialists on South Asia. Over a sequence of Shanghai deli-cacies complemented with repeated toasts, we covered many subjects and talked about potential partnerships between our institutions. Finally at the close of the meal after multiple rounds of *mao-tai,* my host blurted out in flawless British English, "I know you will head the Asia Society, a prominent American institution. But who are you, really? Are you an Indian or an Amer-ican? When I look at you, I see an Indian lady, but if I close my eyes and listen to you, I think of you as an American. Your attitudes also seem more Ameri-can than Indian. Where are your allegiances? I am quite confused."

I was shocked. In a Chinese context, such a direct question, a clear depar-ture from the usual formalities, was highly unusual. I wondered if he would have been so blunt if I were a man and not of Indian origin. I was speechless for a moment. OK, I thought to myself, I had imagined the possibility of such a moment, but I definitely didn't think it would happen so soon! So, this is what came out:

> Mr. Ambassador, I'm glad that you have asked a direct question that seems to be on the minds of many senior Chinese officials I have met. Let me answer your question through a metaphor. I know as a Chinese intellectual you will appreciate it. If I were a tree, my roots would be Indian, and my branches, nourished by the roots, would be American. But as a fruit-bearing tree, I would be able to produce fruit that could belong to the world. That's the real essence of America. You can come from anywhere and become American without giving up your traditional roots.

I don't really know where this idea came from, but it felt very deeply rooted in my soul. I was proud to own my Indian heritage but also to claim my American identity, and I was not going to let a male Chinese diplomat define me in any other way. I'm not sure if I assuaged the ambassador's doubts about my identity, but I saw a slight smile on Robert's face across the table.

If my Chinese colleagues had a hard time understanding the fundamental aspects of my hybrid identity, I must say Indian colleagues—policy makers as well as friends—also continued to peg me primarily in the "Indian" cate-gory. They reasoned that because I was born and raised in India, I was more a non-resident Indian (NRI) than an Indian American, and they expected me to

emphasize Indian issues during my presidency. On my first visit to India after assuming the new role, I had to work hard to remind Indian colleagues and officials that I was hired as the president of the Asia Society, not an India society.

By the time I returned to India six months later in December of 2004 for some work and for my mother's ninetieth birthday celebration, there had been numerous articles about "the first Indian to lead the prestigious New York institution." Ben had saved each of the clippings, sometimes in triplicate if she had received them from other people. It was clear from the way she shared the news with family guests that she *was* proud of me. I was really touched when she asked me to say a few words at the dinner to be organized in her honor.

When I arrived in Ahmedabad on Christmas Eve, the preparations for Ben's birthday celebrations were in full swing: a music program of Freedom Movement songs by a wonderful social activist couple, a village school visit for fifty family members, culminating in a dinner for almost three hundred people. There were thousands of details to attend to, and I wholeheartedly threw myself into the preparations.

In the early morning hours of December 27, I was awakened by a call from Robert just before he left for India, "Nanu, have you been watching television? There has been a horrendous tragedy with a huge tsunami destroying parts of Indonesia, Thailand, Sri Lanka, and even Southern India, claiming thousands of lives." Barely awake and slightly irritated, I groggily replied, "I caught a bit of it in the news before going to sleep. It seems that India didn't suffer as badly. There were so many people at home that I didn't get a full picture." Robert persisted, "This is really big, involving many Asian countries. Have you thought about what you might do at the Asia Society?" "Good point. I will get in touch with Rob Radtke (my number two now) and ask him to put a condolence note on the website and get in touch with all of our International Council members in the relevant countries to ask what we can do to help," I replied, somewhat annoyed that my husband, the former president of Asia Society, seemed to imply that I wasn't paying enough attention to my role as its new leader.

I went back to my social obligations, meeting family members, decorating the backyard, and planning for the flow of each event. Robert arrived just in time for the visit to the village school. The highlight of the visit was a moving performance by a twelve-year-old girl who created a dance piece based on

the image of an inconsolable mother who had just lost her son in the tsunami. As she moved her hands up toward the sky, her long hair flailing about her, and let out a shriek, Robert looked at me and whispered, "You know I was not wrong to encourage you to pay attention to this tragedy of global proportions." Ouch! That hurt. I nodded reluctantly.

Three days later, all the celebrations successfully behind us, we left for Delhi. The minute we entered our hotel room late in the evening, I got a message marked urgent: "Ambassador Holbrooke is trying to reach you. Please call him immediately." Those were the days without cell phones and I had received no other communication from Richard. He literally barked into the receiver, "Where have you been? I have been desperately trying to connect. What good is the Asia Society if it can't play a major role when one of the biggest tragedies has struck the region? I know this is the holiday season and you are in India, but where is your staff?" He wasn't satisfied with my answers about the website and about reaching out to our contacts in the region. "Everyone is trying to figure out how to help, where to send the money, and how to organize the much-needed support. Asia Society must be the first place people go to find answers, and you must figure out how best to handle this, NOW."

Robert saw my concerned face. He knew as well as I that as a nonprofit institution, Asia Society had usually not been involved in fundraising for other causes. But this was not the time to argue with Richard Holbrooke, and I also realized that these were no ordinary times. I immediately went to work to develop a comprehensive plan of programs with help from Robert. Around 2 a.m. as I finished sending the proposal back to the office, Robert gingerly asked, "Nanu, why is it that when I tried to get you to pay attention to your professional responsibilities in Ahmedabad, you sort of brushed me off?" Exhausted from Richard's yelling and our long late-night efforts, I burst out crying. As my tears finally receded, a quiet thought emerged, something I hadn't thought of before.

Even though I prided myself on being a cosmopolitan Indian American, there were times of dissonance in my multidimensional self. When I was in Ahmedabad, I went back to my childhood self, a member of the family, often trying to prove that I wasn't selfish, overdoing my familial obligations. I put the family (my Indian self) ahead of my professional life (my American self). I had gradually learned to bring my familial Indian self to America, but

I had not yet fully integrated my American self into Ahmedabad. It was a reminder, as acknowledged by many scholars and writers like Tina Nguyen that productive constructions of new hybrid identities are made up of active processes that require maintenance and negotiation simultaneously, both of the original home and the new host culture.[1] The work of living in multiple worlds and integrating them into a more seamless whole was a continuous process, and I would have to tend to it for my whole life.

IT WAS FORTUITOUS that my presidency at Asia Society coincided with the meteoric rise of China and India and dynamic growth of the whole Asia Pacific region. It was time for a more expansive vision for Asia Society, one that would acknowledge the need for a partnership among the regions of Asia and the United States with a real sense of parity. As well-meaning and even necessary as the original mission was—to educate Americans about all aspects of Asia—it seemed to imply that Asia was exotic and far away, a place to be understood and appreciated. It reminded me of the time when I first arrived in the United States when I, too, was exotic, from a faraway place, and needed "to be understood."

There was a liberating quality to our work now: the goal was to engage Asian colleagues and institutions as equals in order to work together on global challenges. It was also far closer to the way the emerging Asian powers saw themselves, and it suited both parts of me—Asian and American—much better, too. Now the question was to figure out the ways we could develop new programs and increase our presence in Asia to reflect this nascent global phenomenon of rising Asia and foster greater collaboration among Asians and Americans.

And so, as part of the fiftieth anniversary celebrations of Asia Society in 2006, the board decided to open the India Center in Mumbai to add to our robust center in Hong Kong and somewhat smaller efforts in Melbourne and Manila. By now the Indian economy was roaring and American flights to India were full of American businesspeople opening new offices and establishing businesses. Younger Indian Americans were beginning to return to India in search of a better economic future. It was reasonably easy to get multiyear financial commitments from major business leaders for the establishment of the India Center, which made it possible for us to time the announcement

in conjunction with the Society's annual corporate conference in Mumbai. We secured prime minister Manmohan Singh as the chief guest of the conference and officially inaugurated the India Center of Asia Society, attracting attention from all major media outlets.

Twelve hundred business leaders, journalists, and government officials from more than twenty-eight countries had registered for the conference. The biggest news was the presence of two hundred fifty Chinese business leaders who had accompanied the charismatic commerce minister and then rising star (now in jail) Bo Xilai. Security was tight and the Mumbai glitterati, used to just showing up at the last minute and getting VIP treatment, were disgruntled to hear that they needed to register in advance for entry into the Hyatt Grand Ballroom.

The prime minister made a formal entrance with ambassador Richard Holbrooke, as I waited for them by the stage. We viewed the India Center inaugural plaque and lit a tall bronze ceremonial oil lamp to consecrate the Center. As we walked across the stage to take our appointed positions, the prime minister recalled our previous meetings and pleasantly surprised me by agreeing to stay for dinner after the proceedings (many national leaders give speeches before such dinners and then leave immediately). I smiled, took a deep breath, and walked to the podium.

In my opening remarks, my goal was to portray a new Asia Society, with a reach across all cultures and countries in the region without diminishing my Indian identity or my background in arts and culture. Of course, that was a much-nuanced point surely to be missed by a buzzing crowd proud to see an "Indian" at the helm. I began the conference by welcoming the prime minister and all our guests from around the world. It's all a blur in my memory now, but I do recall that my concluding statement elicited a big round of applause: "This large gathering is a potent illustration that India's time has come. The whole world is watching where India is going."

Frank Wisner, former ambassador to India, graciously introduced the prime minister. Dr. Manmohan Singh, meticulously dressed in white *kurta pajamas* and his characteristic blue turban, spoke in his familiar soft voice, requiring the audience to listen carefully to his words. He congratulated everyone for the opening of the new India Center and recalled his first Asia Society speech in 1991, at the very beginning of the economic liberalization

processes that he had initiated. And then came a sentence that took me by surprise, "We are proud of the fact that Dr. Vishakha Desai, a daughter of India, is now at the helm of this distinguished institution, providing special insights about our country's ancient culture and its contemporary aspirations to American audiences." The entire audience erupted in a prolonged round of applause as I sat stunned in my seat.

The leader of the country had called me "a daughter of India"! The phrase rumbled in my head for days, bringing up unexpected and surprising emotions. Why did it have an almost magnetic power on me? Finally, it dawned on me: the traditional Indian concept of a daughter is a perfect metaphor for my life. Raised with an awareness that her original home is but temporary, an Indian daughter is taught that her ultimate destiny is to leave that home and to join another family, the family of her husband. Even today, Indian weddings feature a poignant ceremony where the newlywed daughter says a tearful goodbye to her own family as she prepares to become a member of another. (For me, the parallel was the wrenching experience of leaving Ahmedabad for America back in 1966, the first step toward accepting a life in my adopted country.) But then there is an important twist in the traditional path of the daughter: freed from the strict obedience expected in her original family, the mature daughter makes return visits to her maternal home for the birth of her children (as was the case with my mother at the time of my birth). At such times, the daughter not only reaffirms her ties to her parents, but also has the maturity to be the ultimate confidante to them, often serving as a dispassionate but trusted adviser.

Yes, I was a daughter of India, simultaneously an insider and outsider, a participant and an observer, a fierce witness and a dispassionate critic. But in this traditional notion of a daughter, it also meant that I had my feet firmly planted in America. Indeed, it was the flexibility and openness of my upbringing in India and my life experiences in a multicultural America that had made it possible for me to be a daughter of the universe, functioning as an Indian, an Asian, an American, and a human often separately but occasionally even simultaneously.

ART

A 'Contemporary Being' at the Asia Society

By HOLLAND COTTER

Vishakha Desai is raising eyebrows by emphasizing the dynamic and evolving nature of Asian art.

Vishakha Desai, director of the galleries at the Asia Society—Seeking to overhaul the society's enduring image as a bastion of the old.

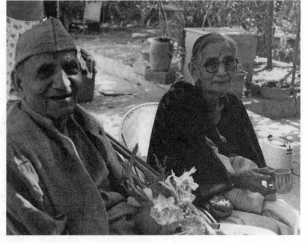

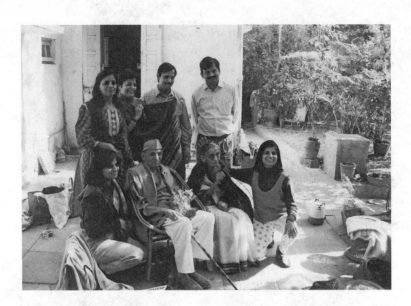

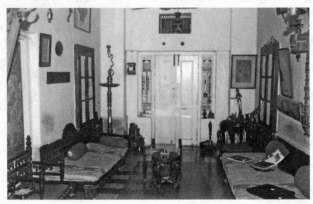

PART V

At Home in the World

*I long, as does every human being, to be
at home wherever I find myself.*

—MAYA ANGELOU

14

Building Communities
across Borders

I N THE FIRST DECADE of the new millennium, it was increasingly evi-
dent that the language of mutual respect so prevalent in the 1990s, while
necessary, was no longer sufficient. In the ever-more-interdependent
world, the in-between-ness experienced by so many of us cultural nomads
had other possibilities, including living a new form of global reality so aptly
described by author Salman Rushdie in *Satanic Verses:* "How does newness
come into the world? How is it born? Of what fusions, translations, conjoin-
ing is it made? How does it survive, extreme and dangerous as it is?"[1]

My teachers in this endeavor of forming new connections were young
social activists and entrepreneurs, Fellows in the new Asia Society program
called Asia 21. I was amazed to see the ease with which these young leaders
from different regions of Asia and the United States moved across disciplines
and geographies from the moment they encountered one another. Utterly
committed to their individual causes in local settings, the Asia 21 leaders were
intrepid in connecting their work to a global context. Their global inclinations
didn't come out because of the power of some generalized global idioms. In
fact, their understanding of the global and their desire to connect across cul-
tures were deeply ingrained in their local and personal circumstances.

Take the example of Shaheen Mistri, the founder of Akanksha Foundation
and Teach for India and an Asia 21 leader. A daughter of a multinational bank
executive, she left India at the age of one and lived in five different countries

and attended ten schools across them by the time she was eighteen. A proto-typical Third Culture Kid (TCK),[2] Shaheen belonged nowhere in particular and had learned to be at home wherever her parents took her. On one of her annual visits to Mumbai to see her grandparents, the eighteen-year-old Shaheen saw young slum children begging in the streets. A common occurrence in India, this time it changed the direction of Shaheen's life. She dropped out of Tufts University in Boston, moved to Mumbai, and enrolled at St. Xavier's College. One year later, Shaheen founded Akanksha ("aspiration") in a rented space in a private school where she began with fifteen students from the Mumbai slums with help from a few college friends as volunteers. She also enlisted family and friends in America to support her cause. Now two decades later, the Akanksha Foundation works with more than 10,000 young people in Mumbai and Pune, supported by a nonprofit charitable arm of the foundation in America. In utilizing her global experience and connections to create an enduring national organization, Shaheen has followed in the footsteps of the great global leader Mahatma Gandhi, a master of using his deep global learnings in the service of creating a powerful national movement, which in turn had global implications.

Shaheen has attributed her ability to be determined and flexible at the same time to her experience of moving around the world and having to adapt to different situations. The same characteristics are found in many TCKs. They learn to discern commonalities in different people, seeing them as humans first rather than identifying them with a particular religious, cultural, or national group. Self-described "inhabitants of the world," many TCKs are strangers to their parents' "home country." Aware of the fact that she really didn't know her "home" country well, Shaheen put her adaptability and transnational experience to productive use by choosing to put her roots down in an unaccustomed terrain. (It's worth remembering that not all TCKs are able to use the advantages of being flexible to create something completely new in an unfamiliar space. In fact, many also suffer from what scholars describe as "confused loyalties" and have difficulty defining where they belong).

Shaheen's ability to be locally grounded and globally connected was even more evident in her subsequent project, Teach For India. Recognizing the need for systemic change in the Indian education system, Shaheen sought out Wendy Kopp, the legendary founder of Teach For America in 2007 and

launched Teach for India the following year, becoming a founding member of the new global network, Teach For All. Today, Teach for India is widely recognized as one of the pathbreaking teaching models helping to reimagine the Indian education system for the betterment of all children. Young leaders such as Shaheen and other leaders in the Teach For All network, comfortable with the processes of globalization, intuitively grasp the idea of building a global community out of locally driven organizations where they can share best practices and learn from each other.

The Asia 21 program was developed in the halcyon days of economic globalization in 2006 when the rise of Asia, especially China and India, changed the equation of global processes. By 2006, we were past the globalization of the 1990s when American and European corporations were spreading their wings, leading to accusations of the McDonaldization of the world. The next phase, identified by Tom Friedman as Globalization 3.0 in his seminal 2005 book *The World Is Flat*, was more the age of the World Wide Web, with multidirectional movements. In fact, the title of Friedman's book was based on his conversation with the Indian entrepreneur Nandan Nilekani, referring to the flattening of economic opportunities and commerce in general. So, while GE was actively pursuing business in India and hiring staff to build things in India, Indian software companies like Infosys (cofounded by Nilekani) were also pursuing software contracts in the United States and were being listed on the NASDAQ. Korean, Japanese, and Chinese companies were increasingly seen as global powerhouses. Clearly, the question was not *whether* we would have a global community but rather *what kind of* a global community we should create.

The Asia 21 young leaders were not simply seeking economic opportunities in the world. They intuitively grasped the necessity of rethinking relationships that could incorporate local, regional, national, and global dimensions in their work. These young leaders were building new communities across Asia, America, and the world, reminding us that it was not enough to understand each other and respect differences. They were using their cultural and professional differences to forge new partnerships: a NASA engineer creating science education in partnership with a Nepali teacher committed to science literacy for girls, a Chinese environmental activist working with a Japanese scientist to study the effects of pollution on seafaring communities. Fueled by the tools of globalization—technology, transportation, and

communication—Asia 21 leaders were able to connect their local passions with large global challenges and resources. They were, in effect, global citizens. I was energized by their work as they inspired me to think about being part of a larger global community that could be created out of a shared vision without losing local roots. It was no longer sufficient to learn to be comfortable being a player in and an observer of the orchestra of one's liminal life. Becoming a conductor of the life and creating new forms of belonging were the challenges and the opportunities of the day. In a globalizing world, it was necessary to envision a larger frame, a third space that could emerge from living in a liminal, hybrid space of multicultural belongings.

THE EUPHORIA AROUND the "flattened" world and global trade came crashing down with the Great Recession of 2008. No institution was spared the effects of the worst economic crisis since the Great Depression of the 1930s; Asia Society was no exception. Perhaps we were hit harder than other cultural institutions precisely because we were on an incredible growth trajectory, raising money in Asia and in America for new centers and new programmatic initiatives. Almost overnight, some of our major corporate supporters, from AIG to Morgan Stanley and Merrill Lynch, almost collapsed or suffered heavy losses. They reduced their philanthropic efforts to almost zero, and we felt the corresponding blows. As one of my trustees mentioned, it felt like we were on steroids and we literally had to come to a screeching halt instantaneously. One of the hardest days of my entire life was when we had to let some longtime employees go, reducing the staff by 10 percent. I had evolved with the institution and had worked hard to create an atmosphere of common commitment to its growing mission with new programs and initiatives. I often described Asia Society as a family with mutual concerns and a shared mission. It felt like I was breaking up the family, and it hurt terribly. Clearly, Asia Society was not alone. Most institutions around us also had to tighten their belts and reduce their budgets, but that was hardly a solace. In addition to reducing staff, we curtailed several programs; but I was determined to keep Asia 21 alive, as I knew that it was part of the institution's future.

It took us a while but we did regain our footing. By 2012, we were getting ready to open two spectacular buildings, one in the heart of Hong Kong,

renovated and designed by the talented husband-and-wife team of Tod Williams and Billie Tsien, and the other one in the museum district of Houston, designed by the Japanese legend Yoshio Taniguchi. This was the beginning of a new phase of Asia Society, decentering the preeminence of New York in the life of the institution and moving toward manifesting the parity of partnership that we had envisioned when I took over the presidency.

I had been at the Society for twenty-two years when we inaugurated these wonderful new facilities. I was proud of what we had achieved, but most importantly I felt that I had also learned a great deal about myself and about the world. But I must admit, I was also tired and beginning to think about a life with less institutional responsibility. The young leaders of Asia 21 had created an itch in me to work with younger people more actively. Despite the economic shocks faced by the powerful forces all around the world, these young leaders continued to engage with their local communities while connecting with the world. Now in my sixties, I kept thinking about the advice I had received from the Museum of Fine Arts (MFA), Boston director when I was considering the Asia Society offer in 1990: "One can always go back to teaching at an older age." It was time to go back to my first passion, teaching and working with young people and having some flexibility to reflect on the learnings about art, politics, and the global condition I had accumulated over the years. I was keen to develop a life that would include teaching and engaging with global issues through institutions, beginning with universities.

I stepped down from Asia Society in the fall of 2012. I thought I had planned this big change in my life carefully. I would have three months before taking on my new responsibilities as special adviser to Richard Armstrong, director of the Guggenheim Museum, and as special adviser for global affairs to Lee Bollinger, president of Columbia University. My Columbia affiliation also included a graduate seminar on the intersection of culture and foreign policy in China and India for the School of International and Public Affairs (SIPA) and a membership in the Committee on Global Thought (CGT). I was particularly excited about CGT, an initiative created by President Bollinger in 2006 with the express purpose of "developing new forms of transnational and interdisciplinary knowledge necessary to understand the interdependent condition of the world." It seemed ready-made for my interests.

As excited as I was about starting a new life that would also allow me more flexibility, I was totally unprepared for my final departure from the institution that had been my professional and intellectual home for more than two decades. I fought back tears as I spoke at the large gathering of staff, trustees, friends, and colleagues from around the city on my last day. It was almost as difficult to leave Asia Society as it had been saying goodbye to my family in India for the first time to go to an unknown place called America. Now I was just going uptown, some forty-six blocks away, but it felt as if I were leaving a family, one that I knew would always welcome me back but to a place that would no longer be my "home."

When I stepped down from the Society, my professional identity was completely intertwined with an institution. In fact, it was so for my entire adult life. I was not emotionally prepared for beginning a life without a central anchor. I had thought that the new unencumbered life would provide a sense of freedom, but for a while it felt like my ship, without an anchor, was listing about without a clear course. Harder still was the acknowledgment that freedom from institutional responsibilities creates space for new possibilities. It can feel like a vacuum and it is entirely up to the individual to configure a new combination. For me that new life turned out to resemble a wheel with multiple spokes. As Robert mentioned, it suited me well as a person who was always more comfortable juggling multiple balls in the air and living a life of multiplicity.

I planned to enjoy quiet three months, a rarity in my professional life, catching up on sleep, indulging in my passion for cooking, taking leisurely beach walks with Robert at our home on the North Fork of Long Island, reading, and working on writing projects. But several things happened all at once, interrupting my dreams of a quiet interlude and thrusting me into multiple new dimensions of a global life. Right after I stepped down from Asia Society, I was invited to join the board of Mahindra and Mahindra, a vehicle manufacturer that was one of the largest Indian companies with increasingly global operations. The incoming CEO Anand Mahindra had been a trustee of the Asia Society. As he was getting ready to take over the helm from his uncle, the long-time leader of the company, he had decided that he also wanted to signal the change by appointing the company's first female independent director of the board (long before it became a law in India). I was

not an obvious choice for the position, as I was neither a businessperson nor an expert in cars or trucks. But Anand was clear, "We have plenty of business expertise, but I want to have someone with deep knowledge of Asia, especially China and Korea, two countries where we have operations. And I feel that your professional experience in managing a global organization with nine centers all over Asia and America would be very beneficial to us."

I was thrilled to have this unique perch to think about global engagement through an Indian prism while learning about the realities of creating a truly multinational company, steeped in the Indian cultural ethos but with a commitment to understanding local cultural attitudes and idiosyncrasies that can affect the success of a business venture. Contrary to Friedman's assertion about the world being flat, I saw that the world was full of peaks and valleys; prejudice against the companies from the Global South was well and alive. For an Indian company to become truly global and to be perceived as "world class," it was important to be mindful of the perceptions of external partners and work doubly hard to gain that position. (It reminded me of the adage that women leaders had to be twice as good and work twice as hard to achieve the same position as men.) The special bonus of the Mahindra appointment was the ability to visit my ninety-eight-year-old mother every quarter, even if only for a day on a three-day trip.

The other unexpected development was my re-engagement with AFS after a gap of forty-five years. In 1968, A year after my return to Ahmedabad, Prime Minister Mrs. Indira Gandhi stopped the AFS program in India as a visible statement of strong anti-American sentiment and in retaliation of Richard Nixon and Henry Kissinger's pro-Pakistan and anti-Indian stance,. Her argument was that India's brightest young minds were being brainwashed by American values, causing "brain drain" and affecting India's future. Nothing was further from the truth, but the program ended in 1969 and I lost touch with the organization. Our connection was rekindled when an enterprising AFS staff member saw the article about my appointment as president of Asia Society in the *New York Times* and noted that I had credited my global awakening to my experience as an exchange student.

Less than a week after the announcement, I got a call from the president of AFS International to speak at their annual gathering. The organization had transformed from being an American exchange program (students coming

to and from United States from around the world) to a truly transnational program in 1989, now encompassing more than ninety countries. (More than 6,500 students participate annually in the program, many crisscrossing the world from Italy to Turkey and from Colombia to Japan.) Recognizing the need for India to rejoin the AFS global community, I helped in small ways to revive the India office in 2005, but I didn't have time to be more engaged with the organization while running the Society. The moment my retirement from Asia Society became public, AFS leadership immediately got in touch with me to join the board. Feeling that it was now my time to give back to the organization that had been instrumental in changing my life, I agreed.

Once again, AFS has become pivotal in my global journey. As a board member and as chair since 2016, I have met thousands of returnees (those who went on the program like me), host family members, and community volunteers, not just at AFS international meetings but also at gatherings in unlikely places: international conferences in Doha and Paris, a board meeting in New York, and at a Christmas party in Southold, Long Island. The minute we realize that we have the AFS experience in common, our faces light up and the first words out of our mouths are "it changed my life." All our cultural differences melt away and our shared experience of being AFSers creates an exhilarating and instantaneous feeling of meeting an old friend who was a stranger only moments before. It's the type of familial experience that is shared by Peace Corps workers, Fulbright scholars, and participants in many other international programs that engender the experience of an expansive belonging.

Through anecdotal conversations I have also learned that many of us AFSers end up engaging with the world in various professional and personal capacities. They range from Christine Lagarde, the past president of the International Monetary Fund (IMF), to Jan Eliasson, the former deputy secretary general of the United Nations. In a recent alumni survey conducted by AFS with more than 10,000 respondents, 88 percent said that their AFS experience helped them connect with people from different backgrounds long after returning home, and 90 percent reported that AFS prepared them to adapt in a diverse workplace environment and inspired them to seek careers in international settings. A comment by Felix Brackman, a Belgian exchange student to Bolivia, is emblematic of the response from many alumni: "AFS was my gateway to the world. As a teenager I had rarely left my hometown.

Motivated by my AFS transformation I pursued a degree that would allow me to see more of the world. After living in Portugal, South Africa, and the Netherlands, I am now living in Tanzania. Thanks to AFS, I could build a career in international development cooperation." Felix was an exchange student in the 1990s, but his comments are remarkably similar to those made by Jan Eliasson at Columbia University in 2018 who went on the AFS program in the 1950s from Sweden to Wisconsin. In 2017, an American student in Accra, Ghana, expressed it best, "What we share as AFSers is the fact that once your eyes are open to the world at a young age, you can't close them again."

With all the goodwill and commitment to world peace at its root, even for AFS it is neither easy nor simple to operate in a global space with a true sense of parity and mutual dependence. In my capacity as the board chair of AFS, now a transnational program operative in nearly one hundred countries, I have learned firsthand the challenges of creating a global organization that is considerate of the national constraints and local attitudes. We can all agree on our aspiration to create a better world through deep experiences in intercultural learning, but how do we deal with power dynamics of nation-states? What about unconscious cultural biases that negatively affect a sense of parity among network partners with unequal resources? How can the partners with more financial bandwidth support those with less? We can create great experiences for the young people who go on our programs but how do we practice what we preach in our operations? Issues of misperceptions, power, and equity continue to create barriers to successful implementation of our mission.

As a member of the AFS "family," I am exhilarated by the passion of our participants, students, families, and communities of volunteers all over the world to create a more just and peaceful world. They are implementing and building on the vision of the young ambulance drivers in World War II who were the founders of AFS. But I also know from experience that creating an inclusive community of globally minded individuals with local roots and national orientation is still a work in progress, full of treacherous holes and exhilarating peaks.

15

Remaking "Home"
in the World

"8 SIBLINGS. 4 TIME ZONES. One WhatsApp Group." As soon as I read the title of this op-ed in the *New York Times* (June 2, 2019), I knew the article was written for people like my family. In the days before WhatsApp, we stayed in touch with weekly phone conversations, e-mails, and occasional group chats to organize family reunions and share information about Ben's health. As mentioned by Maeve Higgins, the writer of the *Times* piece, our mother was also adamant about being available, always, for each other especially when help was needed. Now, equipped with modern technological tools, we were able to fulfill her injunction far more easily than during my early days in the United States.

I WAS ABLE TO SEE Ben more often than any of my siblings in the United States, thanks to my travels for Mahindra. Quite frail physically but alert mentally, Ben was well looked after by my brother Falgun and sister-in-law Shruti and an around-the-clock caretaker. But lonely in our big and now-quiet house, she eagerly awaited my visits every four months. She really appreciated that I took the time to be with her even if it was only for a day or a weekend. Throughout the four decades that I had been away from India, she never asked when I would be back or why I wasn't staying longer. But now with her strong rational mind slowly fading, she was far more emotional

and even on the verge of being needy, something we never expected from our "Rock of Gibraltar" mother. Now her questions betrayed her yearning for connection: "Couldn't you stay a little longer? Couldn't you take a little more time when you come next? I wish we could talk more about the places you are visiting. Which country has the best values especially for women?"

During those brief stays, I loved reading aloud to her articles from the newspaper that would interest her. I happened to be in Ahmedabad a few weeks after the infamous Nirbhaya gang rape case in December 2012 when the papers were full of stories about the case and the large protests by women and men across India. Normally quiet and busy with her spiritual readings, Ben was really riled up about the Nirbhaya case. Weighing less than sixty pounds and unable to walk without a cane or a walker, my diminutive mother kept asking me about taking her to the protests: "How can a country that we fought for and all the work we did for the women's solidarity come to this? You know that was my life before I married your father. I must go to the streets now." She was so insistent that it was hard to talk to her about anything else. In those moments of energy, the flashes of the firebrand she must have been in her twenties were abundantly clear. Rather than dissuading her, the only answer was to take her hand in mine and hold it for a while or gently massage her head and forehead. Seeing her gentle face slowly relaxing, and hearing her say *"bahu saru laage chhe"* (it feels so good to feel your touch), was the true bonus of such visits. I felt that during these "bonus visits" we bonded at a deeper emotional level through small gestures and simple physical touch, providing a sense of completion in my relationship with Ben.

Aware of her gradually declining health, we decided to have a big family gathering in January 2014, to celebrate her one hundredth birthday months in advance of her actual birthday in September. All thirty of us—children, spouses, grandchildren, and great-grandchildren—descended on 38 Jawahar Nagar for almost a week. Ben relished the few signature events scheduled in her honor, especially the afternoon visit with her old friend Elaben, founder of the Self-Employed Women's Association (SEWA), that turned into an impromptu family discussion about women's rights. A wonderful family concert of semiclassical and devotional music with her favorite singer was the only large gathering planned for the occasion. Her favorite activities, however, were gatherings of the family over meals in our beloved backyard. Shruti

expertly planned all the meals following Ben's special recipes, paying special attention to the sweet and savory anchor dishes. One day it was *undhiu* (a special winter vegetables stuffed with fresh coconut, coriander, green chiles, and ginger) and *magni dalno shiro* (a sweet dish made out of mung bean dal). The main dishes were complemented with yogurt curry or different kinds of dal, salads and chutneys, rice, and *puris* (big deep-fried, puffed bread). Another day, it was a simpler South Indian meal of *idli* (fermented rice and lentil steamed dumplings) and *sambhar* (split-peas dal stew with onions, tomatoes, eggplants, and other seasonal vegetables), followed by homemade mango ice cream. Ben tasted everything with the tiniest of bites, usually approving the dishes but occasionally also offering suggestions for the correct spicing.

Basking in the warm winter sun refreshed by the gentle breeze in our garden, we sat around for hours chatting, eating, and welcoming friends and relatives who dropped by. Sometimes our numbers swelled to fifty people for lunch, but there was always enough food for everyone. You could tell from her soft smile that Ben treasured seeing her beloved Jawahar Nagar full of people again. She loved seeing her whole family together, gently reminding us, "I hope you will always have the kind of harmony that I see now, even when I am gone."

As 2014 progressed, it was evident that Ben's end was near. At moments like these, as was the case with my father's passing, the distance felt unbearable. No amount of calls or e-mails could replace the reality of being with Ben, holding her hand or combing her hair. We took turns to be with her and help out Falgun and Shruti during those final months. I kept the cell phone by my side day and night, dreading the inevitable news. It finally came in early September. My San Francisco–based brother Saptarshi, on duty in Ahmedabad, phoned: "Ben is in the hospital ICU, with infection in her lungs, and it looks like we're losing her." All four of us, Swati, Anuradha, Abhijit, and I, followed by Anokhee (Antara's sister, one of the grandchildren now in the United States), dropped everything and flew to Ahmedabad to say our final goodbyes. Antara, strongly discouraged by her doctors, was unable to go with us to see her beloved Nimu (never to be called Grandma at Ben's insistence) but stayed in touch with her through daily video calls.

Entrapped by the oxygen tube in her nose and a feeding tube in her mouth, Ben was well taken care of in the small private hospital where Papa had been.

Her frail body could barely move from one side to another, and her ears had almost given up trying to make any sense of our last-minute messages. Hardly cognizant of our presence, she couldn't speak much but when she did, it was always about "light, open doors, and home."

After several days in the hospital, it was evident her condition was deteriorating rapidly. Determined to make her final days as comfortable as possible, we brought her home, arranged for round-the-clock nurses, and outfitted her room with a brand new air conditioner (something she had always hated, but was now necessary), an oxygen unit, and a special mattress. We prepared the materials for the final rites—a brand new *khadi* sari, a butter lamp, and a pot of *gangajal* (sacred water from Ganga at Varanasi)—and waited for the end. Without our spouses and children, and without any other social commitments of our own, it was as if Ben had determined that we needed to bond as brothers and sisters. We ate together, sang Ben's favorite *bhajans* (semireligious songs) and Gandhian songs together, and took turns sitting with her. We even brought a cake and celebrated her upcoming birthday on September 25 several weeks early, fearing that she may not make it to that day.

Ben surprised us all by staying alive for three more months, long enough to reach her actual one hundredth birthday (even reminding Shruti that she knew we celebrated her birthday early), and long enough for me to visit her several more times. Finally in the late morning of December 18, 2014 (around 10 p.m. India time), my niece Antara called while I was in my office at Columbia: "Nanubua, Nimu has gone into coma. Arjun has just created a Google Hangout for all of us to come together to say our final goodbyes."

The whole family gathered—the Indian side in person, and the U.S. side through the video connection—from New York, Boston, Baltimore, Cincinnati, and San Francisco. Ben seemed very peaceful, her breath slowly diminishing. We spontaneously began chanting *Shri Krishna Sharnam mamah* (I give my all to Shri Krishna) and singing her favorite Gandhian song, *Vaishnav jan* (the one called virtuous who feels for others). Tears rolling down our eyes, we sang as much to come together as a family and provide comfort to each other as to ensure the safe passage of Ben's soul to another world. She quietly slipped away from us in her sleep around 11 p.m. (India time). I was grateful for the tools of technology that made it possible for us to bid our treasured mother the final goodbye.

We saw Ben, at least her body, for the last time late in the evening (early morning in Ahmedabad) on the video screen, now dressed in the crisp white *khadi* sari bought for the occasion, her head surrounded by beautiful rose petals. I couldn't help but recall the wedding photograph of my parents, when she wore a plain *khadi* sari made from cotton woven by my father, wearing no jewelry but flowers in her hair. It was as if she was getting ready to be reunited with her beloved husband to begin a new life somewhere else. Her face looked peaceful, but as the male members of the family lifted her body to take her out of her beloved 38 Jawahar Nagar for the very last time, it felt as if the very life of the house left with her. It made me think of the traditional Indian belief in the life of a temple. Was 38 Jawahar Nagar going to be a temple no longer in worship, a lifeless ruin (*khander*)?

Robert and I left for Ahmedabad the next day (two days earlier than scheduled) to participate in a special ceremony for my mother (akin to sitting shiva in the Jewish tradition, called "sitting" or *besnu*) to represent the United States–based family. Over a four-hour period, hundreds of family, friends, and admirers filed quietly into a large hall, each nodding to our family seated on the floor cushions then bowing to the garlanded photograph of Ben before taking a seat on the mattresses and cushions covering the floor. As the eldest son, Falgun sat to the left of the photograph shrine; next was Robert, now the oldest member of the extended family. Following custom, female members of the family, led by Chitra and Shruti, sat on the right. An instrumentalist and a singer offered quiet meditative music, especially Ben's favorite Vedic chants.

On our return flight to New York, Robert and I kept ruminating about 38 Jawahar Nagar, Ben and Papa's lives, and their impact on our lives, punctuated by tears, a little dozing off, and just holding hands. Childhood images of 38 Jawahar Nagar at its height—full of giggling children, political bigwigs, friends in need, adopted family members, visiting jewelry saleswomen, booksellers, and more—kept going through my mind. Over the years, our family home had gotten increasingly quiet as many of us created new homes on the other side of the world. But Ben at 38 Jawahar Nagar had been our anchor. Our lives were punctuated by the visits we made to be with her, individually or collectively. Now she was gone.

Was this the end of a home that had been so central to the Desai family ethos? I burst out crying loudly enough to wake up Robert who had just

dozed off. Gently brushing away my tears, Robert held my hands. "Nanu, I don't think that 38 will ever be the same again, but that's not the point. 38 Jawahar Nagar is not just a wonderful ramshackle house. It's a spirit that infuses the family, including adopted newcomers like me. I've seen it and felt it. Now it's time to bring that spirit forward. That's what really counts." Robert's words provided the solace I needed. Soothed by his gentle touch, I gradually fell asleep with thoughts of bringing the spirit of 38 to our home in Southold.

When we landed at the Kennedy airport the next morning, I was keen to drive out to Southold and feel the salt air of the Long Island Sound by our house. Robert's words were now intermingled with sentiments expressed by the great writer Pico Iyer: "Home is something internal, invisible, and portable, especially for those of us with multiple roots in many physical places. We have to root ourselves in our passions, our values, and our deepest friends."[1] Ben and Papa had given us the special gift of being rooted in a place while being open to the world. We had the privilege of growing up in a home that provided intense formative experiences, but we were also given the opportunities to take our values, our passions, and our sense of attachments to new places and grow new roots.

This is not an option available to millions of migrants and refugees, who have to flee their homelands in terror and by necessity. For them, the pain of starting in an unfamiliar place against the memories of their lost belongings can be excruciatingly painful. So I consider it a rare blessing that I could remain deeply attached physically to a place while sowing new roots elsewhere. But I also know that the question of "home," as Pico Iyer described, will be a question that I will always be refining and adding to, without forming a definitive answer.

———————

WITH BEN'S PASSING, inevitably the familial relationship to 38 has changed. For one, the house is closed for months at a time while Falgun and Shruti, now retired, spend more time in the United States with the families of their daughters. These days when I go to Mumbai for Mahindra board meetings, I often don't manage to get to Ahmedabad, and when I do go I end up staying with my sister Chitra's family or with my nephew Vishrut. Every other year,

we come together at 38 for a family reunion and refresh our attachment to the place by hanging out in the backyard, enjoying the gentle movement of the swing, and eating delicious snacks with endless cups of tea. Falgun has insisted on not changing the living room decorated with folk bronze objects and other items collected by Papa over the years. The only additions are individual photographs of my parents decorated with sandalwood and cotton garlands, usually brought alive with incense and fresh flowers when we are at "home."

In many ways, for me the feeling of "Home" (with a capital H) has now shifted to our home in Southold. Even though I have a strong affinity for New York City and when people ask me where I live, I always say "New York," it is in Southold that I come closest to replicating the spirit of 38 Jawahar Nagar. Having family gatherings, cooking dinners for family and friends, playing bocce games in our grass backyard by the Sound, reading a book on a small stone patio overlooking the water, enjoying the spectacular sunsets in the summer, and being with a circle of people you care about over leisurely meals, are all the elements of making a home that I associate with 38 Jawahar Nagar.

I have learned to slow down in Southold and get grounded in a physical space that feels reminiscent of 38, especially after long trips that take me across the world for my diverse work portfolio. After years of living in the world of policy and institutional administration, Southold has also brought art back into my life, now through Robert's incarnation as an artist.

After his work with Asia Society and after publishing *A Fractured Mind*, Robert came to artistic practice almost by accident. Soon after arriving on North Fork, during one of our usual beach walks Robert picked up a piece of wood with unusual curves and sharp angles lying on the shore. Judging from its sun-bleached shimmering color, it seemed to have been there for quite some time. He brought the piece home and started cleaning it, removing dirt, pieces of pulp, and outer bark. He moved the piece around to look for the point of balance and attached it to a small base. The next step was to make sure it was protected from the elements. Always a tinkerer of sorts, Robert loved experimenting with different materials and gadgets. He finally settled on the ingenious idea of milk paint, used centuries ago by farmers to paint their barns to make them bug resistant and able to withstand bad weather. By the time he painted and waxed it with organic Brazilian wax, the dead beach

wood had gained a new life. The whole process of finding, cleaning, and protecting the "right" wood with appropriate "energy" was his idea of heaven. The minute we both saw the completed piece, we almost shrieked in unison, "It's so much like the Chinese scholars' rocks!"

Both of us had long appreciated the Chinese practice of seeing art in a "found" rock weathered under lakes and streams by forests, perfected by *wenren* (literati) for a millennium. As a historian of China, Robert was familiar with the importance of the carefully selected rocks in the architectural interiors of the Chinese literati class. By placing small rocks in their studies, the scholar-intellectuals brought the expansive world of nature into their contemplative inner sanctums, serving as a memento of the beauty of the world beyond. As described by a twelfth-century Chinese writer, "within the size of a fist can be assembled the beauty of a thousand cliffs." Usually these objects were sourced by artisans from special locations and often enhanced to look more "naturally" misshapen. Robert loved the fact that he simultaneously assumed the roles of scholar, artisan, and artist: seeing the beauty of the piece, lugging it from the beach, cleaning it, and giving it the final form that became an art object.

I first came across Chinese scholars' rocks in a graduate seminar on Song dynasty China in Ann Arbor in the mid-1970s, and instantly fell in love with the concept and the form. When we organized an exhibition of the Richard Rosenbloom collection of scholars' rocks in the late 1990s at Asia Society, I was once again awed by the utterly contemporary sensibility of "found" or environmental art that the Chinese had perfected long ago. Like the Chinese works, Robert's creations were simultaneously products of water, wind, and trees of the North Fork, while symbolizing the larger world. William Blake described it vividly in his famous poem, "Auguries of Innocence":

To see a World in a Grain of Sand
And a heaven in a Wild Flower
Hold Infinity in the palm of your hand
And Eternity in an hour ...

Blake wrote the poem to evoke expressions of innocence, but for me it also conveys the power of imagination embodied in the act of making and

experiencing art. Once again, I was reminded of the reasons for my deep attachment to all forms of art: whether an art object or a piece of music or a fragment of dance, it can be deeply grounded in a specific place and a particular time while transcending such specificities to connect human beings across geographies and histories.

In so many ways, art is a perfect metaphor for the way I think about globality for individuals. The experience of art is deeply personal and individualistic, creating a sense of *rasa* that the sixth-century Indian philosopher/scholar Abhinav Gupta described as the sentiment art evokes in the viewer, the listener, and the connoisseur. From that aesthetic experience felt individually, we connect to the deepest parts of our humanity and create a shared experience of being human with billions of strangers who inhabit this planet. In this way, we "see the world in a grain of sand" as Blake reminded us.

Coming back to art in Southold was like coming home in a different way. I had worked long and hard to live easily in different cultures; transporting my feeling of home from 38 Jawahar Nagar to Soundview Avenue in Southold was part of that process. Bringing art to the center stage of my life again was perhaps akin to experiencing 38 Jawahar Nagar with a fresh pair of eyes and new sets of experiences after Ben's passing and imbuing it with new meaning. I had kept my professional interests in separate compartments: a dancer, an art historian, a policy analyst, and a student of contemporary politics. At Asia Society I had begun to see them interact more closely. But now I was involved in creating a new space of fusion, breaking the professional silos that usually kept my artistic and intellectual lives apart.

16

Creating a Culture of "Us"

T<small>WENTY-EIGHT STUDENTS</small> trained in ten disciplines from twelve countries in one seminar. It sounds like a recipe for the worst kind of intellectual cacophony in a classroom, but that's what I loved about my graduate seminar, Politics of Culture in a Global Context. Not only did it create a space for me to explore the intersection between my different passions, but it also provided a forum for students to learn to listen carefully to very different perspectives and question their own assumptions. I loved questions that resisted easy answers: Why do we mistrust China's recent efforts to use their cultural "soft power" to project global prominence, even if they are taking a page out of the American playbook of cultural diplomacy during the height of Cold War? (Is it about power or about our perceptions of power?) How should we think about art museums in the West that house the objects gathered or looted from former colonies? (How do we reconcile the dual nature of art—both as a transcendent force capable of connecting people from diverse cultures and as a product of a particular time and place, embodying the power structures now considered abhorrent?)

Depending on their academic and cultural backgrounds and lived experiences, the students answered such questions differently. But as they listened to each other and read diverse arguments by scholars in different academic

disciplines, they also began to develop more nuanced global perspectives on relevant issues. They came to see that rather than being generalized and abstract, any discussion of global or transnational issues had to take into consideration the particular context and perspectives of the scholars doing the writing, while also being cognizant of the voices missing from the debate.

BY 2015, I FELT that I had really found my "global groove" and young people were at the heart of it. Traveling the world for AFS and Columbia and teaching in the Global Thought program, I felt like a student again, learning from young people who seemed to be global natives, at ease with the latest technology, conversant in global issues, and committed to climate change. They lived in the interconnected and interdependent world that I had learned to relish as an essential ingredient of the twenty-first-century reality.

My steadfast belief in the inevitability of a globalizing world came crashing down on November 8, 2016. I was en route from Beijing to Mumbai on the evening of the U.S. elections, which also happened to coincide with the first day India's unprecedented demonetization policy went into effect. Frustrated by the delays in paying the parking fees (because of the disappearance of the 500 rupees notes overnight) and feeling deprived of the anticipated celebration of Hillary Clinton's presidency, I called Robert as soon as I arrived at the hotel in Mumbai. He was with a group of our friends to celebrate the assured victory of Hillary Clinton. Speaking over the boisterous crowd, Robert tried to convince me that it was late in India (4 a.m., India time) and I should try to get some sleep since the result was going to be clear. Anxious to see for myself, I turned on CNN and didn't sleep a wink. At around 10 a.m. (11:30 p.m. U.S. time on the previous night), John King of CNN said there were no more electoral votes for Hillary and called Donald Trump the winner with three million fewer popular votes.

I burst out crying. How could an avowed antiglobalist known for his sexist acts, bigoted attitudes, anti-immigrant rhetoric, and outright lies win the

highest position in the country? Admittedly not a perfect place, the United States had a long history of being "a safe and agreeable asylum to the virtuous and persecuted part of mankind, to whatever nation they might belong" as described by George Washington in 1788.

When Barack Obama was elected in 2008, I had felt that he was our first true global president, a son of an African father and a white mother with his childhood spent in Hawaii and Indonesia. He had given hope to immigrants and multicultural children alike when he said, "I have brothers, sisters, nieces, nephews, uncles, and cousins, of every race and every hue, scattered across three continents, and as long as I live, I will never forget that in no other country on Earth is my story even possible." Obama promoted the idea that to love the nation that celebrated its worldliness was a desired goal. Now we had elected a man who had turned this incredible diversity embodied in the forty-fourth president of America into a false campaign of his "foreign-ness," turning all of us who saw ourselves in President Obama also into "foreigners." I was distressed to contemplate the future for women, black and brown people, sexual and gender minorities, and immigrants of all stripes under the new regime of Donald Trump.

Of course, I was not alone. Newspaper writers and television pundits were full of self-reflections and criticisms. All national polls and well-known commentators had predicted a win for Secretary Clinton, even if they were critical of her policies, practices, or attitudes. Soon there were many books pointing to globalism and its divisive impact as one of the major causes for the success of candidates like Donald Trump the world over. It was most starkly stated in the title of Ian Bremmer's 2018 book, *Us vs. Them: The Failure of Globalism.* Bremmer described how as a young man growing up poor in Chelsea, Massachusetts, he saw that the "American dream came wrapped in a package of 'globalism,' a belief in universal interdependence and the international exchange that seemed to provide paths to prosperity." But he came to see that "Globalism creates plenty of winners and losers, and those who have missed out want to set things right. They have seen their futures made obsolete. They hear new voices and see new faces all about them. They feel their cultures shift. They don't trust

what they read. They have begun to see the world as a battle that pits 'us' versus 'them.'"[1]

Soon this divisive sentiment of "us versus them" was in full force, stoked by President Donald Trump at every opportunity. He made a virtue of being a nationalist by saying "the future doesn't belong to globalists but to patriots," pitting "them"—those who equated a love for the country to encompass humanity—against "us"—those narrowly defined as people wishing to "protect" America by building walls against the world. This general feeling was evident not just in America but also in the United Kingdom and in parts of Europe, where "new" voices and cultures of the migrants, often direct consequences of recent and distant colonial histories, threatened the imagined stability of what the "native inhabitants" perceived as cohesive, monocultural societies.

The virus of divisiveness has now spread across the world. Political leaders in other parts of the world, from Turkey to Poland and from Brazil to India, feel similarly emboldened to foment discordant sentiments. Often in the name of nationalism, political leaders have sowed the seeds of separation in many parts of their societies. In India, after a decisive victory in the national elections, the divisive rhetoric of the ruling Bharatiya Janata Party (BJP) against minorities, especially Muslims, is at an all-time high. The principles of respect for diversity and protection of minorities' rights enshrined in the Indian constitution are being threatened. And freedom of expression, a necessary element of a functioning democracy, is constantly curtailed with an exponential increase in the attacks on intellectuals and public figures who are perceived as being critical of the government.

For the longest time, I felt privileged to be part of two cultures that took diversity as their strength. America has "e pluribus unum [from many, one]" as its motto, and India has "*Vasudhaiva Kutumbakam* [treat the world as family]" engraved at the entrance of its parliament. I was proud of the fact that the ideals of the two countries, even if imperfectly practiced, were based on equality and opportunities for all. As the African American writer Langston Hughes said, "Let America be the Dream the dreamers dreamed," even if "it never was America" for people like him.[2] The founders of independent India

dreamed of a country that would protect its minorities, celebrate its diversity, and respect cultural differences. As Mahatma Gandhi said, the idea of India entailed being open to the world while keeping its foundation strong: "I do not want my house to be walled in on all sides and my windows to be stuffed. I want the culture of all lands to be blown about my house as freely as possible, but I refuse to be blown off my feet by any."[3] As I saw it, such values, embedded in the psyche of the two countries, made them more hospitable to the ideals of global belonging. It was deeply disheartening to see that the leaders (and large swaths of populations who supported them) were shattering what I considered to be the best aspirations of "my" two countries; values that I deemed essential to pave the way to multirooted global belonging.

There is no question that the attacks on all things global, and all values related to global responsibilities and respect for cultural diversities are fierce. Some, especially those surrounding economic globalization, are justified and in need of serious reconsideration. To be fair, the critique of globalization has come from the progressives as well as the conservatives. So, if Trump's followers got enamored by the "America First" slogan, the young people in Bernie Sanders' camp also savaged globalization as exacerbating inequality at home and abroad. The image of predatory elites (primarily from the West, but also increasingly from other parts of the world) ready and willing to extract wealth from anyone and anywhere while leaving the less privileged in their wake has been behind much of the backlash against globalism.

In India, its elected leaders have fomented division along religious rather than economic fault lines, masking the real economic issues of the country in the process. References to the "green virus" standing in for Muslims (green being the color of the Pakistan flag), being wooed by opposition parties are being made by elected political leaders while vigilante groups roam the streets brandishing homemade weapons and shouting anti-Muslim slogans to intimidate Muslim religious gatherings. Many Indian Muslims have expressed fear of walking around in their own neighborhoods. Even in my own extended family, it is difficult to have a dispassionate discussion about the policies and practices of the ruling

party that threatens the very fabric of the syncretic culture of India woven over several millennia.

Increasingly, the resentment and divisiveness has seeped into issues of cultural identity in the United States as well. It is most egregious on the political right in the anti-immigrant rhetoric and increased attacks on minorities. Notwithstanding pronounced differences, it is also prevalent among the more progressive groups and among many students on university campuses in the questions they raise and movements they support: Does a white artist have a right to paint a portrait of an iconic black teenager who was murdered by a white man? Can a white person teach African literature or Indian history when he or she is the direct descendent of the colonial masters who perpetrated so much misery in the regions? These are important questions to raise in light of historical wrongs perpetuated by powerful majorities. But how does one address such legitimate issues involving social justice without creating another kind of fissure of "us versus them"?

Mark Lilla, a professor at Columbia University, created quite an uproar in 2017 when he published his critique of liberalism and put it at the doorsteps of identity politics in *The Once and Future Liberal: After Identity Politics*: "Identity politics on the left was at first about large classes of people— African Americans, women—seeking to redress major political wrongs by mobilizing and then working through our political institutions to secure their rights. But by the 1980s, it had given way to a pseudo-politics of self-regard and increasingly narrow and exclusionary self-definition that is now cultivated in our colleges and universities. The main result has been to turn young people back unto themselves, rather than turning them outward toward the world."[4]

Lilla's arguments may sound exaggerated, but it is worth thinking about the implications of debates around identity politics and cultural appropriation. Is it possible to avoid hostility against those whose values and actions directly contradict your sensibilities? How do we encourage curiosity about people and cultures that may be different from our own? How do we generate empathy that comes from cultural encounters if we insist on singular "ownership" of culture? When thinking about these issues, I am reminded of

Gandhi's famous statement that India's grievances were against the government of the British, not against the British people. In the heat of the fight, it is difficult not to demonize the aggressors, but as Martin Luther King Jr. and Nelson Mandela also remind us, we need to learn forgiveness if we believe in our shared humanity. As hard as it is to raise these questions without sounding naïve or looking like an apologist, they become vital for those of us who steadfastly believe in learning to live together on the earth full of nearly eight billion strangers.

OVER THE LAST FEW years, I have come to realize that the central problem lies in pitting global imperatives against national or local interests. These false binary narratives take away from the reality of the world we all live in, and they ring particularly untrue for young people. Many polls taken of young people all over the world show that they understand the necessity of caring for the planet while taking care of themselves. The strong presence of young people of all colors and cultural backgrounds at recent protests in the United States as well as in India suggests that they are committed to creating a more inclusive society. It is not surprising that the large majority of Generation Z is very passionate about the climate crisis and is concerned about the plight of refugees.

I know from my graduate students and young people I meet around the world that they are capable of understanding the complexities of identity politics at a local level and in a historical context while also acknowledging the necessity of creating a more just and sustainable world. They know that it's futile to build walls, physically or virtually. For young people, the looming climate crisis is an everyday reminder that without coming together as a global community, we are doomed collectively and individually. These are not just abstract thoughts for the youth of the world; they know their future depends on successful handling of these weighty issues.

The ability to simultaneously think and act locally, nationally, and globally comes even more naturally to students younger than the graduate students in the Global Thought program. As a part of a team of researchers on the CGT project Youth in a Changing World, I have been working with

young people (ages eighteen to twenty-four) in Rio de Janeiro, Istanbul, and Nairobi. We have conducted focus groups and discussions with more than five hundred students of diverse backgrounds, ranging from elite universities to community centers in seven different countries. Across geographies and economic classes, I have been struck by three consistent findings in these gatherings: (1) Young people, no matter where they live, are frustrated by the limitations of the systems created by their elders to respond to the pace of change they feel all around them. (2) Equally aware of their local issues (bad roads, corrupt politicians, and lack of jobs) and global challenges (climate change, migration), they strongly feel that we must be able to tackle both. (3) A large majority of them intuitively understand that the global world order is changing, with Euro-American power declining as China continues to rise.

Much to my surprise, the students in Rio, Nairobi, and Istanbul are more interested in connecting with the world beyond their borders than American students (especially if they are from privileged Euro-American backgrounds). The students in the Global South are aware of class and ethnic strife in their own countries but they also want to know about how such issues are handled in other places, particularly outside of the Western world. As a student in Rio said, "We get too much information about America and Europe. We really want to learn about young people in China and India. What are they most worried about? How do they see their future? We have no clue. It would be great to connect with them." Hearing these comments, I am both buoyed by the idea of these young people taking the reins of the world, and distressed to acknowledge that it is my generation that has failed them: we have not created a flexible framework that can respond to the pace of change we have thrust upon their world.

The best part of these workshops is the concluding exercise of a collective drawing. At each location of the workshop, we meet in a large group for introductions and to set the context for the workshop. Participants are then divided into smaller discussion groups to address specific issues that range from education and technology to their sense of belonging and their future. In the smaller workshops, they first discuss the assigned

theme together and then visualize their ideas on a large piece of paper with colored pens. As they plan their visual design, the points become much more poignant and powerful, often surprising the participants themselves.

In Nairobi, a small subgroup was charged with imagining their future and how it compared with what their parents experienced. Their discussion focused on the difficulties of finding a job after they graduated from the University of Nairobi. The drawing was amazingly stark: it began with a curved road full of potholes at the top left corner of the paper with an old British-made car and adult passengers in old-fashioned attire. The road precipitously turned into a steep fall, not a car in sight, as it reached the middle right corner of their paper.

As the workshop participants came back together at the conclusion of the program, each group of eight stood proudly by their large drawing, eager to share their experience and explain their drawing to the rest of the participants. The group with the steep road drawing had identified a young woman as their spokesperson. With a passion in her voice and tears in her eyes, she began her explanation, "Our parents faced plenty of potholes in the road and they didn't have the latest of anything, but their future seemed steady. Now it feels like things are changing dramatically all around us and in the world and we are in a free fall. No security and no options."

The collective drawing made their feelings more potent, as if coming from somewhere deep inside their souls. Their art had given voice to their innermost but unexpressed emotions. There was no escaping from the worries and pain expressed so viscerally in the image, neither for the viewers like me nor for the student creators themselves. Once again, I was brought back to the power of art as a catalytic force that can connect across cultures through deeply individual experiences. It was an apt reminder of the famous saying by Albert Einstein: "I am enough of an artist to draw freely upon my imagination. Imagination is more important than knowledge. Knowledge is limited but imagination encircles the world."

The image of the steep cliff on the road kept reverberating in my mind long after I left Nairobi. I was disturbed by the dystopic vision it created, and struck by its stark contrast with my banyan tree metaphor of a collective,

global belonging. Multirooted and expansive, the banyan tree invites a quiet meditative mind to go deeply within, but provides a gentle breeze coming from the air beyond and flowing through its large and small roots reminding us of our connected humanity. Using the metaphor of the banyan tree, I often make the case that we can fight for our little patch on earth and pretend that it is our world, but we have no choice but to live simultaneously in our little patches, in our national borders, and in the larger world and understand their interconnections.

I now realize that for the young students in Nairobi and for young people everywhere, the image of a banyan tree may not describe their reality. Impatient and restless about the fast-changing condition of the world, the next generation wants answers about their future now. The metaphor of an ancient banyan tree that takes its time to grow wide-ranging roots all around its center feels too passive and unrealistically tranquil for the generation that already inhabits a fast-changing multilayered life. It may also seem too dated.

Like a banyan tree, I had the luxury of growing into the reality of a multirooted global belonging over a lifetime. Born at the dawn of a newly decolonized nation and learning to live in America at an early age, I incorporated new worlds incrementally into my life. The pace of change that I learned to live with was unimaginably leisurely compared to the impossible simultaneity of forces that young people must contend with on a daily basis. I learned to grow and nurture my multiple roots over a lifetime, which in turn helped create a firmer ground to stand on while facing an unfamiliar future. Today, the only thing young people can count on is the speed of change: steadiness of the future is one thing they don't have. The limits and failures of the systems they have inherited from the older generation only exacerbate their inability to deal with the world they inhabit now.

The drawing of a car on a falling road by the Nairobi students provides a powerful metaphor for the anxiety and impatience of young people. The challenge for all of us—fellow travelers on the path to multirooted global belongings—is to create conditions and systems that support young people to go beyond the anxiety of the falling road and experience the tranquility

of sitting under a banyan tree. It is not easy to feel the grounded self that is part of the larger humanity, but the complexity of our intertwined world demands that we commit to making 7.7 billion strangers part of one human family. Our survival depends on it.

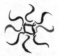

Asia Society Texas Center has come alive.
This is the story of its birth.

To the local, global, cosmic dancer
Best wishes from Anne K and family

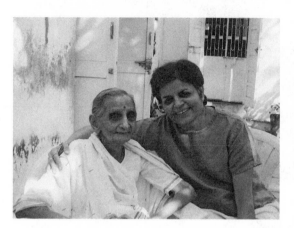

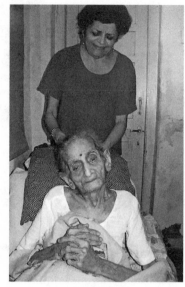

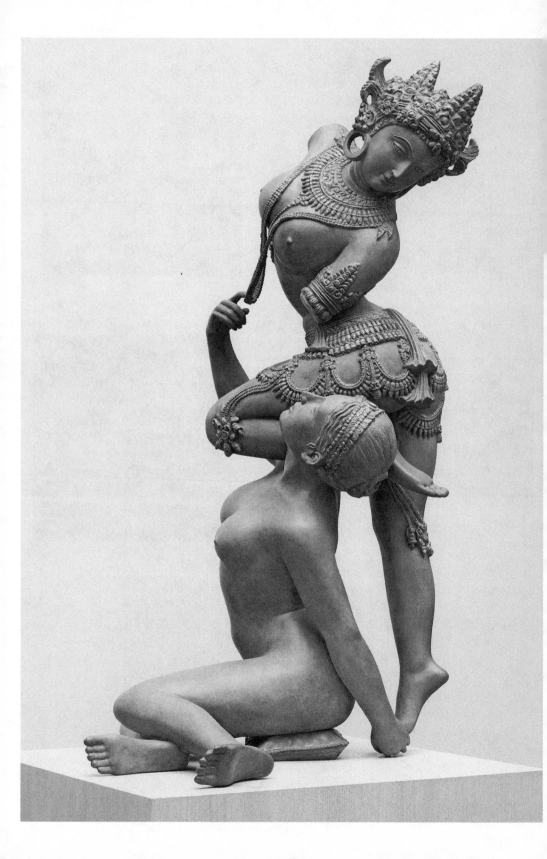

Postscript

Becoming "Family" in a World of Pandemics

"I FEEL THE WHOLE OF HUMANITY in my body." I first heard these words from Faustin Linyekula, a renowned dancer and storyteller and a winner of the 2019 Tallberg Eliasson Global Leadership Prize. As a juror of the prize and a former dancer, I was thrilled to interview Faustin about his passion for dance not just as a creative form but also as an essential human endeavor. Diminutive in size and infectiously energetic in style, Faustin made the direct connection between his body and fellow human beings at an unexpected moment in our conversation. I asked him about his seemingly counterintuitive career move to return to the small town of Kisangani in the Democratic Republic of Congo after spending two decades in Europe where he was a much sought-after artist. Quiet for a while, Faustin spoke softly as if his answer came from some place deep inside him, "I had to feel the history of the place that was part of my body. It was through dance in my body and stories firmly rooted in my hometown that I could create the stories I wanted to tell, hoping that others elsewhere in the world would feel connected to their humanity. Through my work." I smiled knowingly; he brought me back to my early days as a dancer and teacher at the Cleveland Museum of Art. Clearly, Faustin was a fellow traveler on the path of multirooted belongings, looking for global resonance in his hyperlocal experience. He had gone a step further by forging a deep bond with humanity right in his body.

His words came ringing back to me in March 2020 as the novel corona-virus (COVID-19) came rushing into the world at a tsunami-like speed. Stunned by the force of the pandemic that demanded physical distance from fellow humans, we all viscerally felt the connection to the global humanity in our bodies. In a few short weeks, the world we had gotten used to forced us to face stark fissures that we had avoided.

I had finished the draft of this book in late February, feeling that my initial idea for the title, "World as Family," was perhaps too abstract and needed to be replaced. By the time I was ready to edit the text while safely "sheltered in place" in Southold, in early March, the very concept of "world as family" was playing out in real time with the spread of the coronavirus from Wuhan, China, to Washington state. I became acutely aware that the pandemic had ripped the bandage off the wounds of the world. The only way to heal human-ity was to begin treating the *world as family*.

If anything, this expression uttered by the wise Vedic writers more than two millennia ago became more visceral and emotionally resonant. What does it mean to treat the whole human race as family? I know from expe-rience that family always implies the value of collective belonging without giving up a sense of individuality. Each family member makes an effort to help the others in moments of stress and plays a part in preserving the sanc-tity of the unit. It is a delicate dance, with each person pursuing his or her own rhythm but creating a choreography that works in tandem with other members. Because of its emotional underpinnings, when the family doesn't work it can also be highly destructive. With the pandemic raging all around us, what we see is the destructive aspects of our dysfunctional global family. Now we are at an inflection point. If COVID-19 lays bare the stresses in our system, it also highlights the necessity of repairing them.

I observed at the beginning of this book that global challenges such as cli-mate crises and pandemics know no borders, no ethnicity, and no class. With COVID-19, this statement has become a living reality felt in all corners of the world. The pathogens of the pandemic demand that we feel global intercon-nectedness in our bodies, no matter where we live or how much money we have. Embedded in our efforts to protect ourselves from catching the virus from others is also the undeniable truth that we must protect others from being infected by us. Even the phrase "alone together" is a perfect reminder

that our individualizing self is inextricably connected to our collective self that we share with 7.7 billion humans on this planet. In many ways, the novel coronavirus is a perfect metaphor for the necessity and the challenges of relational global belonging that I have tried to articulate in this book.

Arguably, this interconnectedness running through the personal, local, national, and transnational layers of our reality was amply apparent even before COVID-19. But now it is in our faces, staring us down and demanding that we pay attention to the linkages that make us human. COVID-19 has also exposed the limitations of national and international governing systems, deficient patterns of behavior, and callous attitudes of political leaders who insist on maintaining local, national, and global elements as oppositional forces. For once, the marching tide against all things global has met a strong resistance: the persistent pandemic. Even if one wishes to blame it entirely on a single country, it is clear that no one can be safe until the whole world is safe.

LIKE EVERYBODY ELSE, I was caught up in the vortex of the virus as it brought a central aspect of my global life—extensive travels—to a standstill. Seven international trips—Florence (for AFS), Mumbai (four for Mahindra), London (for Teach For All), and Athens (for the Agora Institute of Johns Hopkins)—scheduled during the next eight months, were all cancelled. For the first time in three decades, I spent seven months in one place and slept in the same bed. Initially it felt as if it were the end of all things global in my life. But soon all in-person gatherings turned into virtual meetings, and new Zoom calls were scheduled for virtual birthday celebrations and friendly cocktail hours. Ironically, sitting at my desk in Southold I was connecting with more people from more corners of the world than ever before.

Even as I sustained my global connections virtually, I was happy to be able to go for five-mile daily walks with Robert, getting fresh vegetables at our local farm stands to cook new recipes and embracing our ultra-local life. Never having cooked for sustained periods of time, I threw myself into finding new dishes online and in the Wednesday *New York Times* Food section. Robert couldn't believe that for the first three months of our sheltered life, I didn't repeat a single main dish. From eggplant parmigiana to shrimp pad Thai, we tasted the world through our dinners. Trying out dishes from

diverse cuisines was always my preferred way of cooking. What was more surprising was my desire to cook special Gujarati dishes that I had never bothered to cook, either because of the lack of time or because I could always get my fix for unique Gujarati dishes, *dal dhokli, khandvi,* and *puran poli,* to name a few, on my quarterly visits to India. I terribly missed the sounds, smells, and tastes that I had come to relish on my frequent even if short visits to India for Mahindra board meetings. Now listening to old film songs circulated on the Desai family WhatsApp group and talking to the large Desai family on monthly Zoom calls became cherished additions to my sheltered but connected life. It was as if my global affinities had to be injected with regular doses of local experiences and familial memories, Indian and American, to keep me grounded.

In addition to my ongoing responsibilities, I was energized by new initiatives directly related to COVID-19: (a) a group of concerned "citizens of the world" coming together to start a movement (OneShared.World) to champion global interdependence, (b) virtual fundraising projects for Indian craftspeople and American performing artists whose sources of livelihood suddenly dried up, (c) participating in Youth in a Changing World workshops featuring virtual conversations to discuss the impact of the pandemic on young people's current lives and their futures. In all these calls, one thing was palpable: the desire to connect not only with loved ones but also to forge new bonds across borders.

If the urge to connect was evident in our nonstop virtual efforts in the age of COVID-19, the virus also created an undeniable havoc in all ongoing global systems and projects, exposing existential fault lines. Take AFS as an example. It began with the initial breakout in China where we had more than four hundred students from twenty-five countries. No matter how much we believed in interconnections and intercultural experiences, our only option was to get all the students out in less than thirty-six hours and get them safely to their "native" homes. Within weeks, we were dealing with some eight thousand students in all parts of the world in ever-changing conditions: surging infections with countries closing borders, stopping passengers at airports or putting them in quarantine for fourteen days, and urging all their citizens to return home. On one hand, parents were calling the AFS national offices 24/7 to get their children back; on the other hand, host parents, worried

about the dangers of travel for their "AFS kids," were asking if there was any way to shelter them and wait out the virus. True to form, the students were less worried. Even as they were preparing to return to their "home" countries before the completion of the program, many were planning reunions with their host families during more hospitable times.

AFS was literally a microcosm of the larger global conditions in which the virus proliferated. Each national AFS partner, while operating according to national directives, had to work with colleagues across the world to accommodate their local constraints. As a network, we had to come together to develop guidelines that were flexible enough to handle diverse national conditions. Our responses to the virus were varied. The instructions had to be clear enough so that all partners could march to the same drum: suspension of the program, safe return of the students, and planning for the post pandemic world. On virtual town hall meetings that often involved two hundred people from thirty different countries, my job as the chair of the board was to assure my network colleagues that we could weather this crisis by applying the values at the heart of our organizational DNA, the very qualities that are essential for a globally minded life: flexibility, empathy for diverse points of view, and commitment to finding collective solutions but there was no denying that this was an existential threat to the organization that was based on intercultural experiential learning for young people. It became immediately clear that we needed to come to terms with the interdependent nature of the world.

Simultaneously local, national, and transnational, AFS is an exemplar of a new kind of global, what I would call *Global 4.0*: three-dimensional in nature and encompassing the economic, political, and cultural aspects of our lives, all played out with different intensity at local, national and global levels. The recognition that we need to focus on the interdependent nature of our world is evident in our new COVID-19 world. Efforts at connectivity and gestures of kindness are visible all around us, from making masks for first responders in the United States to organizing meals for migrant workers in India, individuals and organizations have stepped forward to treat the "world as family" in the spirit of "magnanimity" first articulated in the ancient Vedic verse.

At the same time, the fissures, fractures, and limits of global systems have also become painfully obvious. The complete lack of coordination to deal with the pandemic is conspicuous by its absence. Rather than coming

together to combat the unprecedented global crisis, countries have closed their borders and some leaders have chosen to blame others for the spread of the virus. All over the world, leaders and individuals alike are shocked by the inability of a superpower like the United States to effectively deal with the virus. On the other hand, the muscular approach of China not only in dealing with the virus but also its increasingly authoritarian approach to Hong Kong and all domestic and global matters has been equally shocking. According to a recent Pew Research Center survey, for the first time in decades, close to 70 percent of Americans have a negative view of China. The nadir of relationship between two of the strongest global powers has exacerbated the global crisis.

In the United States, the fragmented approach has played out at multiple levels, ranging from developing a consistent approach to vaccination, to states having to compete for ventilators for a surge in hospitalized patients, and getting adequate test kits to control the virus. The lack of a coordinated national approach to reopening the country in the post COVID-19 world has meant unexpected increases in deaths in some regions and a slower than desired pace of eradication of the disease. Rather than resolving to strengthen the global health system, Donald Trump elected to withdraw from the World Health Organization (WHO), refusing to work in a coordinated manner to combat the once-in-a-century crisis that has engulfed the world. (Thankfully, Joe Biden has promised to join WHO as one of his first acts as the President.)

The spread of the coronavirus and the casualties from COVID-19 have also made visible the glaring inequality in global and national systems. In America, a disproportionate number of African Americans and Latinos have died from the virus infection. And in India, the people with the fewest resources have suffered the most from the lockdown and social distancing measures ordered by the government. As Tom Friedman wrote in one of his columns in the *New York Times* (May 31, 2020), at the height of the pandemic in the United States, while the pathogens may not know borders or class, how we have dealt with the pandemic is entirely based on national policies and class structures of the society.

In the United States, the inequities laid bare by COVID-19 have been aggravated by yet another crisis following George Floyd's wrongful death at the hands of police officers in Minneapolis. As W. J. T. Mitchell wrote in his insightful essay in *Critical Inquiry*, "As summer arrived in North America, after an endless spring of pandemic and plagues that is not yet over, and that

swept away hundreds of thousands of lives, a single death [that of George Floyd] suddenly captured the imagination of America, and of the world."[1]

Widespread protests demanding social justice for all, especially Black Americans, in the midst of the pandemic at the end of May and continuing for months have gone viral around the world. Transfixed by the protests against police brutality in the United States, thousands of people showed up in London, Berlin, Stockholm, Paris, Tokyo, and Nairobi, as much to show solidarity for the Black Lives Matter movement as to call for an end to systemic injustices and police brutality in their own countries. Social media platforms in many countries around the world are lit up with the battle cries for social justice. In India, young people pushed for removal of light-skin-color preference in matrimonial sites such as Shaadi.com and in the whitening cream ads by major companies. Issues of casteism against Dalits and other minorities were widely written about by intellectuals and academics. What may have been seen as a local issue quickly morphed into a global challenge requiring national solutions.

The twin crises of the coronavirus and urgent demands for social justice have exposed the inadequacies in the global, national, and local systems, just as they have shined a light on the urgent need for collaboration across local divides and national borders. Professional colleagues and friends in my age group are largely weary and pessimistic about any possibility of developing tools to navigate the interdependent world. Some see an acceleration of nationalist and racist sentiments (border closings in Europe threatening the very idea of the European Union, increased racist attacks on Chinese Americans as an extension of antagonism toward China, the rhetoric of political leaders to pursue "law and order" to stop the protests) exacerbated by the complete lack of global leadership to face these unprecedented global crises. To paraphrase Alan Stoga, chair of the Tällberg Foundation and the force behind its Eliasson Global Leadership Prize, it's doubtful that we can return to the system that was designed for a world that changed long ago, and one should be concerned about accelerated deglobalization favoring hyper-nationalism.[2] Against the probability of the world reverting to parochial national interests, the idea of embracing a new kind of global, one that truly creates a "family" of humankind, interdependent and mutually responsible, seems daunting and audacious, but also essential to pursue.

Once again, my hope comes from young people. Locally isolated for now but globally connected forever, they are clear about the realities of the inter-related world and about the necessity for change. They are frustrated by the leadership and impatient to have a seat at the table, or change the shape of the table itself if necessary, to determine their future. Their presence at street protests and their demands for social justice vividly demonstrate their frustrations with the status quo. This is as evident in the United States as it is in India and Thailand. I see it in the enthusiastic response of young people to engage in the new initiative, OneShared.World. From more than thirty countries, they are willing to get up at all hours of the night to participate in the development of educational toolkits or to plan a virtual summit on the sidelines of the first-ever virtual UN General Assembly. Their energy also came through loud and clear during the three virtual town halls we organized at the height of the pandemic in April (prior to the beginning of social protests) with ninety young people from ten different countries in conjunction with the ongoing Youth in a Changing World project at Columbia University.

The conversations focused specifically on the effects of COVID-19 on their current lives and its impact on the way they imagined their future. Contrary to the images of students frolicking on the beaches of Florida with no concern for the looming dangers of the pandemic, students from the global South as well as the United States were deeply aware of the relationship between their personal disappointments and global disruptions. "It's amazing to realize that we are all in the same boat, our education interrupted and our aspirations thwarted. So many of us are frustrated about the condition of the world but grateful and guilty about our privileged lifestyle," said a young woman from Mumbai. An African student in Istanbul shared, "I get irritated about my confined space and then I think about the restricted movements of refugees where they have no control over their space. I realize how privileged I am to have my own room no matter how small."

It was gratifying to hear them talk about changing the rules of the game that govern the world. A Turkish student said, "We must reflect on what is essential in our life and how we acknowledge those who provide 'essential' services to us during these challenging times. What if we pay more to grocery store clerks and primary healthcare workers because of their crucial contributions to our life?"

I was particularly struck by their urge to incorporate the commitment to "we" into their reflections about "I," especially in their observations about the climate crisis. "It's amazing that dolphins have returned to Venice beaches, and for the first time in our life we can see the snow peaks of the Himalayas and the tips of Kilimanjaro! And this has happened in less than a month that we have been under the lockdown. I love to travel, but what if we all reduce our travel for the sake of the environment? It's a clear example of how we humans have created a mess of this earth, but now we know that we could also reverse the negative effects of carbon dioxide emissions with our actions," an Indian student from Mumbai exclaimed, immediately followed by a student from Nairobi, "We have known about climate change before but now the impact of the pandemic makes the climate crisis very real, not an abstract thought. It's high time we recognize that we don't have to hog the earth entirely for our own selfish causes. We better change our behavior and learn to share the earth with other species and be mindful of their unique needs."

One of my favorite comments came from a student in Tunisia: "How is it possible that with all the technological advances and scientific know-how available to us, the world powers were so unprepared? With all the multilateral institutions in the world, why the total lack of coordination for one of the biggest global crises of our lifetime? At every level, the pandemic has made the failures of our systems and our leaders amply evident. It's time for young people to take the reins and change the systems to make them compatible with the reality of our world." In the context of the crisis, the student's impatience with the mismatch between the globalizing world they have known for their entire life and the systems they are fearful of inheriting seemed fully justified. I am awed by their clarity around the issues and their willingness to work toward a new vision.

The crisis of COVID-19 has made it clear that viruses are inevitable and they travel without any regard for national borders, economic privilege, or religious affiliations. But they need not turn into unmanageable pandemics. It all depends on how we deal with the viruses as they happen. The first step toward successful management of any serious pathogen is to acknowledge that whether we like it or not, all of us, residents of this earth, are inextricably linked with mutual responsibilities. As stated by United Nations Secretary-General António Guterres, the pandemic shows us that none of

us is safe until we all are safe. The crisis of social justice needs to be seen in the same light. None of us can claim to have access to justice or freedom if they are privileges available to some and not rights guaranteed to all. Like the climate crisis, this is not a new issue and it is certainly not unfamiliar. The question is whether this time we can own this reality and fight for systemic solutions with a shared sense of responsibility.

For too long, we have focused on what differentiates us and divides us, often at the expense of our connections. For too long, we have pursued individual interests over collective responsibilities. One of the ways to feel that sense of mutual belonging is to celebrate the multiplicity of belonging within us.

The novel coronavirus has shown us how quickly things can change not only in the natural world but also within ourselves and in our attitudes toward others. The question is whether the changes can be lasting. All crises, including the current ones, have the capability to open new worlds previously unimagined. In fact, history teaches us that it is through crises and catastrophes that we are forced to make changes. The African American writer James Baldwin said it best: "Any real change implies the breakup of the world as one has always known it, the loss of all that gave one an identity, the end of safety. . . . it is only when a man is able, without bitterness or self-pity, to surrender a dream he has long possessed that he is set free. . . ." We may not have all the tools to create an effective working of a global family, but we need to surrender the dream of survival of the fittest and create a vision of sustainability for all.

So, let's use the current crises as catalysts to rebalance our priorities and implement the principle of reciprocity embraced by all the religions of the world in one form or another. No longer an abstract Vedic ideal but an urgent necessity, the interdependent nature of the world requires that we begin to treat the 7.7 billion inhabitants of the planet earth that we call home as our family.

Acknowledgments

THIS BOOK HAS BEEN IN THE MAKING FOR A DECADE, going through many *avatars*, as has my life. The impetus for a deeper reflection came from my husband Robert Oxnam in the form of a casual observation: "When we are in India with your family, I feel like you become a different person. And sometimes, even at home in the U.S., you have attitudes and behaviors that seem alien to me. At the same time, you feel totally comfortable and at home, not just here in the U.S. but in all parts of the world. I think there's something about living between different cultures that would be worth writing about." The more I thought about this idea of living, documenting, and reflecting on a liminal life, and the more I tried it on friends and students, the more they encouraged me to think about the value of living with multiple belongings in a globalizing world. So, I must thank people in my entire universe—friends, family, colleagues, and students—who have cheered me on and expanded my worldview as I developed the ideas in the book not just over the last decade but throughout my life.

Although the book is based on my life story and my reflections on how I have traversed the realities of multi-rooted belongings to create a more capacious sense of global family, I have benefited enormously from insightful comments from a large group of people who have read the manuscript as it went through different iterations: Bart Friedman, Linda Sweet, Cynthia Polsky, Amei Wallach, Leslie Stahl, Lise Stone, Akash Kapur, Irina Bokova,

Daniel Obst, Shagun Sethi, Ken Dychtwald Anuradha Desai, and Antara Desai. Thank you, for the questions you raised, clarifications you sought and suggestions you made. Special thanks also go to Wendy Strothman, who helped with shaping the initial draft of the book. The two anonymous readers made invaluable contributions in creating a sharper focus for the book. You have made the book more readable and relevant for others, even though I take all the responsibility for whatever limitations it may contain.

Much of what I have written is based on my own memories and discussions with family members, but I have been enormously helped by several written sources. My mother, the consummate keeper of all family archives, ranging from correspondence between my parents before and after their marriage to all the letters I wrote during my AFS year and all the newspaper clippings about me in the Indian publications, provided an invaluable help as I constructed my understanding of their relationship and my own life. In the last few years of her life, I felt particularly fortunate to have frequent visits with her to ask questions about her upbringing and her early work just as I was embarking on the book. My sister Swati Desai and her husband Gary Stephens worked on the enormous treasure trove of my parents' letters from 1934 through the 1950s with an intent to translate and work on a family publication. Their organization of the letters in a chronological form came in handy as I reconstructed my parents' early relationship. Similarly, my own diary from the AFS year, notes and the materials I have saved from various parts of my life (following in the footsteps of my mother), have been important sources to check my own recollections or as reminders of things I had forgotten.

For the past few years when the book began to take its final shape, I was very fortunate to have student assistants who not only helped with research on complex issues such as literature on hybridity or issues of identity in a globalizing world, but also suggested areas of further exploration or points of omission. I have benefitted from conversations and correspondence with a number of students and other young people, especially Manasa Sitaram, Lara Kok, and Selma Waihe. Children of my friends around the world have also been my guides as have been younger members of my large family. Thank you, Joey, Smita, Nils, Surabhi, Vishrut, Reema, Anaar, Josh, Antara, Anokhee, Preeya, Aloke, Saahil, and Maansi. Special thanks go to M. J.

Gutierrez, Helena Najm, and to Shagun Sethi. I am particularly indebted to Kunal Shankar, a seasoned journalist and a recent graduate of the Global Thought MA program, for his careful reading of the manuscript, raising questions, suggesting clarifications, and especially adding nuanced thinking to the India sections.

I feel fortunate to have landed at Columbia University Press for the publication of the book. The entire team, starting with Jennifer Crewe, Associate Provost and the director of the Press, has been supportive from the very beginning. I could not have had a better editor than Eric Schwartz, the editorial director, who worked diligently through all parts of the text with me. Special thanks also go to Milenda Lee, the book designer who not only supported but encouraged the possibilities of using artworks throughout the book to amplify the ideas I was trying to convey. Other team members, Lowell Frye, Meredith Howard, and the copyediting team deserve special thanks for shepherding the publication and the marketing process.

As I began to contemplate the life of the book after its publication, it was Jamie Metzl, a good friend and founder of One Shared. World, who suggested that I talk to Ashley Bernardi of Nardi media to amplify the message of the book with the help of her team. Indeed, I have benefitted enormously from new friends I have met (only virtually so far) through OneShared. World, and special thanks go to all of them for the conversations we have engaged in as we have endeavored to make the idea of an interdependent world as felt reality.

One of the many blessings in my life has been to be supported by enormously talented and dedicated assistants—my partners in the work place, who give my peripatetic life some semblance of order. At Asia Society, I was fortunate to work with Mirza Burgos, and later Elizabeth Lancaster and Mary-Hart Bartley, who helped with the initial birthing of the book. Christopher Lucas, my colleague at Columbia, has been my right and left hands, helping me take this book to the finish line, while keeping my almost maniacal schedule amid multiple other responsibilities in the President's office at the university. It is doubtful if I could have come this far without his constant attention to all details of this book, and to the many moving parts of my life.

I am very aware that while there are people who have specifically helped with the book, there are many others who have helped shape my thinking about the ideas articulated in the book without being directly involved. They

are writers, philosophers, and artists, as well as colleagues at institutions I have been associated with, friends who have become part of my life, and family members who continue to buoy my spirits through tough times. Special shout out to Shahzia Sikandar for her firendship and her offer to use one of her new works that grace the end of the book. My enormous debt to my intellectual mentors Sherman Lee, Walter Spink, and Rudolph Arnheim. They opened my eyes to the world of art, the power of images, and the thrill of a scholarly quest. To my colleagues at Asia Society, the talented staff and committed trustees who taught me the value of collective leadership; my colleagues at Columbia, particularly Lee Bollinger, Carol Gluck, and the entire CGT family of staff and academic members who deepened my understanding of and commitment to thinking and acting globally; the sprawling AFS network, especially the international board and the President Daniel Obst who continue to be committed to building a more perfect organization even in tough times; the Tällberg Foundation colleagues, and to chair Alan Stoga, with whom I have served on the Global Leadership prize jury, and the amazing winners of the prize who inspire me to do more and think about the world in deeper and more creative ways; the Teach for All network and its leader Wendy Kopp, and all the boards I have had the honor of serving on, where I have learned the enormous value of collectively making a difference in the world. Last but not the least in this category are the students and young people all over the world: you keep me young and motivated to learn more and think a fresh.

Many writers have said that family is the one where they have to take you in no matter how far you stray. The extended Desai clan, growing by the year and now numbering thirty-six and ranging in age from two to seventy-eight, is my Rock of Gibraltar. Through them, I have come to appreciate the very idea of family in the ancient Vedic phrase "World as Family" that has become the title of the book. The multi-generational Desai clan knows the value of showing up to support each other at the time of need, but also in times of important life events. Over time the family has grown—friends who adopted Ben and Papa as their honorary parents, people who became members of the family by marriage or through particular causes or activities— expanding our notion of the family. Through my family, I have learned that it is possible, and desirable, to rejoice in the individual accomplishments of its

members, and to let go of individual slights for the sake of the family unity. We often say that along with their commitment to integrity and openness, the biggest contribution of Ben and Papa to our lives is the possibility of growing individually without giving up the close bonds collectively. To paraphrase the words of my niece Antara, if I had to be reborn, I would ask to be a member of the Desai family again and again.

The very last bit of gratitude is reserved for Robert, my soulmate, my intellectual sparring partner, my best friend, and my husband. Throughout our life together, he has pushed hard to get underneath the calm surface that I have learned to project and get to my beating heart, not always with ease, but always with the desire to be connected more deeply. In that process of opening me up, Robert has made me a better writer, more reflective and more thoughtful. At times of doubt, he has shored me up, and at times of frustration, he has insisted that I look again to make a sentence better, the idea clearer. Along with my parents, Robert has been instrumental in shaping my internal life. I carry forward my indebtedness to all three of them to pass it on to young people to carry the torch of capacious belonging.

Notes

INTRODUCTION

1. Donald Trump, opening remarks at the seventy-fourth session of the United Nations General Assembly, New York, September 24, 2019.
2. Anthony Kwame Appiah, *Cosmopolitanism: Ethics in a World of Strangers* (New York: Norton, 2006), xxi.
3. Nils Alexander Horn, "Tri-Continental Confusion," a college application essay, May 7, 2013.
4. Gloria Anzaldua, *Borderlands/La Frontera: The New Mestiza* (San Francisco: Aunt Lute, 1987), 79.

1. TOO BAD, ANOTHER GIRL!

1. India Census 2011, https://censusindia.gov.in/2011-prov-results/data_files/india/Final_PPT_2011_chapter5.pdf. The most recent data is from the Central Government's planning department mid-decade projection—NITI Aayog's data for 2013–15: https://niti.gov.in/content/sex-ratio-females-1000-males.
2. Amartya Sen, December 20, 1990, *New York Review of Books*, https://www.nybooks.com/articles/1990/12/20/more-than-100-million-women-are-missing/.

2. HOME: BEAMS, DREAMS, AND FOOD

1. Pico Iyer, "Where Is Home?," TED talk, June 2013, https://www.ted.com/talks/pico_iyer_where_is_home?v2=0#t-385316.

2. A landmark series by the artist was the subject of a full exhibition at the National Gallery of Art, Washington, D.C., September 2017–May 2018.
3. Azar Nafisi, *The Republic of Inmagination: America in Three Books* (New York: Penguin Random House, 2015).

3. DANCING WITH GODS

1. This has been fairly well documented. Not only regional kings but also men from the aristocratic and priestly communities—Brahmin men particularly—had *devadasi* mistresses. They disowned the children born from these relationships. Devesh Soneji, *Unfinished Gestures: Devadasis, Memory, and Modernity in South India* (Chicago: University of Chicago Press, 2012). It is available as an electronic source: https://clio.columbia.edu/catalog/11255038.

4. WHO IS KWAME NKRUMAH?

1. Pico Iyer, March 18, 2000, "Why We Travel." https://picoiyerjourneys.com/2000/03/18/why-we-travel/.
2. In the movie *Gully Boy*, which portrays Mumbai's budding hip-hop scene, actor Kalki Koechlin spray-paints Fair & Lovely skin-whitening cream advertisements in a late-night car ride as a mark of protest. And following George Floyd's killing in America, Unilever, a maker of fairness creams—a multi-billion-dollar business in India—has decided to scrap this line of products.

5. STRANGERS BECOME "FAMILY"

1. Salman Rushdie, *Imaginary Homelands: Essays and Criticism, 1981–1991* (London: Penguin Random House, 1991).
2. Gloria Anzaldua, *Borderlands/La Frontera: The New Mestiza* (San Francisco: Aunt Lute, 1987).

6. VIETNAM: WAR OR COUNTRY?

1. Tina Santi Flaherty, *What Jackie Taught Us: Lessons From The Remarkable Jacqueline Kennedy Onassis* (New York: Penguin, 2014).

7. THE TRAUMA OF RETURN

1. Chimamanda Ngozi Adichie, *Americanah, A Novel* (New York: Penguin Random House, 2013).
2. Jhumpa Lahiri, *In Other Words* (New York: Knopf, 2016), 127.
3. Edited by Angelika Bammer, *Displacements: Cultural Identities in Question* (The Regents of the University of Wisconsin System, 1994).

8. ATTACHMENTS, MADE/UNMADE

1. A. K. Ramanujan, *Is There An Indian Way of Thinking—An Informal Essay* (New Delhi: Sage Publications, 1989).

10. BETWEEN BEING AND BECOMING

1. License Raj refers to bureaucrats who abuse their bureaucratic power and require elaborate red tape to obtain permits to allow the private sector to set up businesses. It led to a pervasive culture of bribing public officials to get things done.
2. India has never allowed for dual citizenship with any country. There have been growing calls lately from the burgeoning diaspora, but domestically it is a contentious issue. Citizenship would mean political participation and holding public office, something many Indians view as a privilege that should be reserved to those who choose to reside in the country.
3. Alessandra Foresto, "Essay: Why I Became an American Citizen" (March 7, 2017): https://www.popsugar.com/latina/Why-I-Became-American-Citizen-Essay-41755040.
4. Lutyens' Delhi is a reference to Central New Delhi, named after its lead architect, Sir Edwin Lutyens. This 26-square-kilometer area is also known as the Lutyens Bungalow Zone, which houses the Presidential Palace, parliament, PM's residence, and the main central government offices and residences of MPs.
5. Emperor Jahangir was the fourth Mughal king (1605–1627) to reign over large parts of South Asia as part of an empire that spanned three centuries.
6. Susan Faludi, *In the Darkroom* (New York: Metropolitan Books/Henry Holtmpany, 2016).
7. Bharati Mukherjee, "Essay: A Four-Hundred-Year-Old Woman," in *The Writer On Her Work*, ed. Janet Sternburg (New York: Norton, 1991).

11. EXPANDING IDENTITIES

1. Roger Bromley, *Narratives for a New Belonging: Diasporic Cultural Fictions* (Edinburgh: Edinburgh University Press, 2000), 9.
2. Holland Cotter, "The Brave New Face Of Art From The East," *New York Times*, September 29, 1996, https://www.nytimes.com/1996/09/29/arts/the-brave-new-face-of-art-from-the-east.html.
3. Wendy Doniger O'Flaherty, *Siva—The Erotic Ascetic* (Oxford University Press, 1981).

14. BUILDING COMMUNITIES ACROSS BORDERS

1. Salman Rushdie, *Satanic Verses* (London: Viking, 1989).

2. Third Culture Kids (TCKs) is a term coined by U.S. sociologist Ruth Hill Useem in the 1950s, for children who spend their formative years in places that are not their parents' homeland. Globalization has made TCKs more common: https://www.bbc.com/worklife/article/20161117-third-culture-kids-citizens-of-everywhere-and-nowhere.

15. REMAKING "HOME" IN THE WORLD

1. Audio recording, *My latest Passage to India*, Carnegie International, 2018.

16. CREATING A CULTURE OF "US"

1. Ian Bremmer, *Us Vs. Them: The Failure of Globalism* (New York: Portfolio/Penguin, 2018).
2. Langston Hughes, "Let America Be America Again," (1935) in *The Collected Poems of Langston Hughes* (New York: Knopf, 1994): https://poets.org/poem/let-america-be-america-again. Hughes wrote this poem while on a train from New York to Ohio reflecting on his life as a struggling writer during the years of the Great Depression.
3. M. K. Gandhi wrote this on June 1, 1921 in *Young India*, the weekly journal he published between 1919 and 1931, where he wrote prolifically.
4. Mark Lilla, *The Once And Future Liberal: After Identity Politics* (New York: Harper Collins, 2017).

POSTSCRIPT: BECOMING "FAMILY" IN A WORLD OF PANDEMICS

1. W. J. T. Mitchell, "Present Tense, Part 3: The Two Plagues, Converge" *Critical Inquiry,* June 8, 2020.
2. Alan Stoga, "Civilization, Interrupted," April, 2020, on-line publication, Tällberg Foundation, https://tallbergfoundation.org/conversations/civilization-interrupted/.

Photograph Notes

Photographs are from the personal collection of the author or from family members, unless specifically stated otherwise.

Each gallery section reads from top to bottom and left to right on each page.

Cover image: *Cell Series: 1*, Robert Oxnam, pastel on Chinese paper

INTRODUCTION

Opening: The Banyan Tree at Matri Mandir, Auroville, Credit: Lisbeth Nusselein

PART I: ROOTS

Opening: Backyard, 38 Jawahar Nagar, 1978 Credit: Horst Schastok

Gallery

1. Marriage of Niru and Nirmala, officiated by Ravishankar Maharaj, 1945 (photograph printed in a memorial publication on the occasion of Niru's passing, 1994)
2. Author at six months, 1949
3. Ben at 90, 2004
4. Papa at 70
5. Backyard at 38 Jawahar Nagar
6. Front steps at 38 Jawahar Nagar
7. Windows and sculptures, facing the outside entrance, 38
8. Backyard, 38 Jawahar Nagar

9. Giving a talk at the residence of Chief minster of Jammu and Kashmir, 1964
10. Lead dancer in the School dance drama
11. Brochure for the solo Dance recital, 1968
12-13. Photographs from the dance recital, 1968

PART II: CROSSING

Opening: Santa Barbara High School graduation, 1967

Gallery

1. Passport photo prior to the visit to the U.S., 1966
2. Desai Family, 1966
3. AFS Students from India, class of 1966-67
4. Extended Desai family at the airport for the author's first overseas trip, 1966
5. Mummy Reed, Julia and the author, 1966,
6. Author, Julia, Noni, Mummy, 1967
7. Noni, Poppy, Mummy, Julia, 1966
8-9. Santa Barbara home, Romero Canyon Drive
10. Author and papa at the Santa Barbara News offices, newspaper clipping, 1966
11. Art teacher Jack baker and the author in the art studio at Santa Barbara High School, 1966
12. Author at the art class
13. UCSB dance performance against the painted backdrop by Jack Baker
14. High school graduation, SBHS, June 1967

PART III: IN-BETWEEN-NESS OF BELONGING

Opening: Shiva Nataraja, the Cosmic Dancer, Chola Dynasty, 11th c., Tamil Nadu region, India, Cleveland Museum of Art, Purchase from the J. H. Wade Fund, 1930.331

Gallery

1-4. With students from East Cleveland Public school at the Cleveland Museum of Art, 1970
5. Photograph by the author's former husband as part of his art portfolio
6. Installation of an Indian sculpture for the reinstallation of the Indian galleries, Museum of Fine Arts, Boston, 1981
7. Preparation for the Indian ritual for the public opening of the Asian galleries at the MFA, Boston, 1981
8. Ben and Papa at the opening

9. Catalogue cover of the exhibition, Life at Court, Art for India's Rulers, 1985
10. Boston Museum group at home with Papa, 1987
11. Boston Museum Group at Taj Mahal, 1987

PART IV: EXPANDING THE CIRCLE

Opening: Female Head, Ravinder Reddy, India, 1995, part of the exhibition, Traditions/Tensions Contemporary Art from Asia, 1996

Gallery

1. Statue of Liberty, Tseng Kwo Chi, from the exhibition, Asia/America: Identities in contemporary Asian American Art, 1994
2. Dwelling, Yong Soon Min, from the exhibition, Asia/America, 1994.
3. Article by Holland Cotter in the New York Times, 1993
4. To Borrow your Enemy's Arrows, Cai Guo Qiang, Commissioned by the Asia Society for the exhibition, Insdie Out: New Chinese Art, 1998 (now in the collection of the Museum of Modern Art, NY)
5. Wedding in Central park, 1993
6. Hiking the Dolomite, Italy, 1992
7. Wedding in Central park, 1993
8. Ben and papa on his 80th birthday
9. Desai family at Papa's 80th birthday celebration
10. Living room at 38 Jawahar Nagar, 1980
11. Antara with Ben prior to her departure for the U.S., 1997
12. Antara with her twin cousins after the cancer treatment, 1998
13. With Emily Rafferty, the President of the Metropolitan Museum of Art and Richard Holbrooke at the Art Table celebration honoring the author, 2006
14. Four Presidents of the Asia Society, Phil Talbot, Robert Oxnam, Nicholas Platt, the author, on the 50th anniversary of the Asia Society, 2006
15. Opening lighting Ceremony for the Asia Society Centre in Mumbai with the Indian Prime Minister, Manmohan Singh, 2006

PART V: AT HOME IN THE WORLD

Opening page: Sunset at Soundview Home, July 2020

Gallery

1. Asia 21 Gathering, Japan 2008
2. With Daniel Obst, President and CEO of AFS International, 2018
3. AFS Prize for Young Global Citizens for the inaugural winner, Luisa Fernanda Romero Munoz (Colombia) at the AFS Global Conference in Montreal, 2019

4. Asia Society Houston building designed by Yoshio Taniguchi, inaugurated in 2012
5. Asia Society Hong Kong campus of renovated and new buildings designed by Todd Williams Billy Tsien, inaugurated in 2012
6. With sisters Swati and Anuradha on the occasion of stepping down from the Asia Society, 2012
7. Celebrating the gift of art work by Cai Guo Qiang given by the trustees, co-chair Henrietta H. Fore in the foreground, the artist holding the picture, 2012
8. A constructed image created by Ann Kirkup, a staff member a the Asia Society for the celebration of the author's twenty two year-tenure with the citation: "To the local, national cosmic dancer," 2012.
9. With Ben, ca. 2010
10. With Ben, October 2014
11. Final departure, December 2014
12. Stage at *Besnu* (paying respects) to Ben, December 2014
13. Found Wood sculpture inspired by Chinese Scholars Rock, Robert Oxnam, 2012
14. Soundview Home
15. Workshop for Committee on Global Thought, 2018
16. Facilitators of the Youth in a Changing World Workshop in Rio de Janeiro, 2018
17. Collective Drawing by the participants in the Youth in a Changing World Workshop, Nairobi, 2019

PostScript

Facing: Shahzia Sikander, *Promiscuous Intimacies*, 2020. Patinated Bronze. Courtesy of the artist and Sean Kelly Gallery (Photo by Jason Wyche)